# THE Wayward Leunig

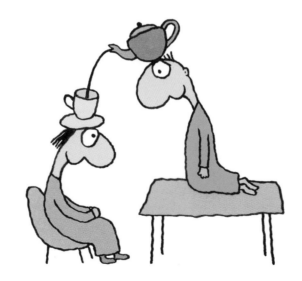

The Penguin Leunig

The Second Leunig

The Bedtime Leunig

A Bag of Roosters

Ramming the Shears

The Travelling Leunig

A Common Prayer.

The Prayer Tree

Common Prayer Collection

Introspective.

A Common Philosophy

Everyday Devils and Angels

A Bunch of Poesy

You and Me.

Short Notes From the Long History of Happiness

Why Dogs Sniff Each Other's Tails.

Goat person

The Curly Pyjama Letters.

The Stick

Poems 1972-2002

Strange Creature

When I Talk to You.

Wild Figments

A New Penguin Leunig

Hot

The Lot.

Curly Verse: Selected Poems

The Essential Leunig: Cartoons From a Winding Path

Holy Fool

Musings From the Inner Duck

# THE Wayward Leunig

## CARTOONS THAT WANDERED OFF

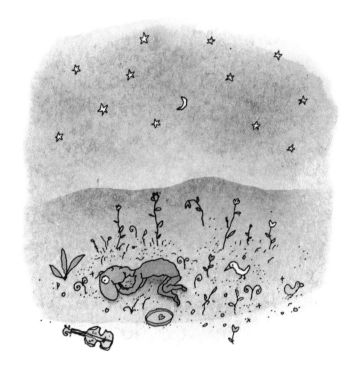

VIKING
*an imprint of*
PENGUIN BOOKS

VIKING

UK | USA | Canada | Ireland | Australia
India | New Zealand | South Africa | China

Penguin Books is part of the Penguin Random House group of companies
whose addresses can be found at global.penguinrandomhouse.com.

Penguin
Random House
Australia

First published by Penguin Group (Australia), 2015

10 9 8 7 6 5 4 3 2 1

Copyright this collection © Michael Leunig 2015

The moral right of the author has been asserted.

Design by Michael Leunig and Adam Laszczuk © Penguin Group (Australia)
Colour separation by Splitting Image Colour Studio, Clayton, Victoria
Printed and bound in China by 1010 Printing International Ltd

National Library of Australia
Cataloguing-in-Publication data:

Leunig, Michael, 1945– illustrator.
The wayward Leunig: cartoons that wandered off / Michael Leunig.
9780670078769 (hardback)
Caricatures and cartoons – Australia.
Australian wit and humor, Pictorial.

741.5994

penguin.com.au

# The Wilful Wandering Mind

Most of the cartoons in this collection were created for daily or weekly newspapers over a period of about forty-five years. There is a traditional expectation that an editorial cartoon will be relevant to contemporary issues, addressing the obvious political or social matters of the day by cleverly shedding satirical light on their machinations. This is an excellent idea, but when faced with such dire responsibility the author of this book often had delinquent urges that intervened and took over the process, resulting in cartoons that bore no apparent relationship to the important, heavy questions; cartoons from a time when the mind wandered off and got lost down tempting, delightful sidetracks. Well, not permanently lost, but absent for long enough to forget about the limitations of normality

and the grave issues for a while – yet with sufficient time to take a piece of paper and a pen and wilfully redraw the familiar arrangements of modern life. As if this wasn't strange enough, I also wanted to rid my work of those common elements of popular humour and cartooning: witticisms, detachment, punch lines and caricature. I wanted something more lyrical and primal; something more vulnerable, raw and risky.

And why would a person want to do such a thing?

It could be because some souls have a peculiar, instinctive need to escape the dull confines of material reality, to flee and playfully reinvent the human condition, perhaps in spiritual defiance of the oppressive banality, misery, and mass-minded stupidity that loom over our days. Perhaps too in the belief that there is more to life, a fascinating primal substrata beneath the ways of worldly power. One sometimes must fly creatively in the face of the whole thing in order to understand it. One also needs to revolt at times to fully live and breathe and come to one's senses. The self needs to be assertive and make its unique marks as an act of liberation and regeneration.

As we know, it is not easy to be free (neither the struggle for freedom nor the having of it), and perhaps the mind does not just wander off, but actually seeks to escape with great diligence, and when it sees a chance it slips down a dark alley or through an open door or window. Sometimes it drifts away during a break in conversation. There are many ways.

Such has been the working life of this cartoonist: the recurring tendency to mentally stray into the realms of the peculiar, the silly, the mysterious and the unfamiliar – and to be joyfully irrelevant there and find strange realisations concerning love, hate and human nature. Some of the cartoons in this collection are funny, I trust, some dark,

some delightful; others are dubious, poignant and poetic, and there are those that are quite mad or incomprehensible – but all are in a way heartfelt and interesting to the soul, I believe, and hopefully of some improbable or unknowable value to the wayward human spirit.

Michael Leunig

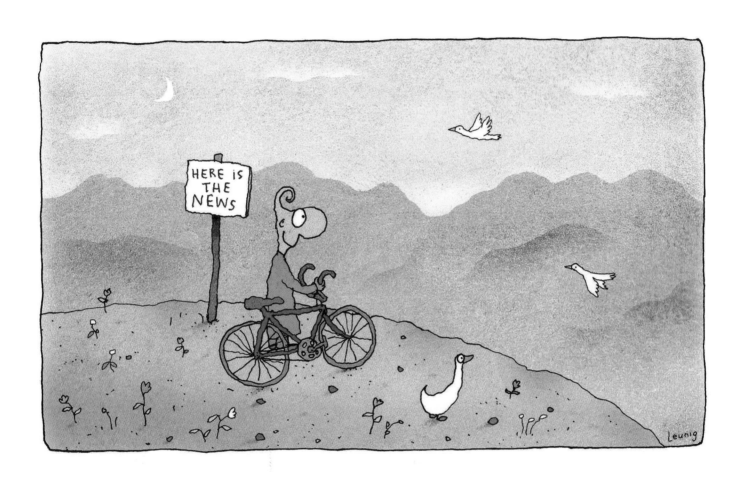

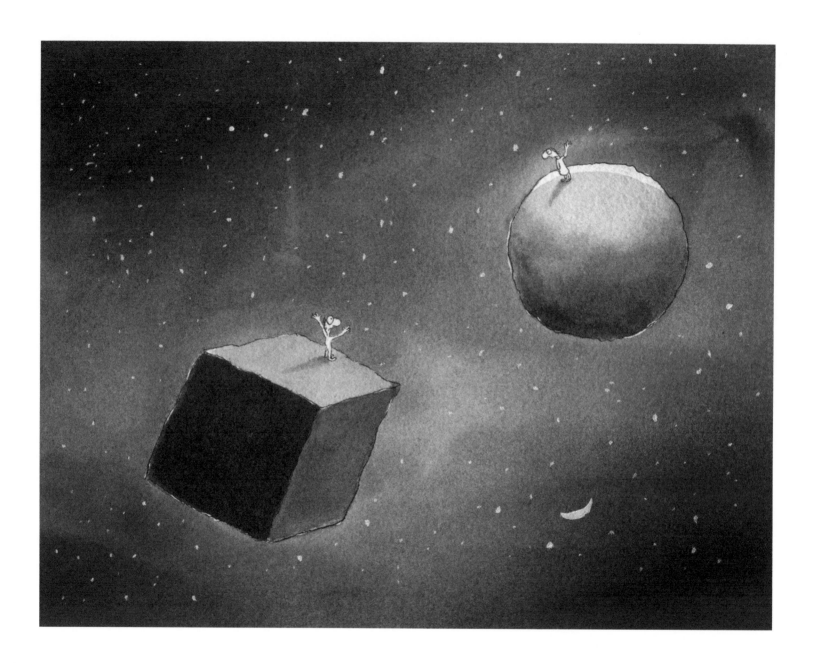

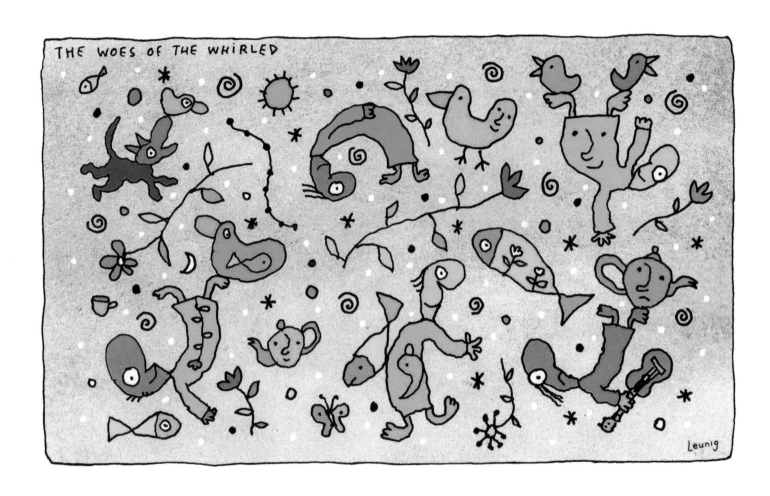

THE WOES OF THE WHIRLED

Leunig

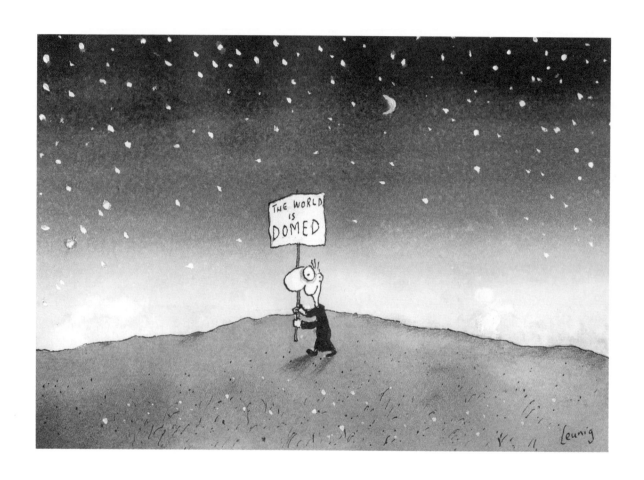

4

I went to Mars on a rocket ship
To look for signs of life.
I found a woman there.
She became my wife.
We had some little babies.
They were so unique;
Neither Earthling nor Martian
Did they speak.
Yet they sang, they played.
They GLEAMED.
We slept peacefully together.
We dreamed
Of a planet up above
Where there is new life
And there is love.

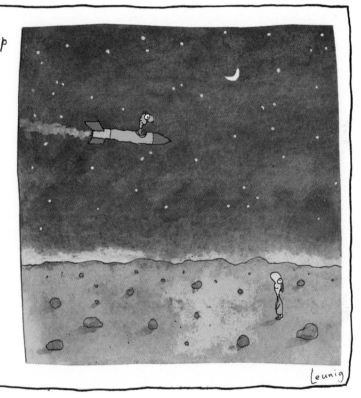

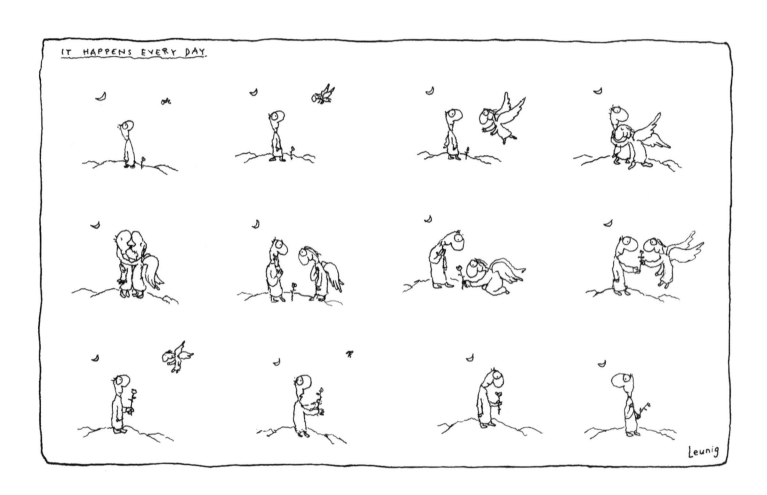

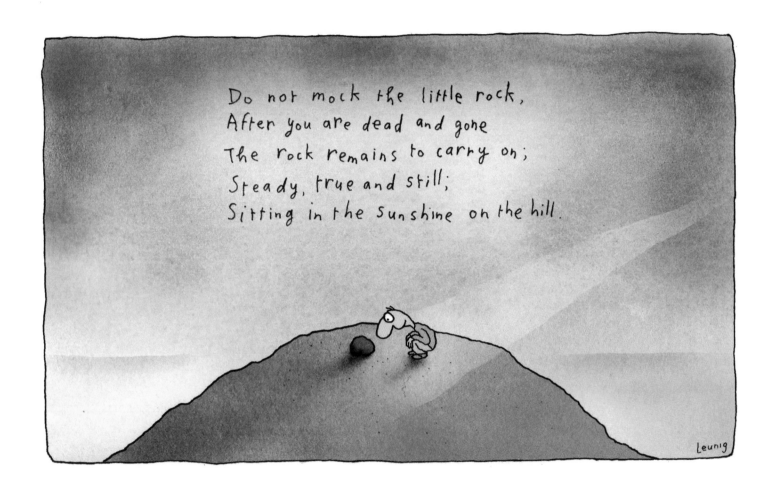

Do not mock the little rock,
After you are dead and gone
The rock remains to carry on;
Steady, true and still;
Sitting in the sunshine on the hill.

HUMANS EMERGED FROM
THE PRIMEVAL SLIME...

...BUT THEY NEVER GOT OVER
IT AND NEVER FOUND
MUCH HAPPINESS.

SO THEY CREATED
TECHNOLOGY SLIME
TO LIVE IN...

... AND WITHOUT FURTHER
ADO THEY DESCENDED INTO IT.

END OF STORY.

Leunig

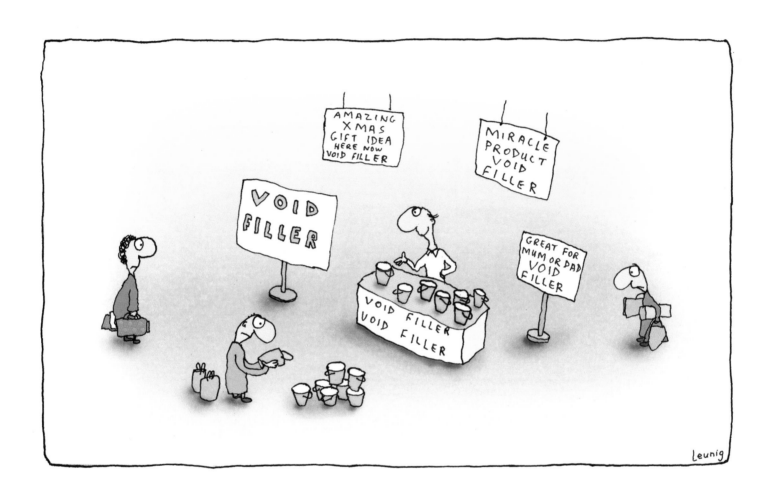

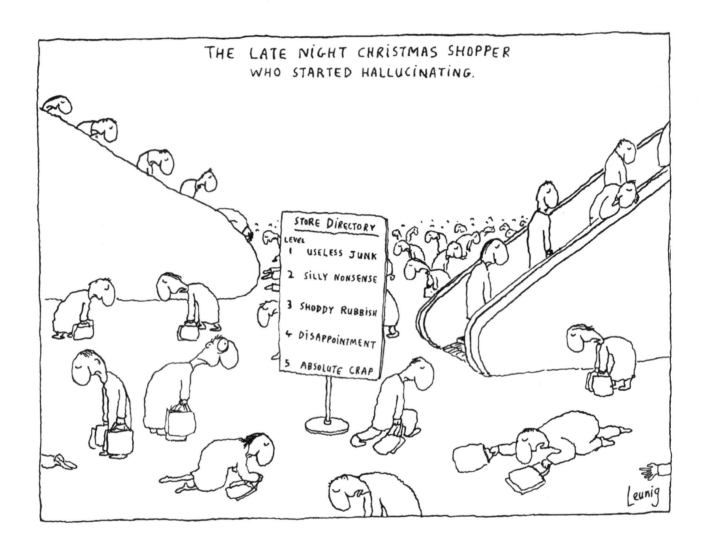

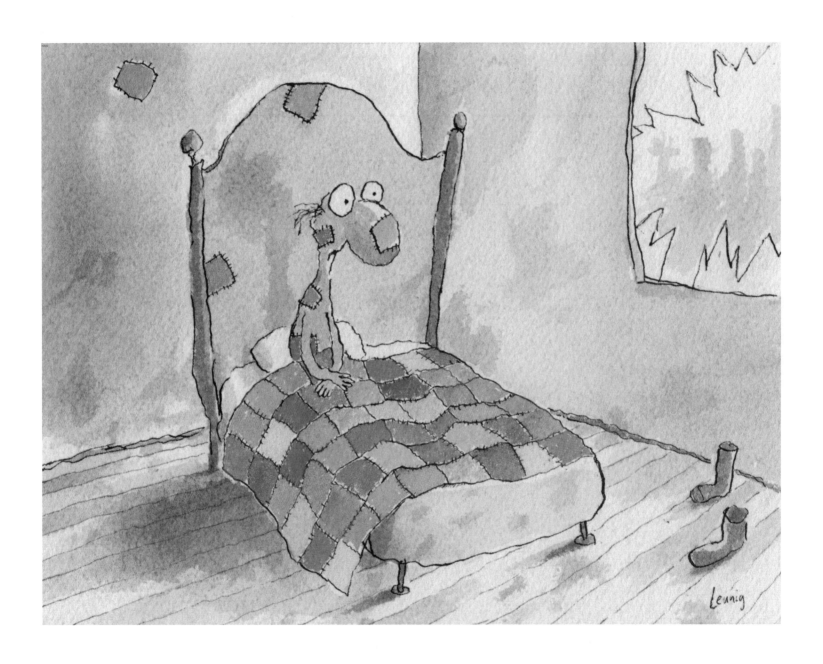

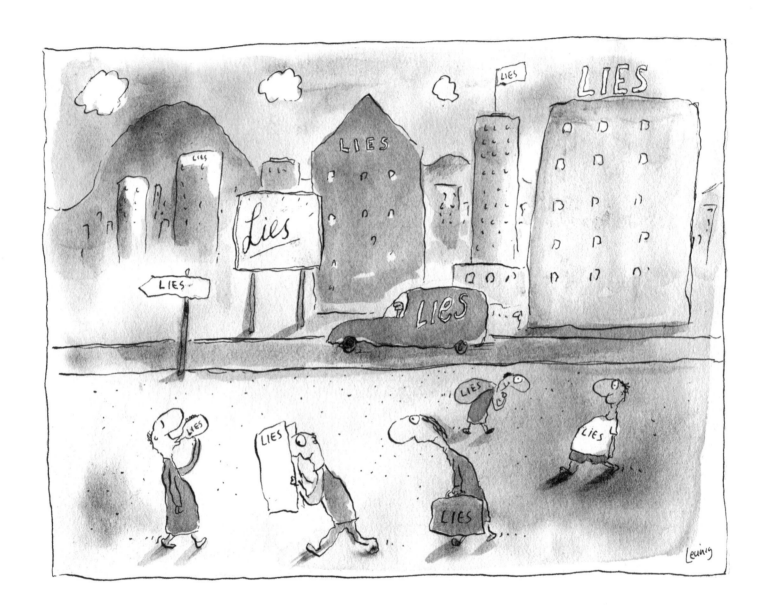

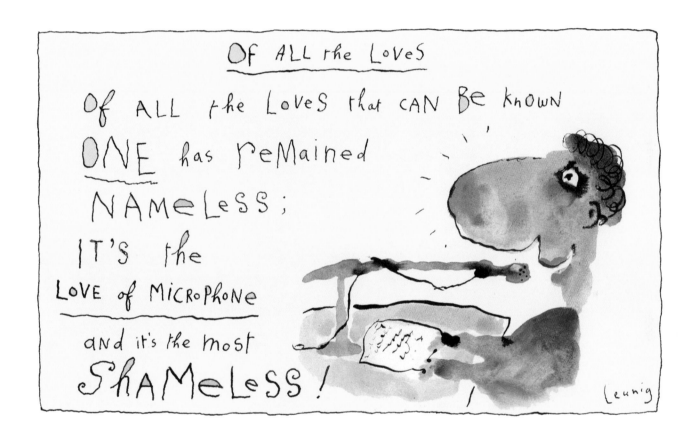

# OF ALL the LoveS

OF ALL the LoveS that CAN Be knOwn
ONE has ReMained
NAMeLeSS;
IT'S the
LOVE of MICROPhone
and it's the most
ShAMeLeSS!

Leunig

HERE'S THE PLAN....

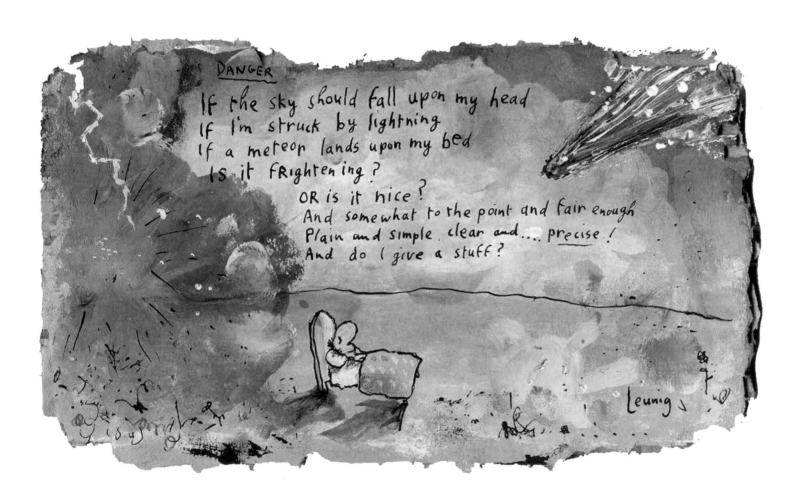

DANGER

If the sky should fall upon my head
If I'm struck by lightning
If a meteor lands upon my bed
Is it frightening?

OR is it nice?
And somewhat to the point and fair enough
Plain and simple, clear and ... precise!
And do I give a stuff?

Leunig

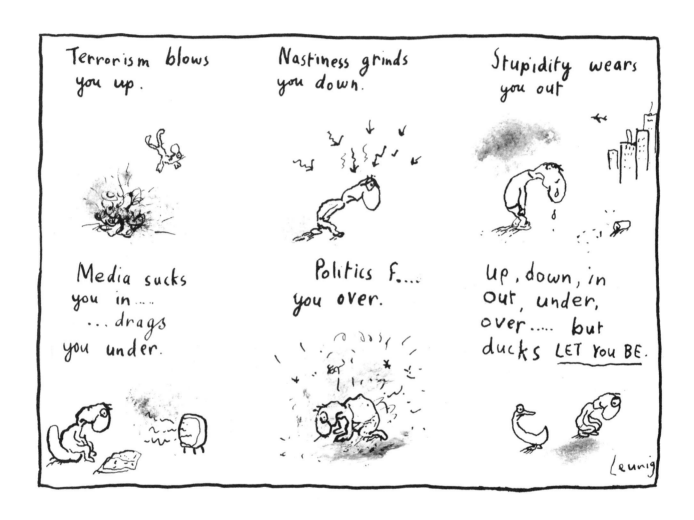

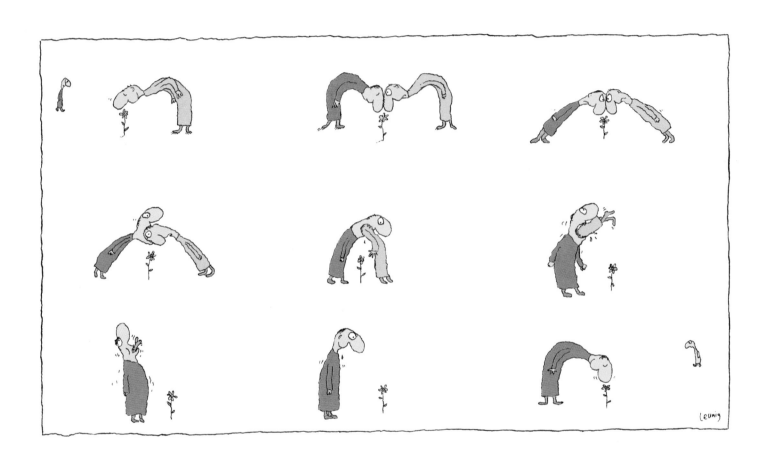

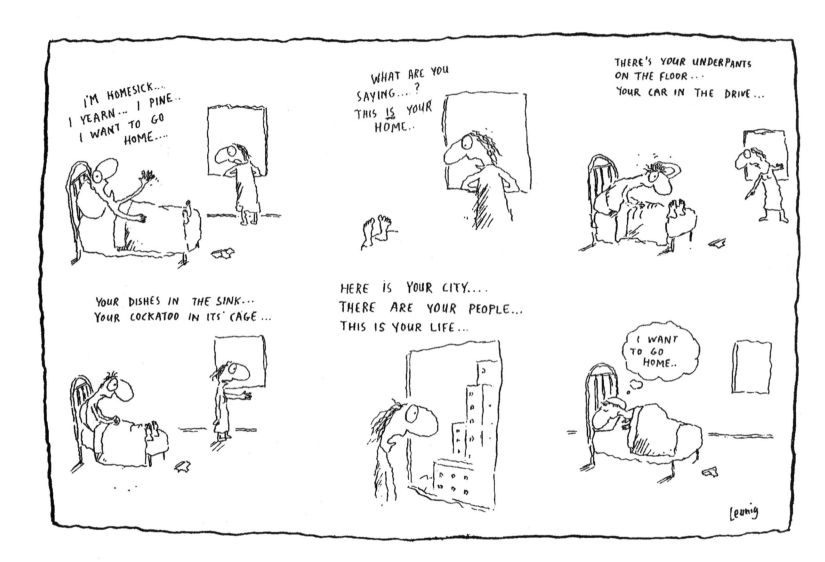

Mavis darling, there's
been a dreadful terror attack:
the snails have eaten all my
lettuce seedlings...

Leunig

Between the whimper and the bang
Life is like a boomerang.

Thrown by some great hairy hand.
Spinning out across the land.

Spinning out across the years
Spinning lies and spinning tears

Spinning heart and spinning brain
Spinning pleasure spinning pain

Spinning out and spinning round
And spinning back towards the ground.

A graceful loop across the land
Then back into the hairy hand.

Leunig

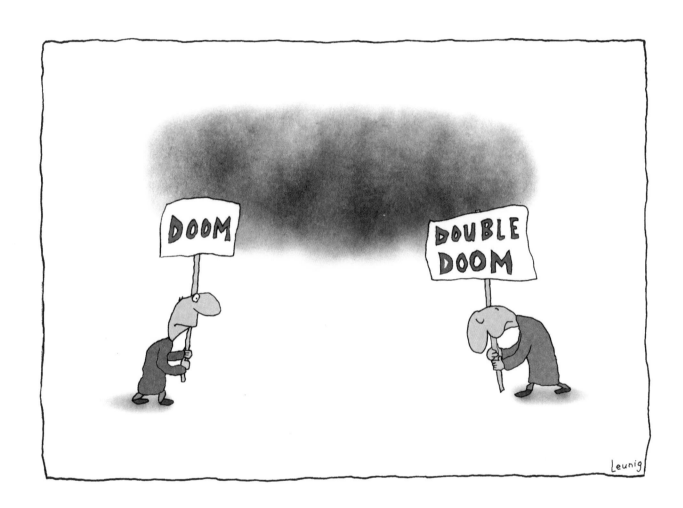

HIS RADIO AERIAL HAD
BEEN SNAPPED OFF BY VANDALS
SO HE IMPROVISED. HE
REPLACED IT WITH A WIRE
COATHANGER

HIS CAR ROSE UP FROM THE
GROUND, THE COAT DRAWN
SKYWARD BY THE POWER OF
THE TROUSERS.

BEFORE DRIVING OFF
HE ABSENT-MINDEDLY
HUNG HIS COAT ON THE HANGER

THE COAT DOCKED WITH THE
TROUSERS. HE WAS TRAPPED
IN SPACE. CAUGHT BETWEEN
HEAVEN AND HELL.

UNWITTINGLY HE DROVE UNDER
A PAIR OF TROUSERS WHICH WERE
HANGING IN THE SKY

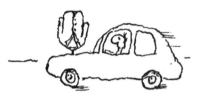

EVERY DAY LIFE WAS BECOMING
MORE DIFFICULT TO LIVE AND
HARDER TO UNDERSTAND. WAS THIS
THE LAST STRAW...? THE FINAL
HUMILIATION....?

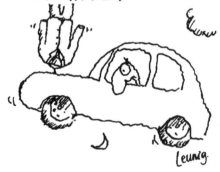

Leunig.

22

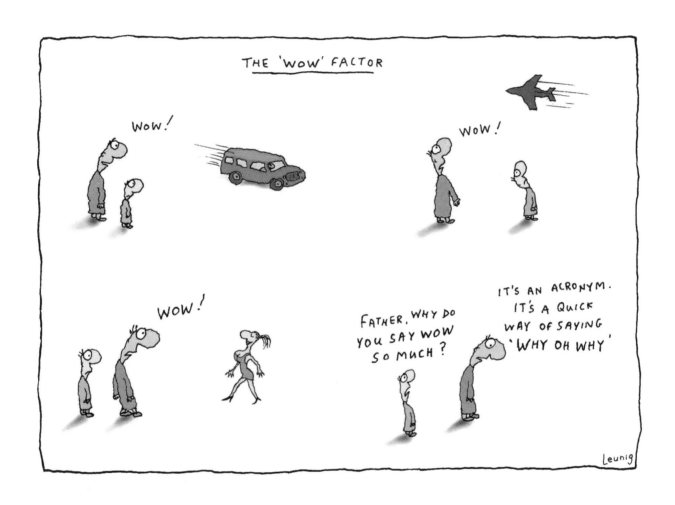

## SWALLOWS AS A CURE FOR DEPRESSION.

A depressed and worried man sits on his veranda in the evening.

The man becomes enchanted by the nimble gliding of the little birds. How light they seem...

The sun is sinking and so are his spirits.

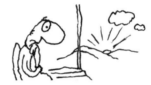

Soon his heart is swooping and darting through the heavens where the first stars are beginning to appear.

Swallows swoop down from the darkening sky and flit gracefully about before roosting under the eaves.

Soon his mind has come to rest with the sleeping birds.

Leunig

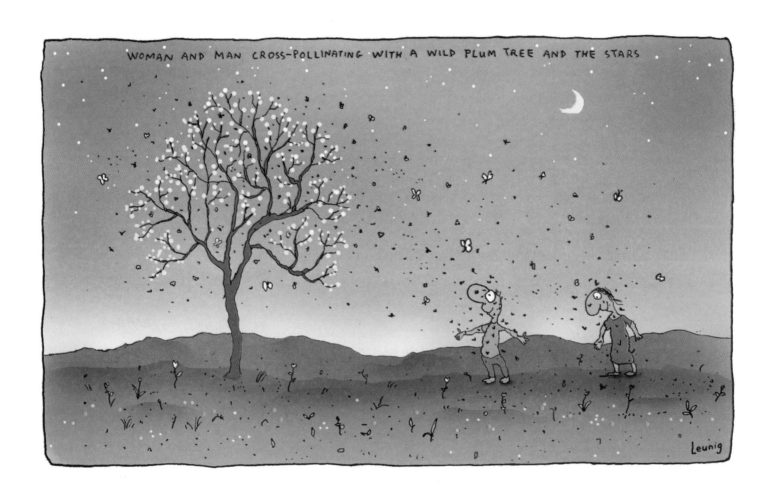

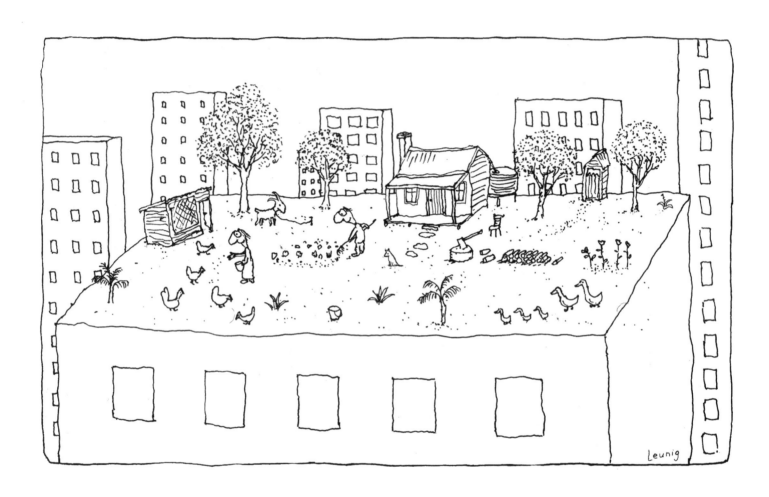

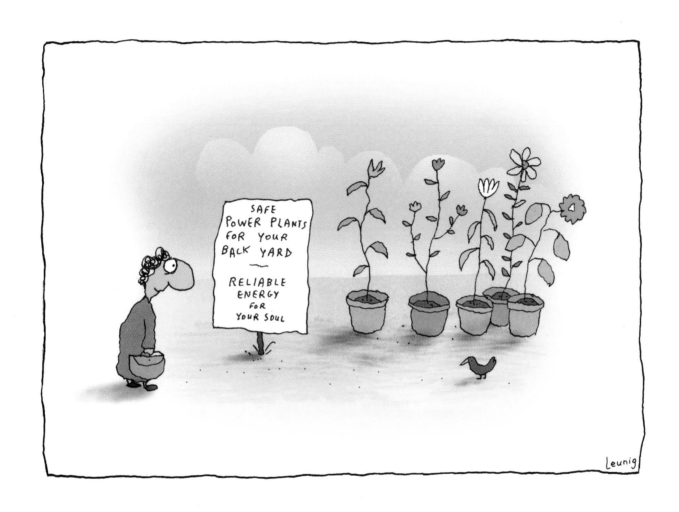

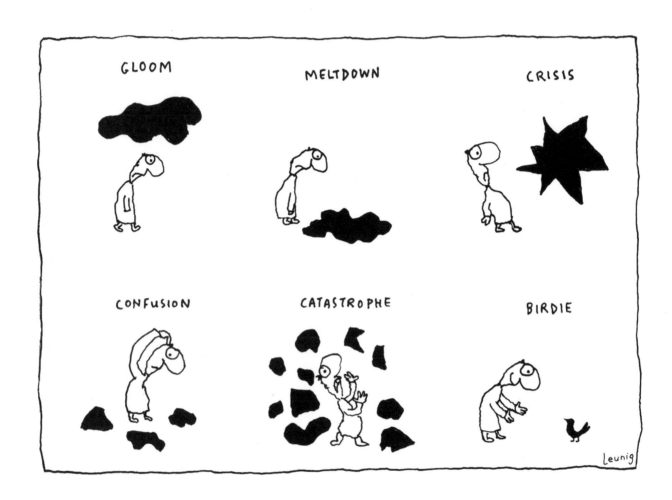

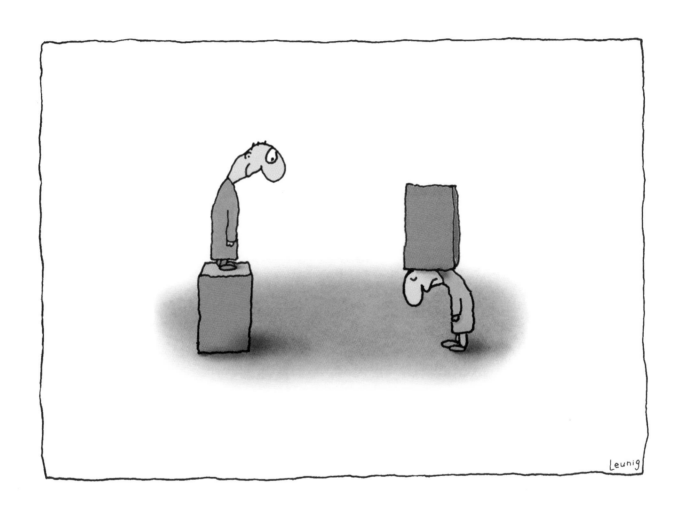

29

## Does God Exist? <u>AN ESSAY</u>

More to the point:
what does it matter
if God exists or not?

After all, everything
else seems to exist, so
what's the problem?

Certainly, sometimes
it's not easy to exist.

For instance – <u>POLITICALLY</u>!
For all the say you have
in the way things are,
you might as well
<u>NOT</u> exist.

Some people exist on
the smell of an oily rag;
other people eke out
an existence. Eking
is the key to wisdom
and a life well lived.

Some people want
other people not to
exist. This is a very
unfortunate situation.
Yet everyone exists
and <u>everything</u> exists.
Sort of. So get used
to it. It all exists.
(FOR THE TIME BEING)

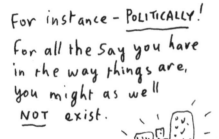

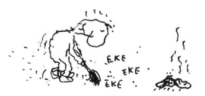

Leunig

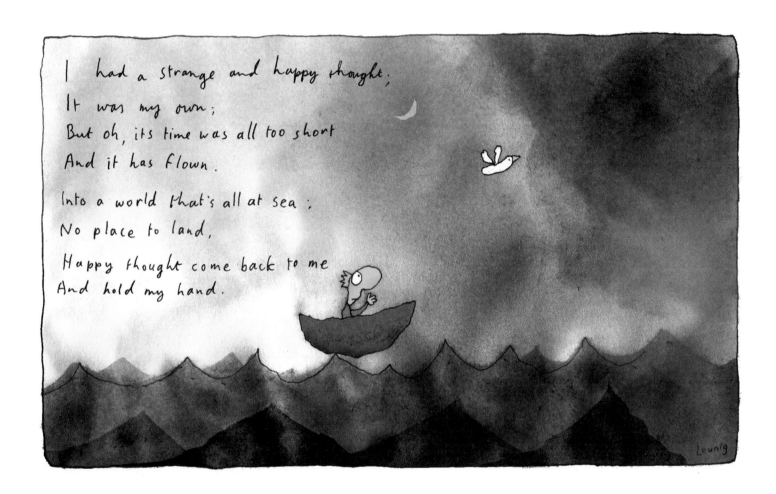

I had a strange and happy thought;
It was my own;
But oh, its time was all too short
And it has flown.

Into a world that's all at sea;
No place to land,

Happy thought come back to me
And hold my hand.

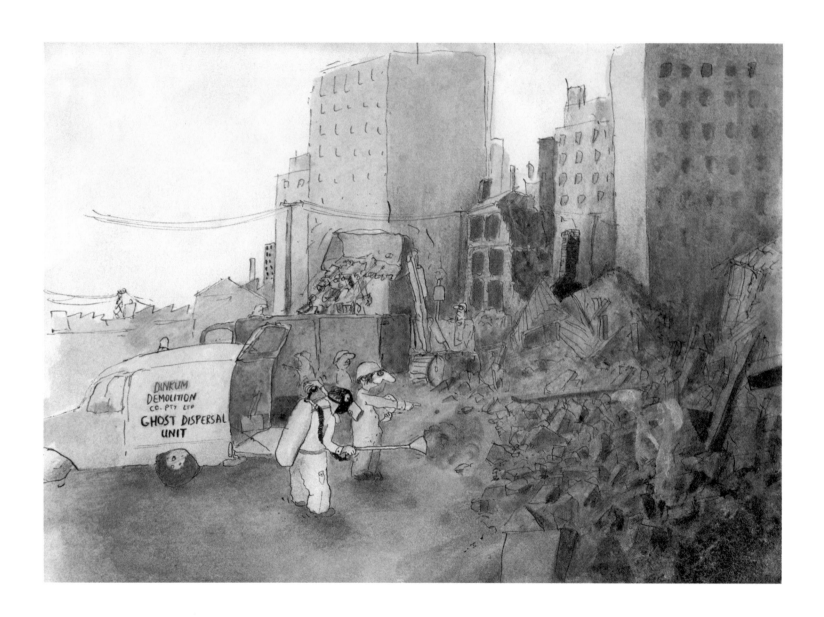

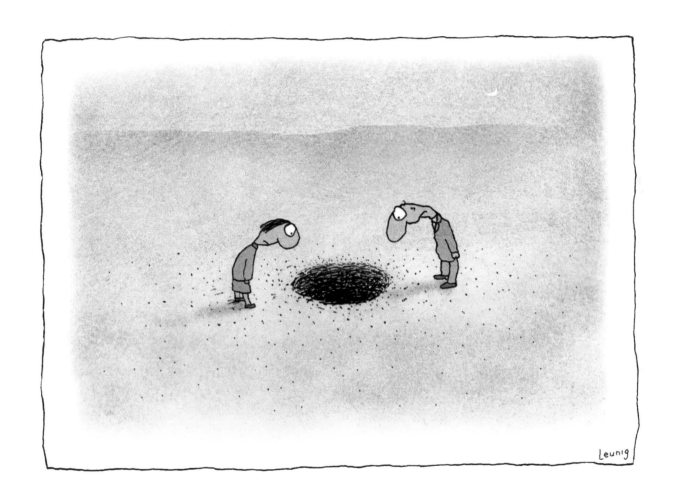

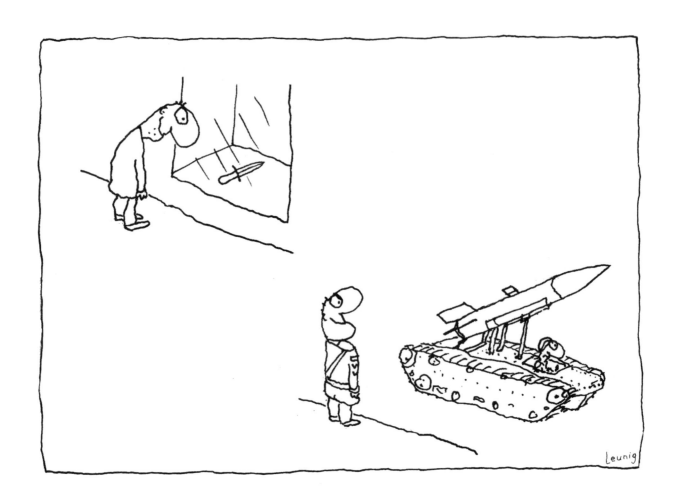

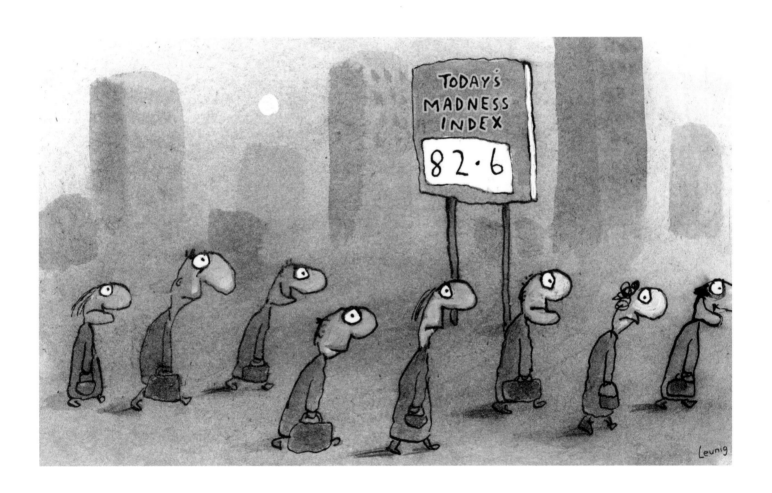

Father what is
the law of karma?

That's the law
we hope is more
effective than
international
law..

BUSH
BLAIR
HOWARD
STILL
FREE

Leunig

37

## CONTROLLED CRYING

Put the crying child in a room by itself and shut the door.

Put the nature lover, the truth speaker, the peace maker and the soul searcher in rooms by themselves and shut the door.

Put the crying asylum seeker in a room by itself and shut the door.

Teach them to stop crying. Teach them to give up and shut up and go to sleep.

Leunig

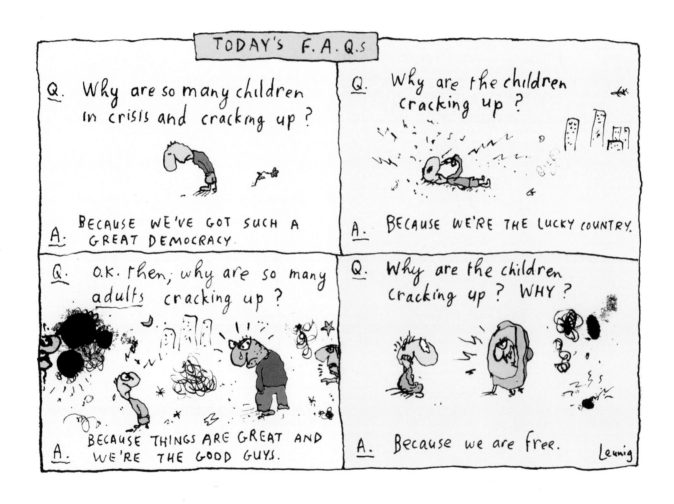

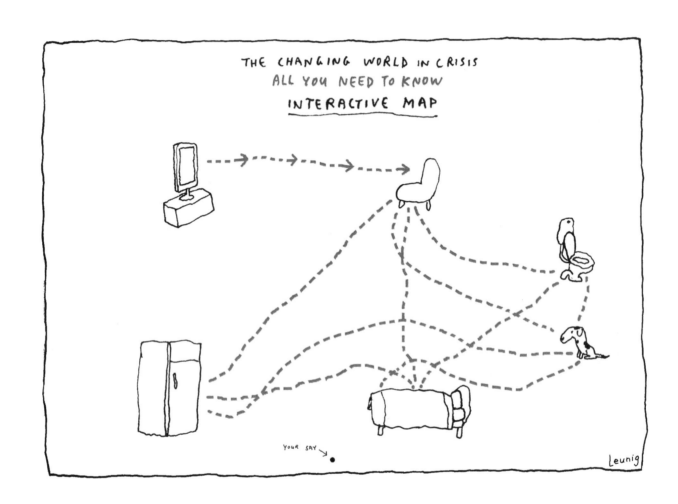

| TODAY'S Q. + A. | |
| --- | --- |
| Q. Why are so many Australian children cracking up?   A. NOT THIS AGAIN! YOU'RE BEING NEGATIVE. | Q. Yes but why are so many children cracking up?  A. AUSTRALIA IS A RELAXED, SPORTING NATION OF POSITIVE, FRIENDLY WINNERS SO JUST CHILL OUT! |
| Q. YES, O.K. but why are the children cracking up?  A. NEGATIVITY IS A DARK, UN-AUSTRALIAN EVIL. THIS IS THE LAND OF SUNSHINE AND OPPORTUNITY... AND YOU'RE A BORING LOSER. | Q. ALRIGHT. O.K., but why are the children cracking up?  A. WE HAVE A WORLD CLASS, AWARD WINNING, DEMOCRATIC SOCIETY WITH A BOOMING ECONOMY AND GREAT GOLDEN BEACHES. Leunig |

41

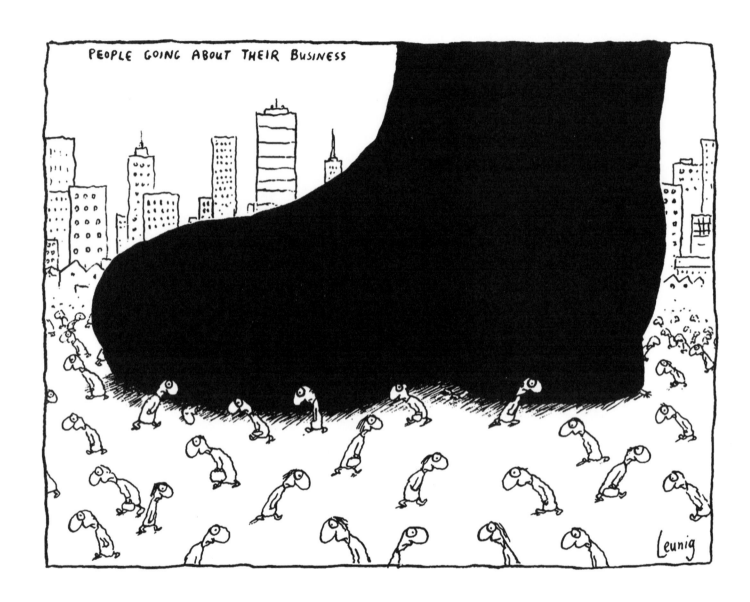

## LAMENT

As I lay sleeping
The graffiti boy came creeping;
Creeping through the dark
To make a boring mark
That made no sense
Upon the paling fence.

I can recall
When old Jack Frost would call
As I lay curled;
He painted half the world
In sparkling white;
And always got it right.

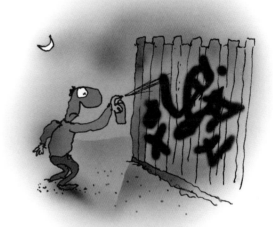

Leunig

Demon babies are special. They have special needs.

But it will all seem worthwhile when you hear the clitter-clatter of tiny cloven hooves around the house.

What do you do with that little tail when the nappy is changed?

Good behaviour may signal developmental problems. A new pitchfork for young Lucifer may be the answer.

Horning, as well as teething, may be a hellish time.

A bad start is vital if your demon baby is to fulfil its destiny as Prime Minister, CEO, Football hero Superstar or media celebrity.

Leunig

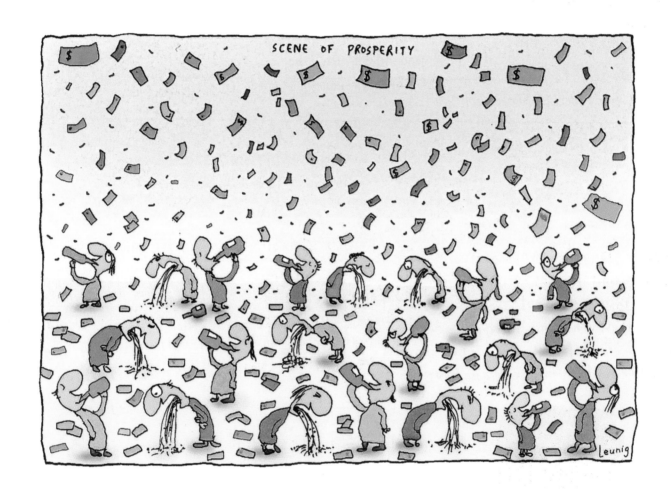

Burglary, forgery, bribery buggery, thuggery, treachery trickery, rape. For these things he was sent to Australia on the first fleet as a convict

In the new colony he was regarded as a model prisoner and a "good bloke" and he earned an early pardon.

He worked hard, clearing the land.

Before long he owned a luxury unit in Noosa. It was white inside and out. So were his clothes and his mercedes Benz. So different from the blackness of SOLITARY CONFINEMENT.

He also owned nearly all of the breweries, newspapers, television stations, supermarkets, political parties and a host of other things

At the end of each day he lay his head on the pillow and mumbled to himself: "burglary, forgery, bribery, buggery, thuggery, treachery, trickery, rape."

## WHERE THE HOON SUCKS

(apologies to William Shakespeare)

Where the hoon sucks, there suck I;
In an Irish pub I lie;
There I couch as bowels do cry.
Off the handle I do fly
In the summer hot and dry.
Merry, merry I shall be;
Head butt if you look at me.

Leunig

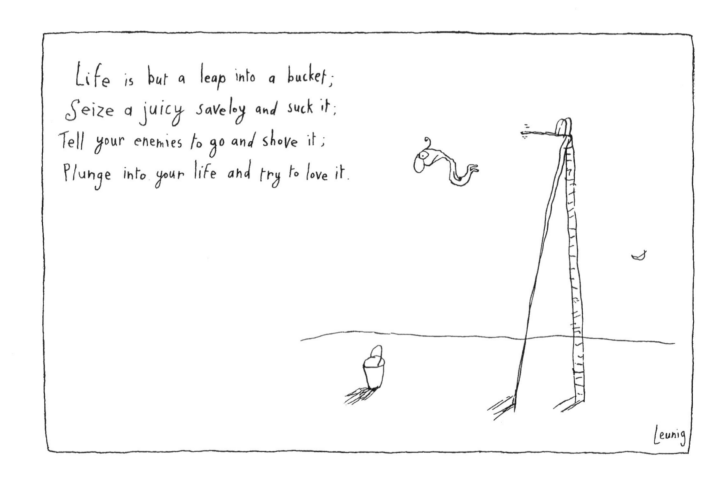

Life is but a leap into a bucket;
Seize a juicy saveloy and suck it;
Tell your enemies to go and shove it;
Plunge into your life and try to love it.

Leunig

49

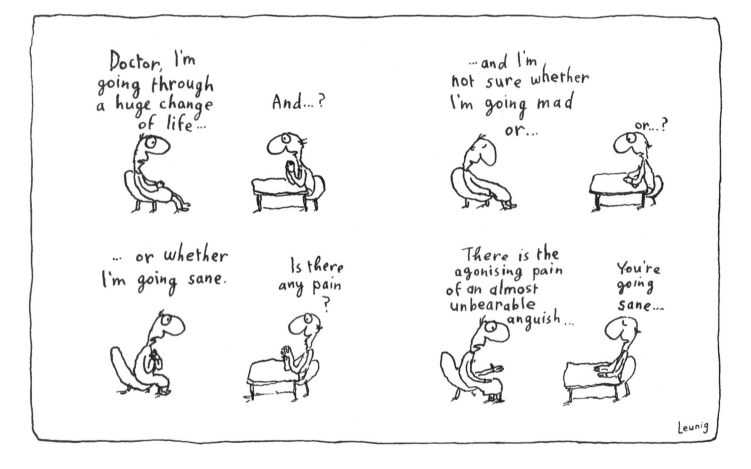

## STAN THE FAN

I'm a huge fan of the fan
And when I'm feeling hot
I have a fan called Stan
I turn him on a lot.

I lie there on the bed
Stan sits upon a stool
He slowly turns his head
And everything is cool

I love to sleep with Stan
And feel him by my side
Stan's the lovely man
Who keeps me satisfied.

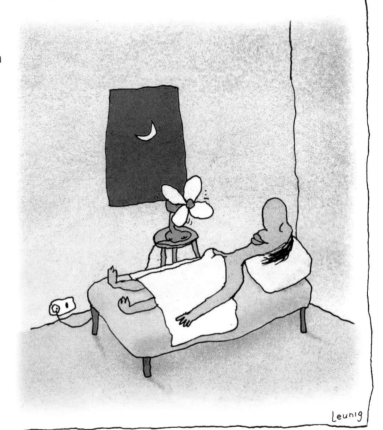

Leunig

There they were
in the doctor's waiting
room; each with their
own sickness.

Bob with his bobolosis.
Emma with emmaditis
Peter with peterenteritis

Freda with Fredamania.
Mavis with mavis fever.
Harry with harry's syndrome.

Each of them suffering
from being who they are:
each seeking a cure for
the ordinary oddness
of existence.

But alas, the doctor
can't see anyone
today. He's slumped in
his chair suffering from
acute doctorphobia.

There is no cure for anyone.
Eventually everyone
becomes FULL BLOWN.

Leunig

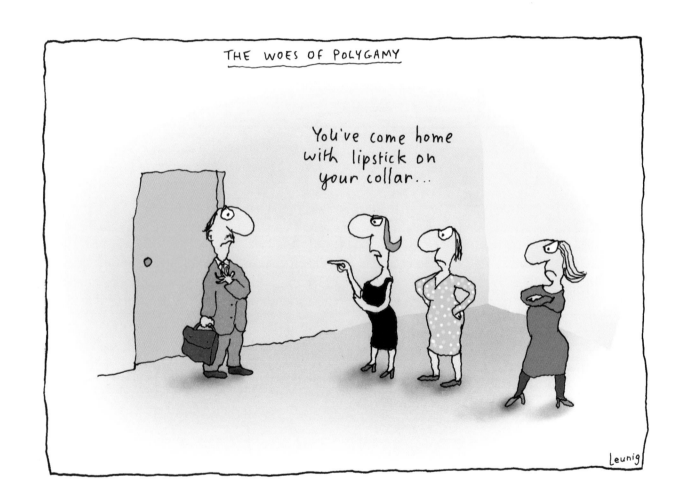

The Coach's wife.

# THE TRILL

The streets were crammed with cars. The shops were crammed with people. The shelves were crammed with stuff.

Their homes were crammed with stuff Their lives were crammed. Their minds were crammed.

The world was crammed and each day there was less space between things.

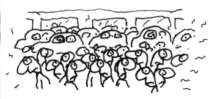

Until at last everything was so tightly crammed that there was no space between things at all

...and everything merged into one solid lump of undifferentiated matter.

Down onto this huge solid lump a tiny wren fluttered and gave a bright little trill.

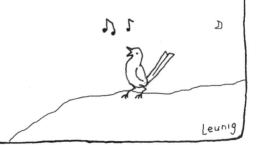

Leunig

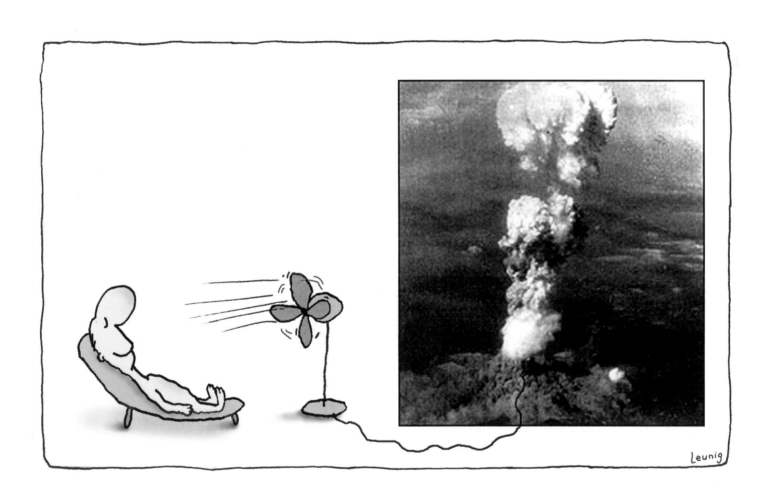

Leunig

# SIX DEGREES OF WEARINESS

**ORDINARY END OF YEAR FATIGUE**

Completely frazzled, burnt out and done in.

**COMMON WORLD WEARINESS**

Ground down, fed up and exhausted

**Too tired to care**

Had a gutful and can't go on.

Leunig

# Father's Day Gift Catalogue

**MOBILE PHONE – SHAVER.**
Now dad can shave and attend to those important calls as he drives to work.

**TRIBAL DRUM WITH EMAIL FACILITY.**
Now dad can access those vital business messages while he's connecting to the lost tribe of his soul and following his bliss.

**SAXOPHONE TELEVISION WITH CORDLESS ELECTRIC DRILL.**
Now dad can watch current affairs, play the blues and attend to those odd jobs around the house.

**WRAPAROUND SUNGLASSES WITH CONCEALED TEAR CATCHERS AND REAR DOWNPIPES.**
Now dad can cry without anybody noticing.

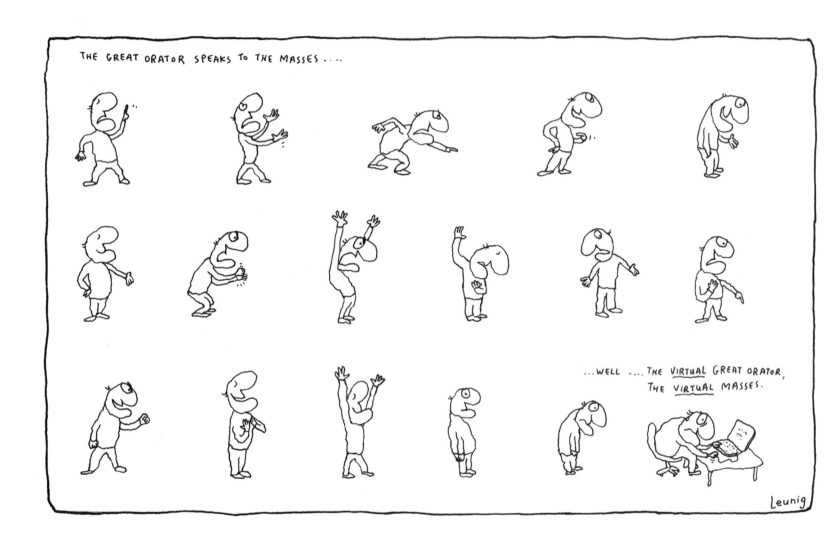

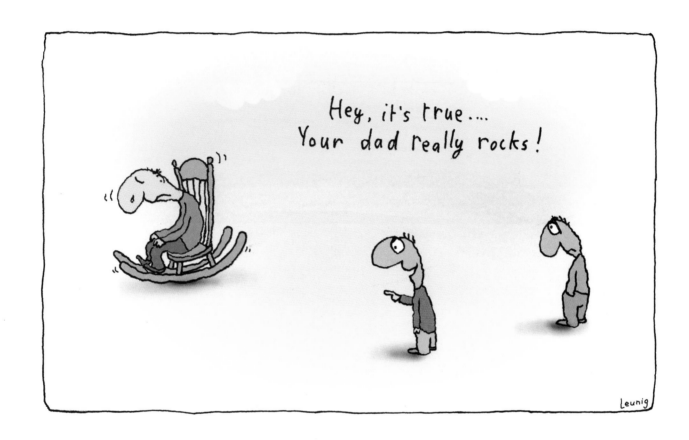

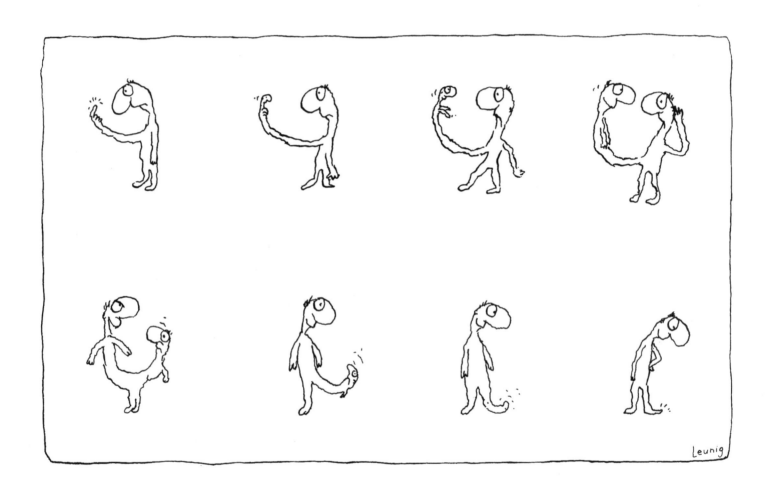

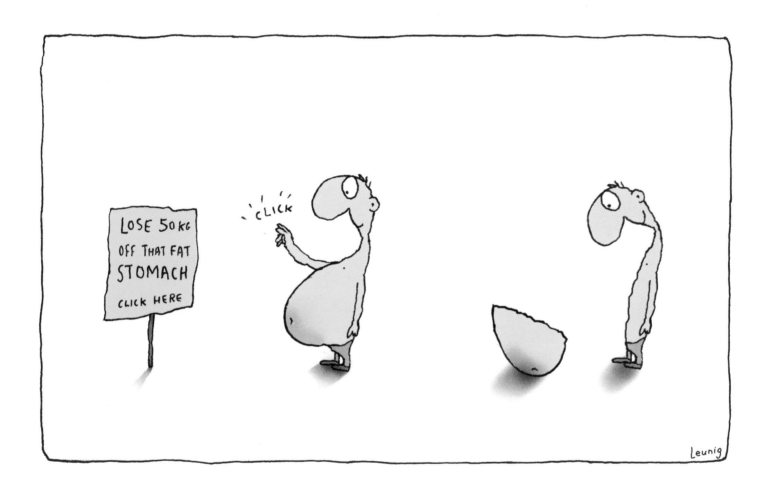

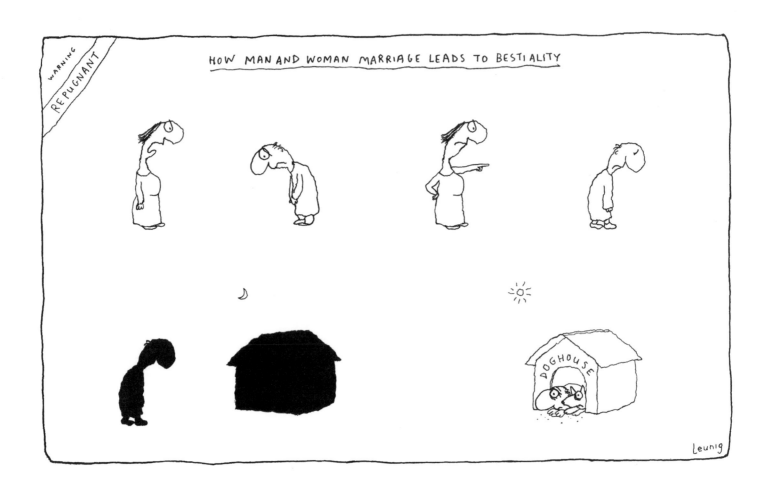

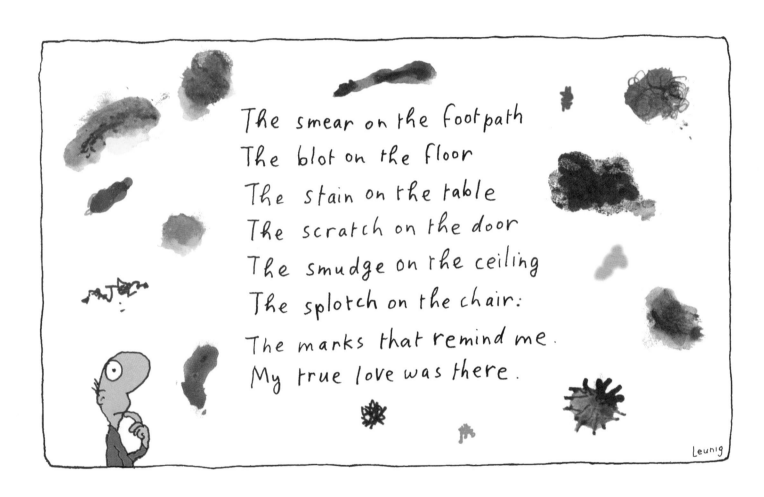

The smear on the footpath
The blot on the floor
The stain on the table
The scratch on the door
The smudge on the ceiling
The splotch on the chair:

The marks that remind me.
My true love was there.

Leunig

Same sex marriage will obviously lead to people marrying animals.

It will also lead to group marriages where three or more individuals will want to marry each other

Soon people will demand the right to marry THINGS such as rocks or trees or caves.

Then people will fall in love with mountains, forests and rivers, and want to marry them.

This will lead to persons wanting to marry landscapes and entire ecosystems including vast herds of buffalo or wildebeest..

...which will lead to the ultimate disaster: humans falling in love with the earth and wanting to live in peace with it 'til death they do part.

Leunig

All my father left me was the moon
"When I'm dead, it's yours" he said
And all too soon his will was read
But he continued speaking from the grave:
"It will not save you, this moon I gave you
From sadness, human madness, life and death.
But step outside into the night and take a breath,
And while you do, for what it's worth,
That happy man up there who got away from earth
Will smile at you".

Leunig

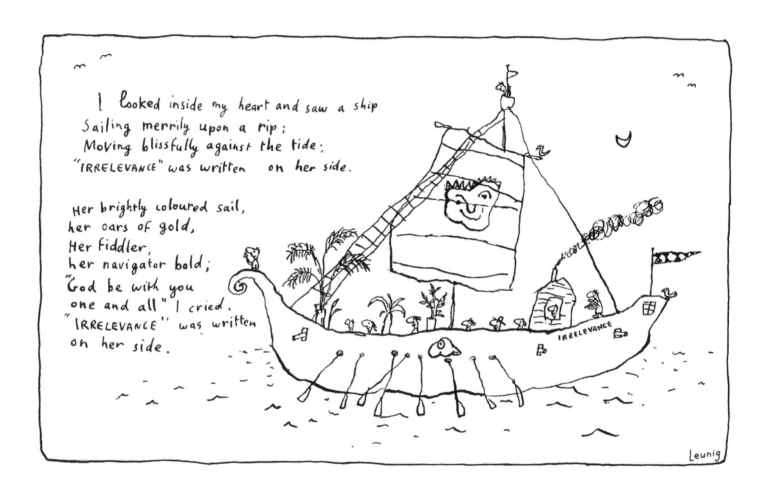

I looked inside my heart and saw a ship
Sailing merrily upon a rip;
Moving blissfully against the tide;
"IRRELEVANCE" was written on her side.

Her brightly coloured sail,
her oars of gold,
Her fiddler,
her navigator bold;
"God be with you
one and all" I cried.
"IRRELEVANCE" was written
on her side.

Leunig

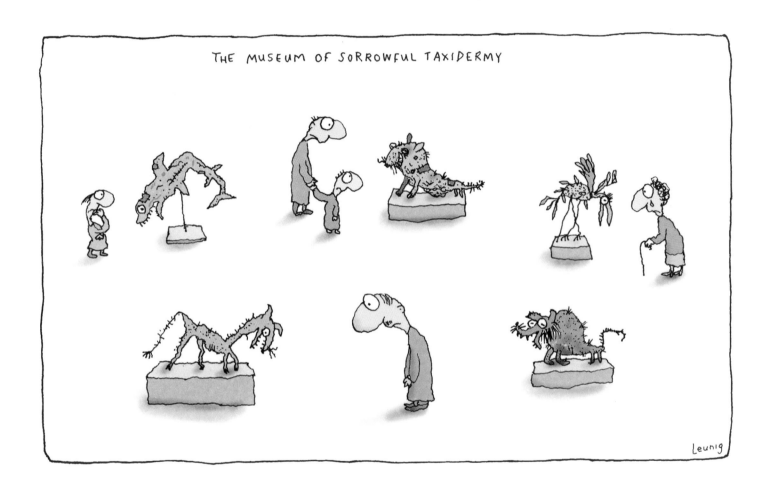

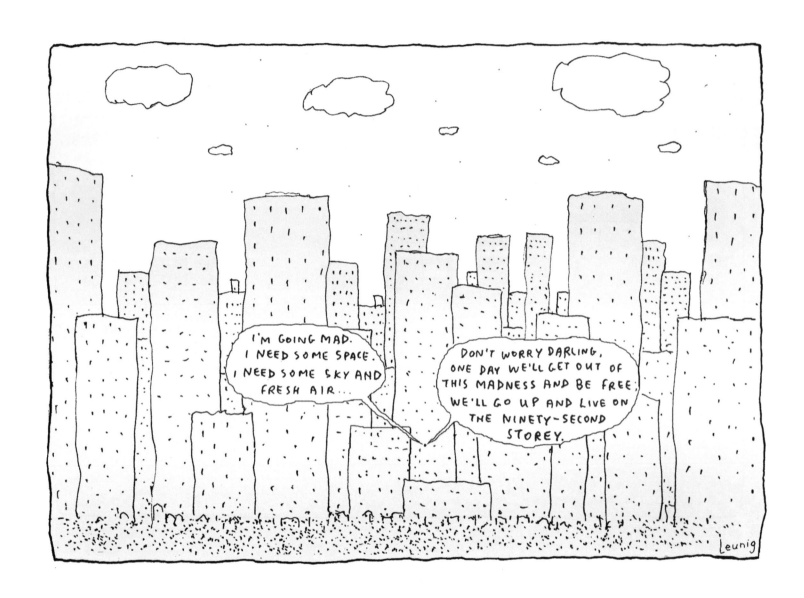

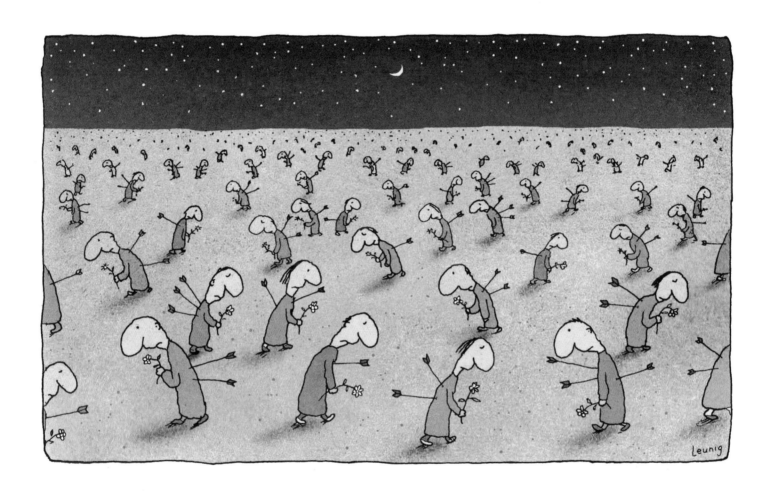

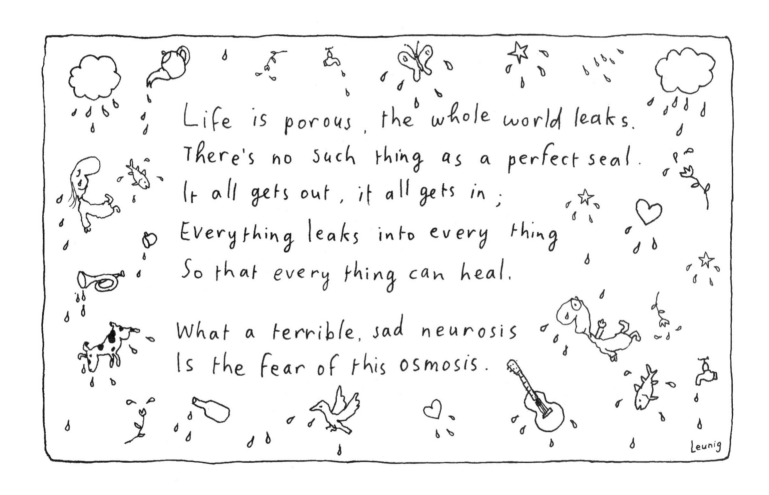

Life is porous, the whole world leaks.
There's no such thing as a perfect seal.
It all gets out, it all gets in;
Everything leaks into every thing
So that every thing can heal.

What a terrible, sad neurosis
Is the fear of this osmosis.

Leunig

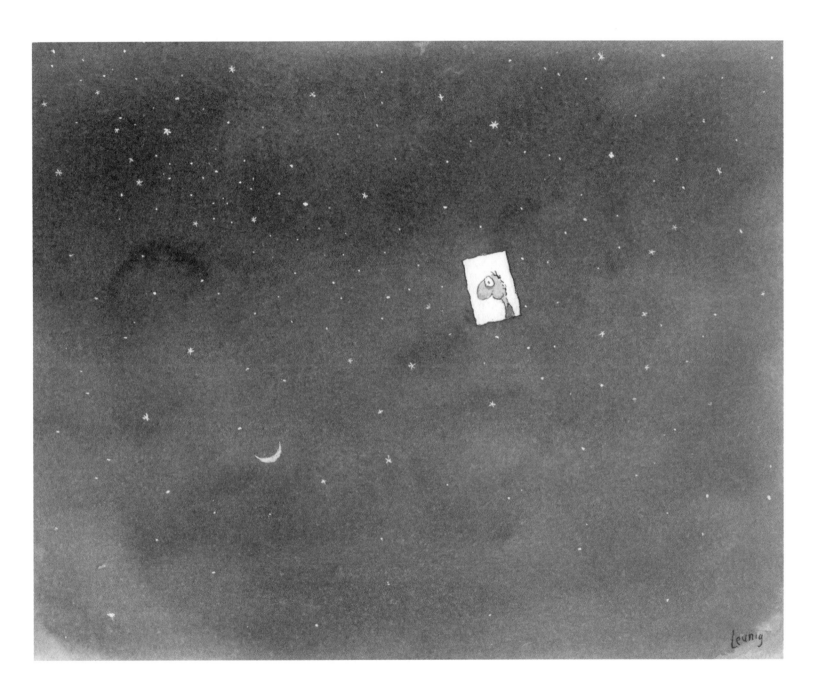

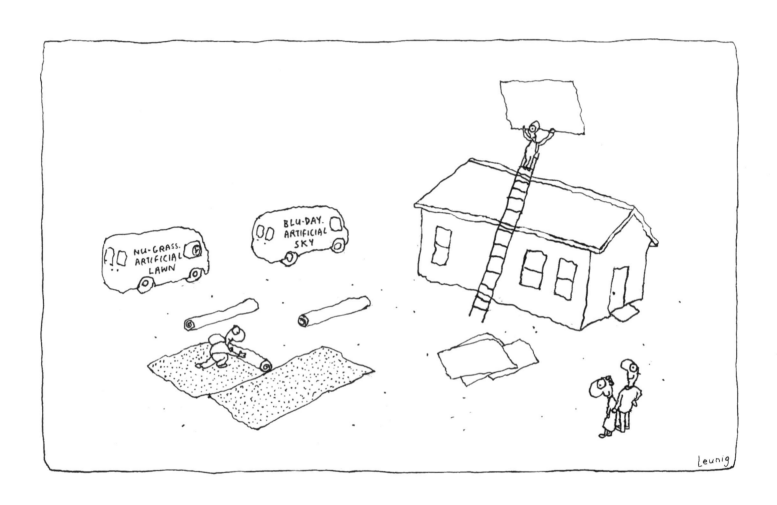

74

You are your
SIM card and
your SIM card
is YOU

LEFT
Adam Receives
his SIM card.
from God

YOU MUSTN'T JUST
Share your SIM card
around with any
old Tom, Dick or
Harry... it's a Woman's
most precious gift
to her husband
on their Wedding night.

I'm haunted by fears
that my SIM card is getting
up to mischief behind my back
and running AMOK.

YOU HAVE
OBVIOUSLY
REPRESSED
YOUR ANGER
AND STORED
IT IN YOUR
SIM card..

Leunig

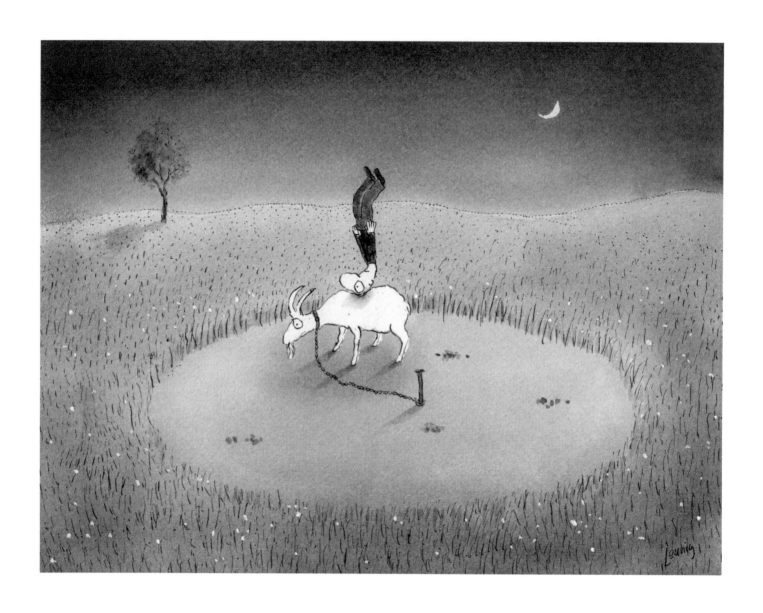

## A KISS

He never thought she'd be a frump
She never thought he'd be a grump
They never thought their circumstance
would be as strange as this...
She hung her head and had a weep
He went to bed but couldn't sleep
They couldn't understand it
So they settled for a kiss.

Leunig

Today is INTERNATIONAL BONO day

This is the day we remember the people who can't get enough Bono

It's also the day we remember those who have had too much Bono

Tomorrow is also International Bono day.

One day isn't big enough.

Leunig

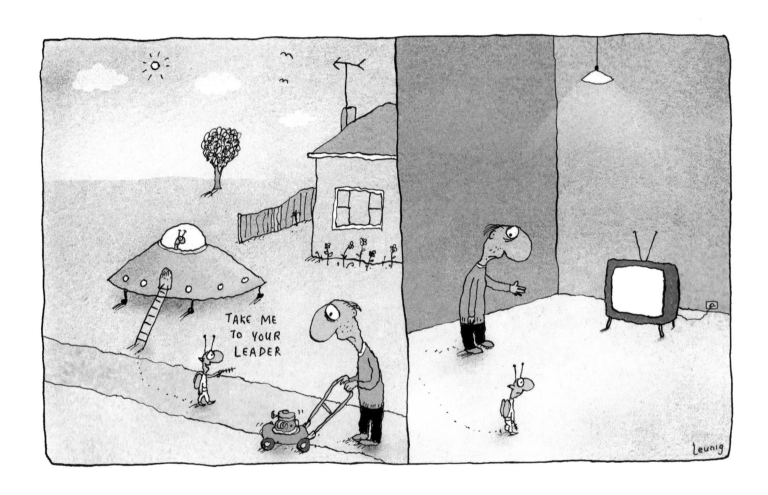

79

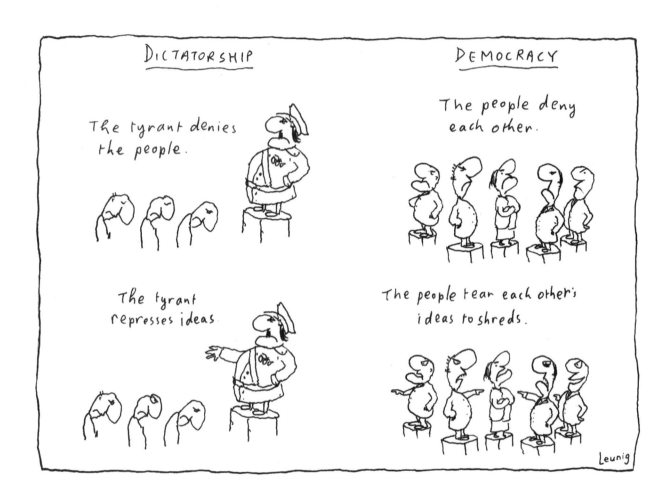

HERE IS THE NEWS.

HERE IS THE ENTERTAINMENT.

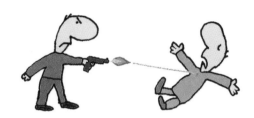

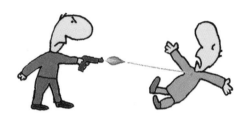

HERE IS THE POLITICS.

HERE IS THE ICON,
THE SYMBOL,
THE LOGO.

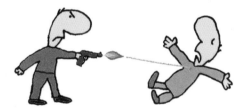

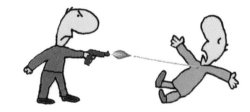

Leunig

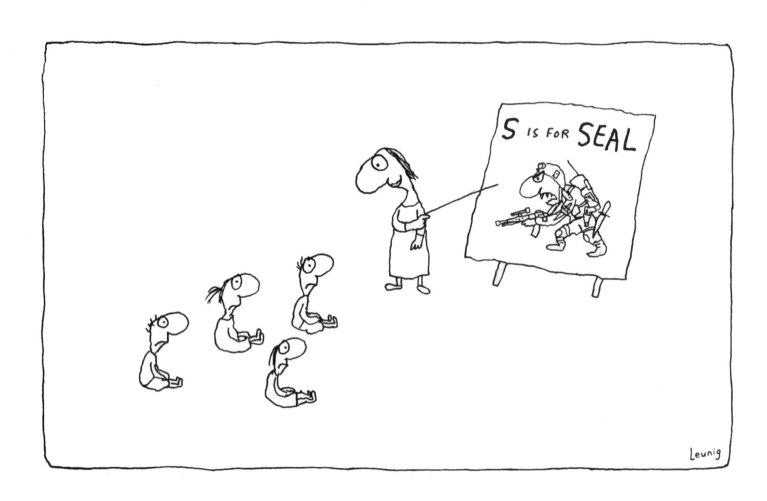

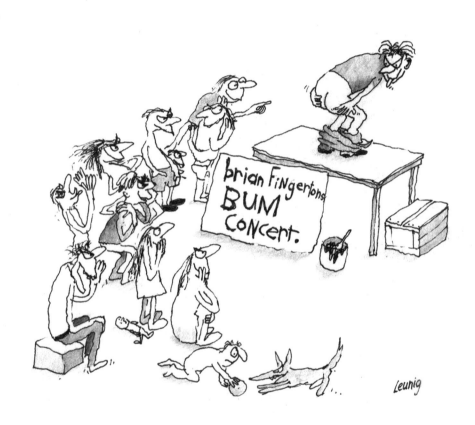

Steve Anvilbanger, AWARD-WINNING columnist, gets tough on peaceniks.

"America will do whatever it takes to make sure there is never another September eleven."

"Even if it means changing the calendar and having September ten twice, and then moving straight on to September _twelve_. The bleeding hearts can go to _hell_"

"The wet elites and the bleating liberal peaceniks are on the run — a confused broken rabble of sickening wimps. WELL DAMN THEM!

..Maybe I shouldn't mix the whiskey and the viagra together before I work. It could be a deadly cocktail.

Leunig

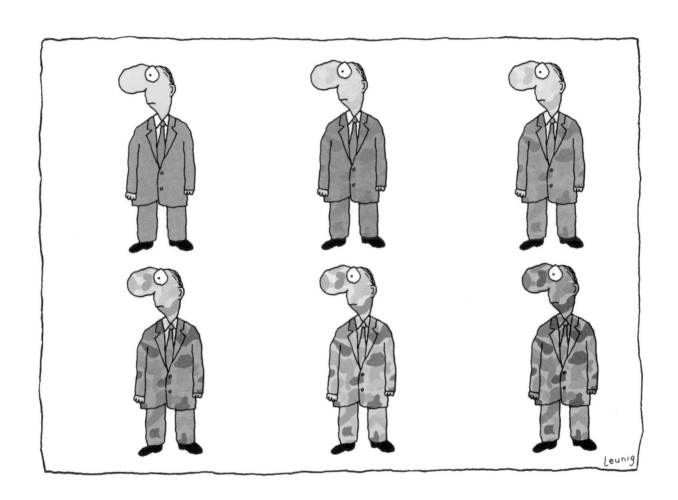

Mr. War, our unwanted, uninvited house guest shows no sign of leaving. What a morbid presence.

Then silence. Later, a short snuffling laugh, a low growl, the quick squeaking of leather in the dark. A squalid disillusioning sense of shame loneliness and confusion fills the home.

He is having a strange disturbing effect on our home. We are bickering a lot. Relationships are troubled.

Yesterday Mr. War left photographs in odd, prominent places all through the house; sordid sickening pictures of cruelty, savagery, blood and death.

Mr. War has a huge, seething intensity but offers no meaning or sense. From the darkness of the next room he will suddenly cry out something like "BANG!" in a violently loud, ugly and demented voice.

We were shaken and distressed and deeply saddened. "BANG!" cried Mr. War from the blackness of his room. And then his horrible snuffling.

Leunig

# THE STEVE ANVILBANGER QUIZ.

## WHAT IS WRONG WITH THIS PHOTO?

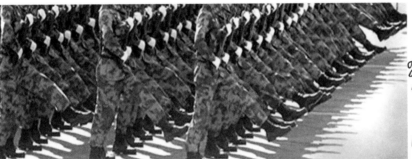

Steve Anvilbanger, the most important political commentator in the world, enemy of lefties greenies and terrorists, upholder of decency and common sense. As an exercise in vigilance and right thinking Steve asks you to examine this photo and spot the two errors.

## ANSWERS

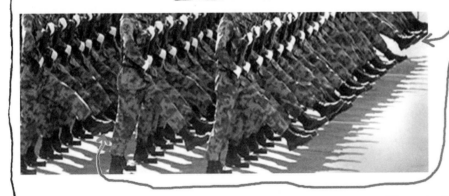

THIS FOOT SLIGHTLY OUT OF STEP

**AND**

THIS FOOT SLIGHTLY OUT OF STEP

STEVE SAYS:

WRONGDOINGS OF THIS NATURE ARE A SERIOUS THREAT TO NATIONAL SECURITY AND THE OFFENDERS SHOULD BE INVESTIGATED FOR LEFTISM. AND PUNISHED.

Leunig

87

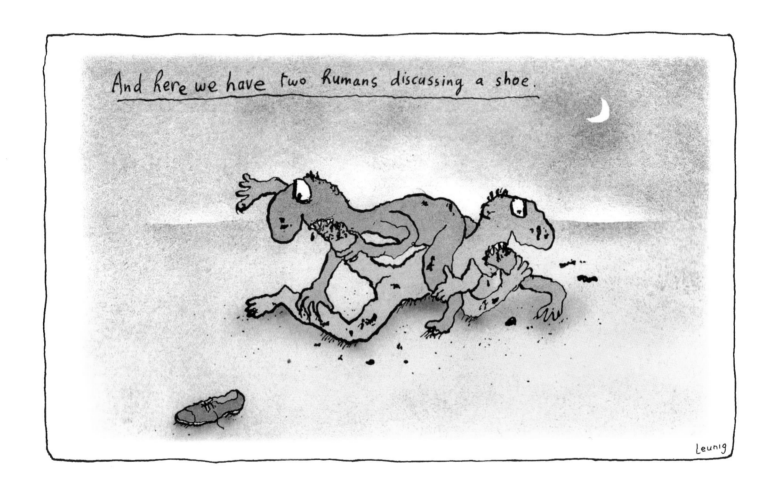

7.30 am. The first cold, wet mattress of winter is found abandoned in the gutter. What pitiful wretchedness. Symbol of these tragic times. Standard bearer of the future world.

God have mercy upon your soul brave mattress.

I'm not a mattress, I'm a print journalist. I'm an editor. I'm a newspaper guy

The flimsy cotton cover — dirty, torn and wounded; with perished sponge rubber bulging forth like oozing ulcers. Cast out and degraded. Nevermore to comfort or to dream.

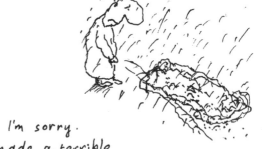

oh I'm sorry. I made a terrible mistake

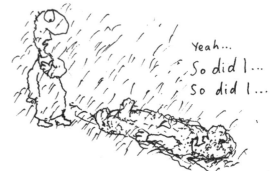

Yeah... So did I... So did I...

Leunig

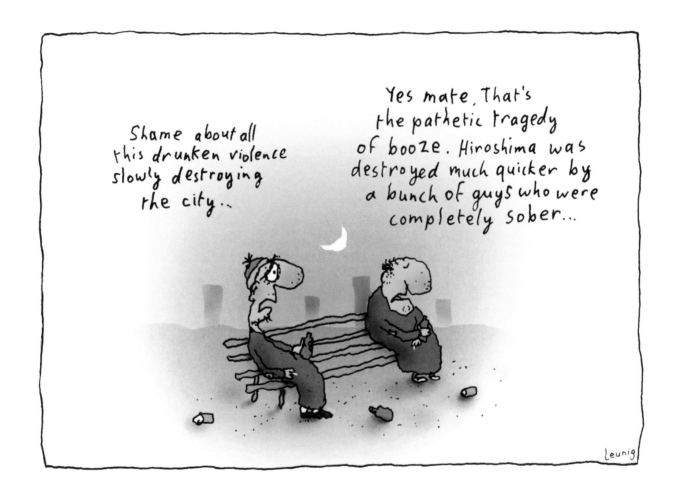

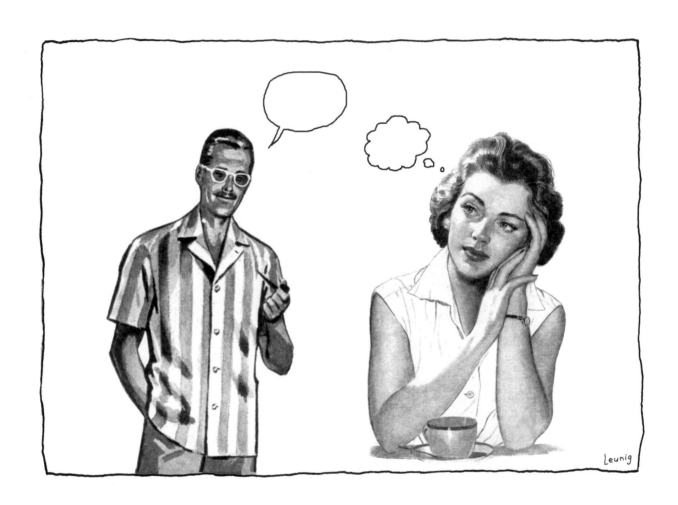

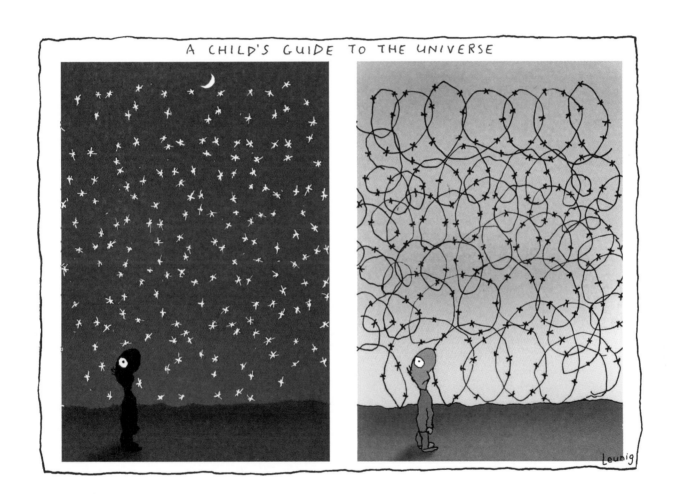

A CHILD'S GUIDE TO THE UNIVERSE

Leunig

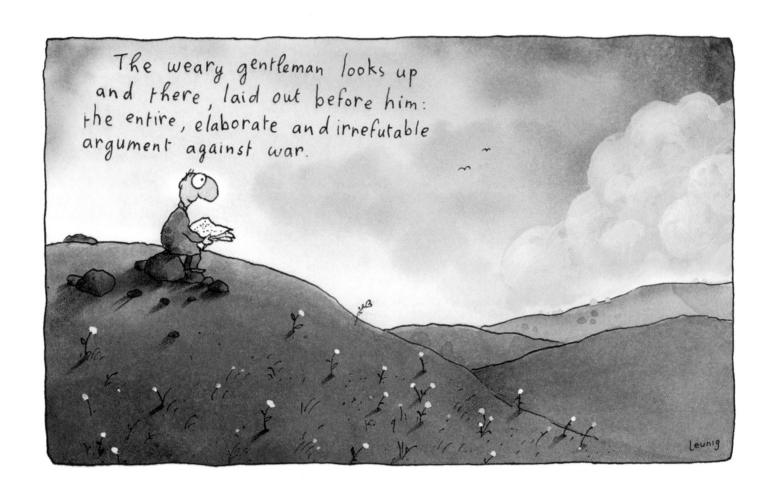

## TO STARE AT NAKED LADIES

I am much too gentle
To go to a gentlemen's club;
A gentle sentimental man;
A temperamental gentleman—
To go to a gentlemen's club.

I am much too naked
To stare at naked ladies;
The heartbreak is too much to take
The naked staring much too wearing—
To stare at naked ladies.

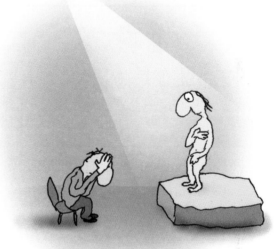

Leunig

## HOW TO MAKE A GOOD CUP OF TEA.

The WORLD: so monstrous and
incomprehensible, so crashing
and raging out of control..

So hurtling and dangerous.
So wild and wicked and twisted.
So complex and ever-changing

But you and me... Look at us!
So fragile and flawed
So vulnerable and tired.
So worried and wanting...
small and powerless and in the dark.

So now.... Make
the cup of tea!

Leunig

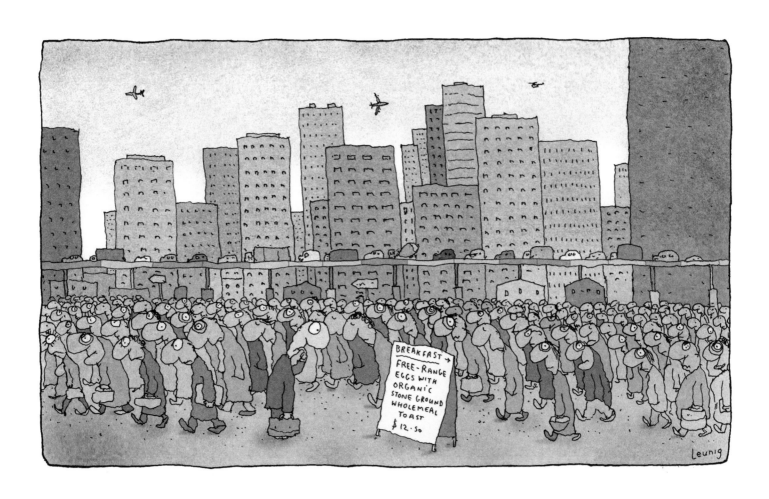

## BREAKFAST WITH GOD

I had breakfast
with God...
In the park.
For free!

Well, if the truth
be known, it cost
me the price of
one fruit bun.

But God did not
charge. God simply
appeared. We spoke—
and two angels
began to sing.

I asked God for
no favours. God
asked me for a
piece of fruit bun.
I obliged.

We talked about
this and that.
The angels flew
away. My thoughts
flew away.

I went blank.
God went quiet.
The sun came out.
We closed our eyes.
Breakfast with God.

Leunig

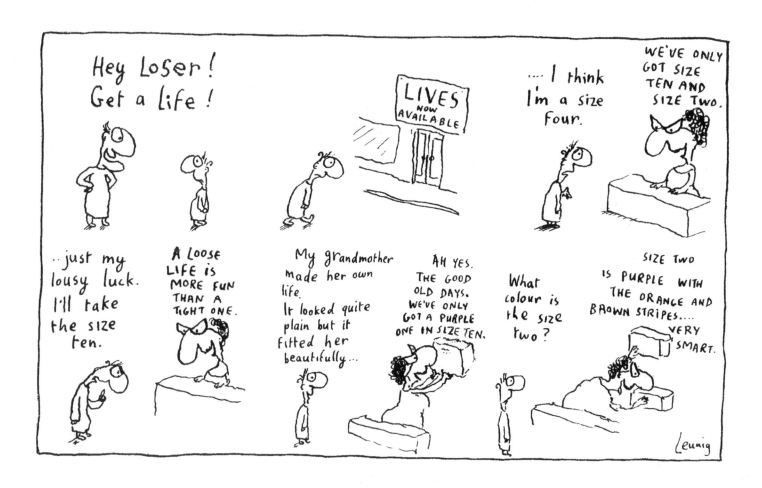

Some people are hard wired. They can be very hard.

They have bits of string, little twigs, sand, scraps of crumpled paper, tiny feathers, pips, dust and leaf litter.

Some people are soft wired. They can be quite soft.

They can be very, very unimportant.

Some people don't have wires.

They have no place WHATSOEVER in modern political systems or current debates.

Please ignore them.

Leunig

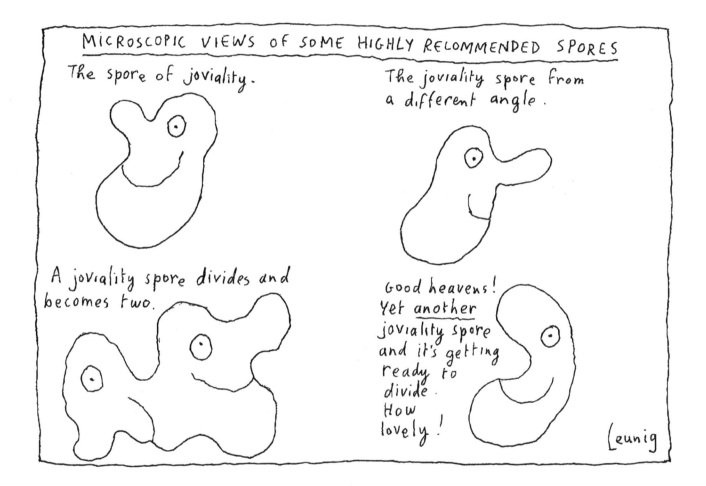

Goatperson, Goatperson on the hill;
I admire your steady will;
How this big, wide world would worsen
If you were not there, Goatperson.

Goatperson, Goatperson in a hole;
I admire your steady soul;
How this big wide world would worsen
If you were not there, Goatperson.

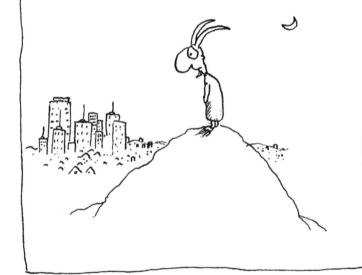

Leunig

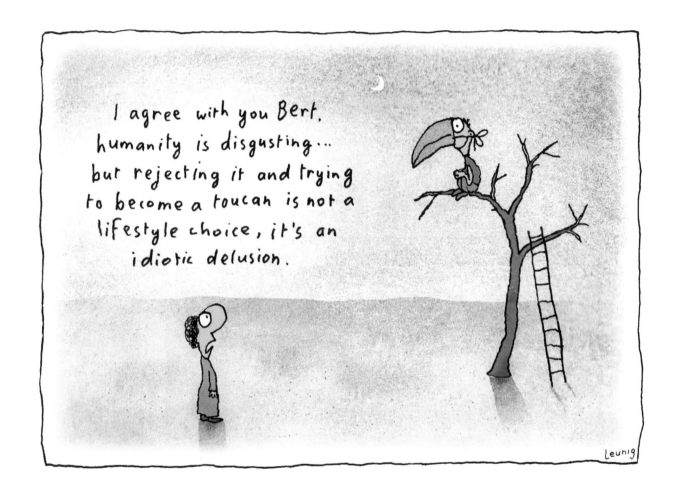

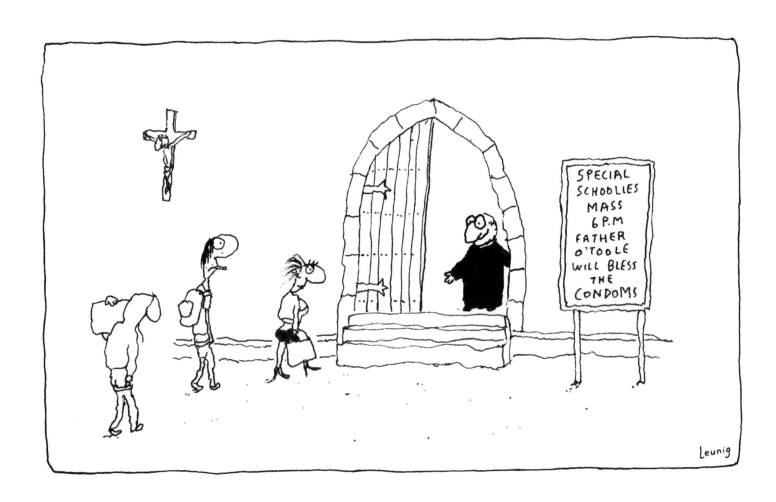

SPECIAL
SCHOOLIES
MASS
6 P.M
FATHER
O'TOOLE
WILL BLESS
THE
CONDOMS

Leunig

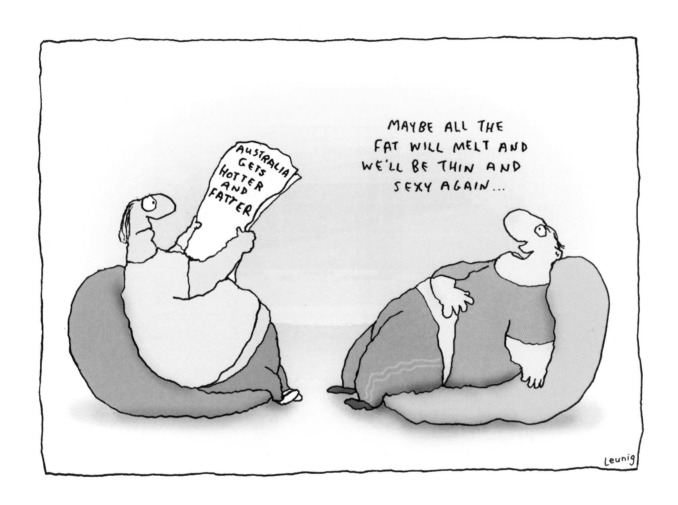

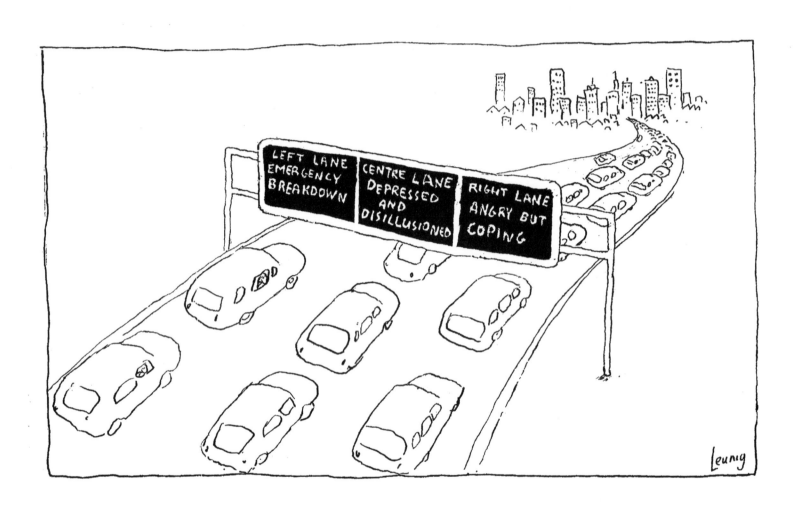

Son, I'm worried about your mental health...
sitting in your bedroom doing this self-harm
nonsense. Get out and do some harm in the
world like normal successful people do.

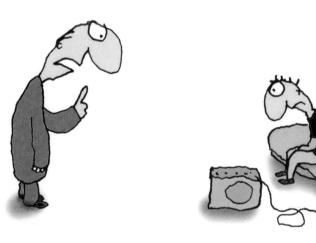

Leunig

# A BIOGRAPHY

He took it like a man:
Right on the chin,
And when he was older
His jaw caved in.

She took it politely
With a sweet smile
But when she was older
She was thoroughly vile.

They took their revenge
And got very rich;
The chinless wonder
And the vile old bitch.

Leunig

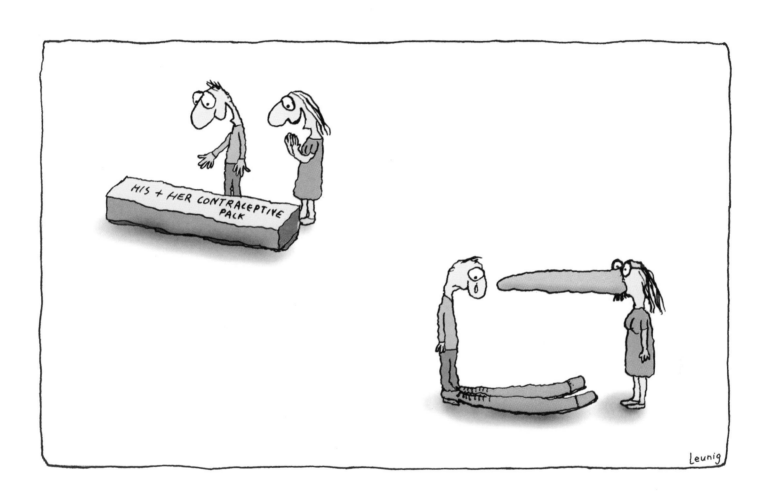

## TODAY'S WEATHER REPORT FOR THE HOUSE

The Bureau has issued a sheep weather alert for the entire house.

cold stares will be experienced along the hallway followed by torrents of abuse and storming out of the house

This is due to a cold Frump which is expected to cross the doorstep in the morning.

as a depression centres itself over the couch.

There will be a cloud of dust in the kitchen

The Frump should weaken by late afternoon

and gales of laughter coming from the loungeroom.

Fine and funny conditions should then prevail with the chance of an occasional small discharge of wind.

leunig

# IMMUNISATION !!!

Pixie scientists conducting experiments to develop immunity in children against the new epidemics threatening the world. These include: mass-mindedness, hostility, belligerence, intolerance, bullying, fear, bitterness, cruelty, speed, noisiness, arrogance and just being an egotistical, selfish, power-hungry, cunning nasty piece of work.

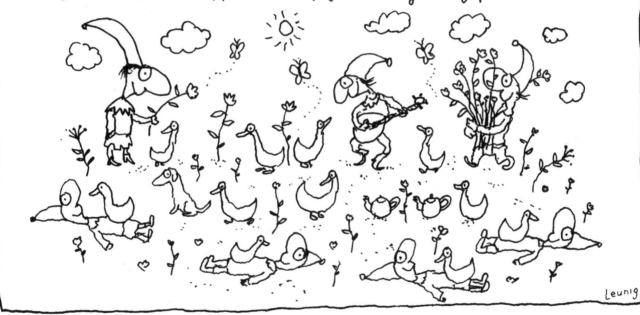

Leunig

# A WINTER'S POEM

A CLEVER CREATURE IS THE SNAKE
WHO SPENDS HIS WINTER NOT AWAKE.
HE SNUGGLES IN HIS LONG THIN BED
AND BREWS UP VENOM IN HIS HEAD.

THE HUMAN IS A DIFFERENT SORT
HE SPENDS THE WINTER WATCHING SPORT.
HE YELLS ABUSE IN CONCRETE STANDS
AND EMPTIES OUT HIS POISON GLANDS.

Leunig

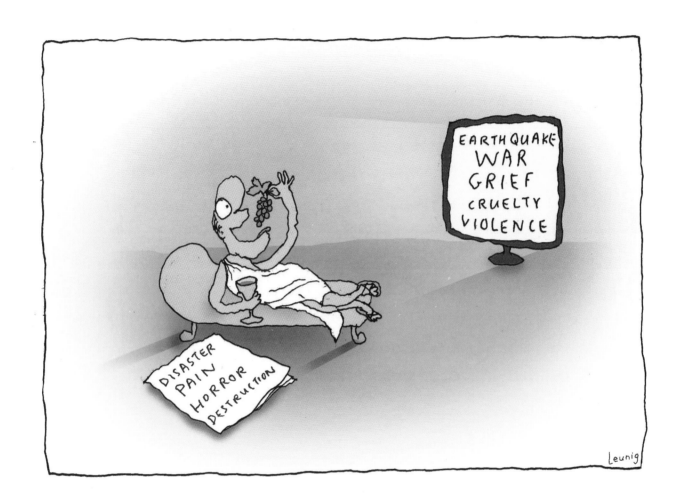

## THE BARBARIANS

Barbarians wait at the gates of the city;
Dusty, dishevelled and not very pretty:
A duck and a pixie; smeared with derision,
A funny old woman with x-ray vision.

"Lock the gates" cry the powers that be,
"We'll come undone if that woman should see
Through our power and glory, and then run amok
With that terrible pixie and horrible duck."

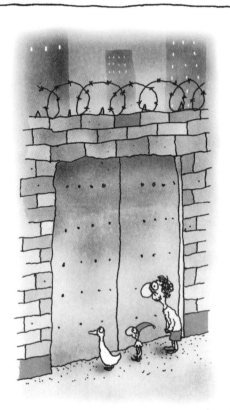

Leunig

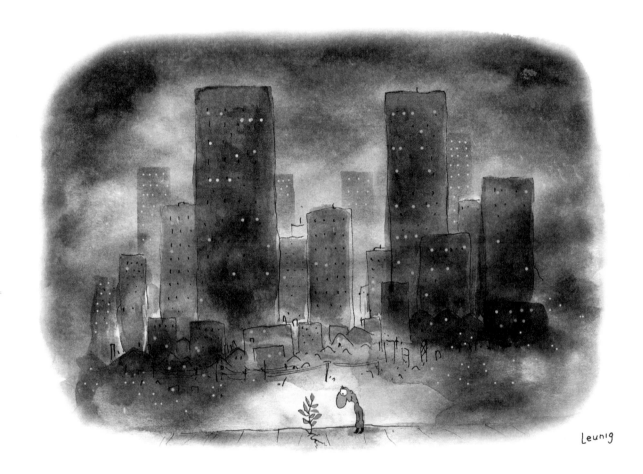

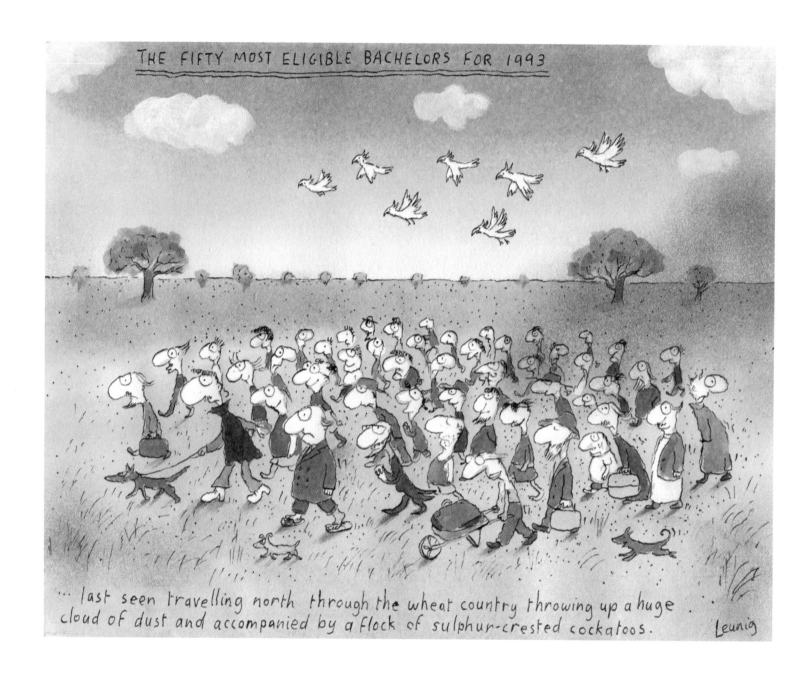

THE FIFTY MOST ELIGIBLE BACHELORS FOR 1993

...last seen travelling north through the wheat country throwing up a huge cloud of dust and accompanied by a flock of sulphur-crested cockatoos.

Leunig

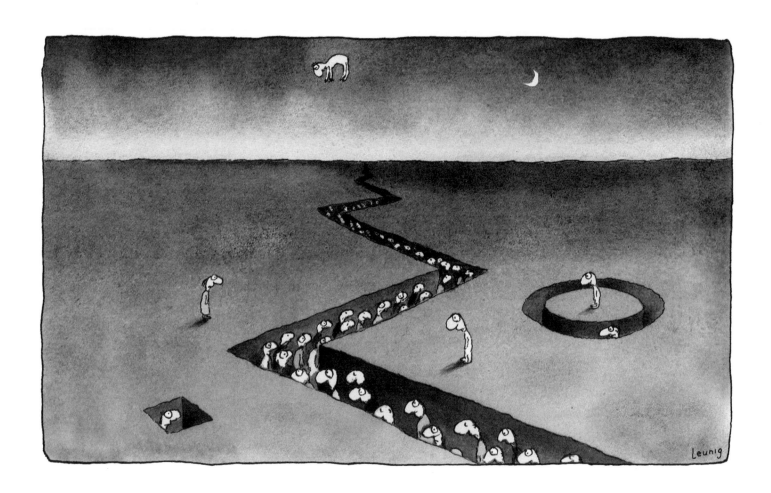

## A WHOLE FAMILY OF PERSONALITY DISORDERS

Mother is
passive aggressive

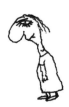

Father is
massive repulsive

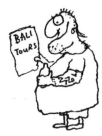

Son is
abrasive dismissive

Daughter is
emotive percussive

Dog is elusive
persuasive.

The cat has
a mysterious
unfathomable
mood disorder.

Leunig

A BIOGRAPHY

He was just one
simple man...

...with two crazy
psychiatrists...

...three strange
houses...

...Four disastrous
marriages...

...five cluttered
email accounts...

...six sensitive
burglar alarms...

...Seven sworn
enemies...

...eight scratchy
credit cards...

...nine mysterious
allergies...

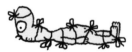

...and ten little
statues of Buddha

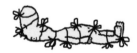

Leunig

# THIS WEEK'S NEWS QUIZ

WHO SAID THIS?

COMPLETE THIS
SENTENCE BY THE
PRIME MINISTER:

TRUE OR FALSE?

NUMBER THE FOLLOWING
IN ORDER OF IMPORTANCE

Leunig

THIS WEEK'S TOP TEN BEST SELLING NEWSPAPERS, MAGAZINES, PERIODICALS, JOURNALS

**Braying Twit**

- MEDIA
- DESIGN
- TRAVEL
- ART

**CRUDE LUNGE**

- STYLE
- ENTERTAINMENT
- DESIGN
- ART

**FATUOUS CLAPTRAP** INCORPORATING "SMARTALEC DRIVEL"

- MEDIA
- DESIGN
- LIVING
- ART

**INANE FOP MONTHLY**

- FILM
- STYLE
- TRAVEL
- DESIGN

**SHALLOW GUFF MONTHLY**

- FILM
- STYLE
- TECHNO FASHION
- ART

**Loudmouth Perspectives**

- MEDIA
- LIVING
- STYLE
- TECHNO DESIGN

**Prattling Dingbat**

- TECHNO FASHION
- FILM
- LIVING
- MEDIA

**PUSHY TWADDLE WEEKLY**

- ART
- STYLE
- ENTERTAINMENT
- MEDIA

**SCREECHING NINNY BULLETIN**

- STYLE
- ENTERTAINMENT
- ART
- MEDIA

**THE DAILY IDIOT**

- STYLE
- DESIGN
- MEDIA
- ART

Leunig

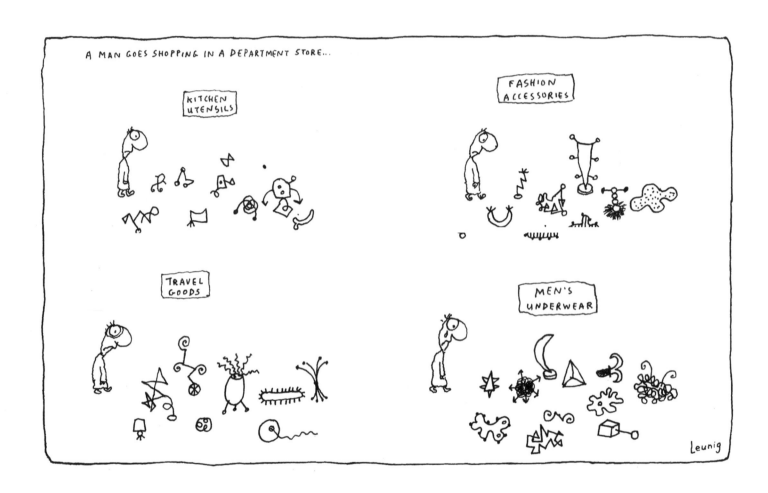

Baby wants to get some rest
But mum has tattoos on her chest:
A tiger's head, a dragon's tail
Baby's gone all sad and pale
A lightning bolt, a monster's eye
Baby starts to sob and cry
A spider's web, a Union Jack
And these good words: "TO HELL AND BACK"

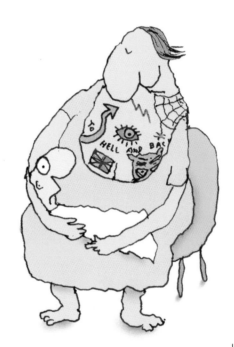

Children who will not leave home are becoming a big problem!

They travel along power lines at night and visit nests of neighbouring children in the roofs of other houses.....

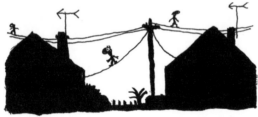

Sometimes they get into the ceiling and build nests and cannot be flushed out or dislodged.

Where they mate and fight and cause a terrible din. A nest of grandchildren in the roof is a particularly nasty situation and is certainly a major headache.

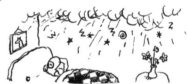

Leunig

## Summer Diary

Today **we got a letter** from the authorities. They say our family isn't **doing** enough about terrorism. They say we're too slack and disorganised. But heavens above — it's summer!

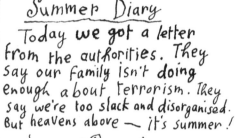

The dog absolutely refuses to growl at strangers. Instead he just licks them. How slack is <u>that</u> ?!

They are threatening to take control unless we clean up our act. Not easy for a family whose motto is, "Live and let live"

**Sure**, the garden's a bit overgrown **which provides** concealment opportunities; but **we like it that way** — it brings the birds; **we hide in it ourselves. It's nice!**

We've made a bit of an effort to instill some fear in the children but they just laugh at us and tell us to relax.... Fair enough.

We're supposed to report any unusual activities. The fact is, we've never known anything else. We <u>like</u> "unusual". We thrive on it. Christmas eve is our deadline. We're trying to get the **dog up to speed** but it's not looking good.

leunig

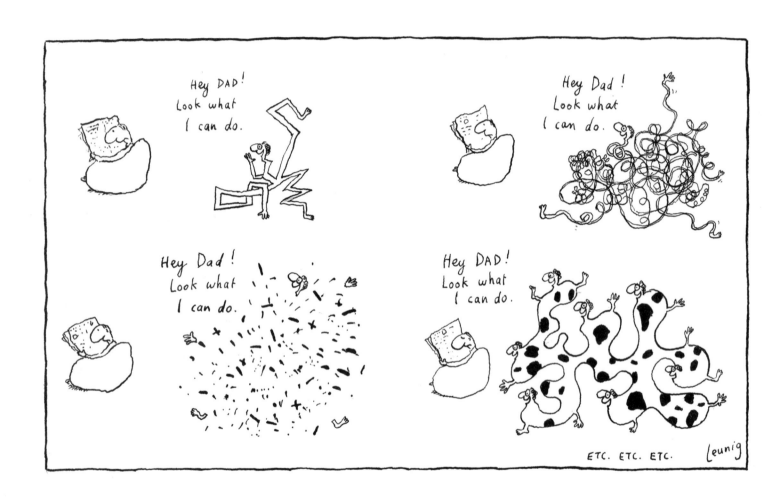

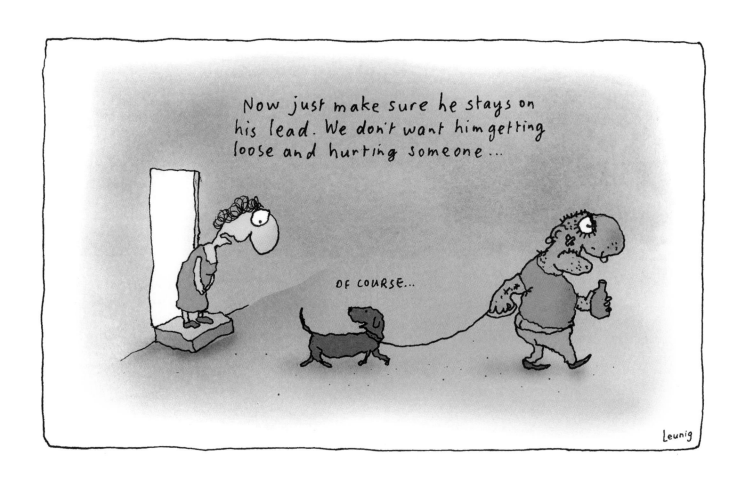

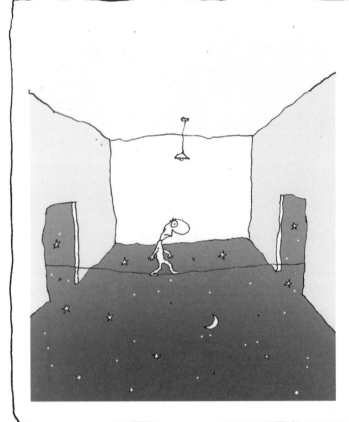

Life's a room without a floor;
The entrance and the exit door
Connected by a tightrope.
So balancing a bright hope
Against an overwhelming gloom
We make our way across the room
Until... half way... perhaps
The rope just maybe snaps.

And yet, regardless of the cause
We make it to the great outdoors.

Leunig

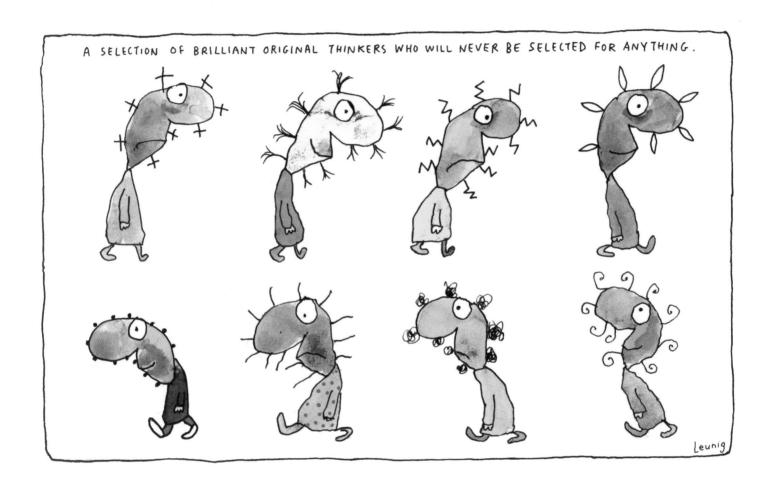

A SELECTION OF BRILLIANT ORIGINAL THINKERS WHO WILL NEVER BE SELECTED FOR ANYTHING.

"DEAR FRIEND IN GOD. I AM
SUDANESE PRINCESS WHO WANTS
TO MAKE LOVE RELATIONSHIP WITH
YOU BUT NEED YOUR BANK DETAILS
SO I CAN TRANSFER MY INHERITANCE
OF $7·7 million to you."

"WINNING NOTIFICATION:
CONGRATULATIONS, YOU HAVE
WON SIX MILLION POUNDS IN
BRITISH LOTTERY. PLEASE SEND
YOUR BANK DETAILS SO WE CAN
TRANSFER YOUR PRIZE MONEY"

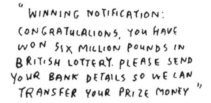

"I AM SAMANTHA.
YOU DON'T KNOW ME BUT
I AM DYING OF CANCER AND
HAVE FALLEN IN LOVE WITH
YOU. PLEASE SEND ME YOUR
BANKING DETAILS SO I CAN
TRANSFER NINE MILLION
DOLLARS TO YOU SO I CAN
DIE HAPPY."

"THANKS. MY BANK DETAILS
ARE AS FOLLOWS:
IT IS MADE OF PORCELAIN,
IT IS PINK, IT HAS POINTY EARS,
A CURLY TAIL, FOUR LITTLE LEGS
AND A SLOT IN ITS BACK."

Leunig

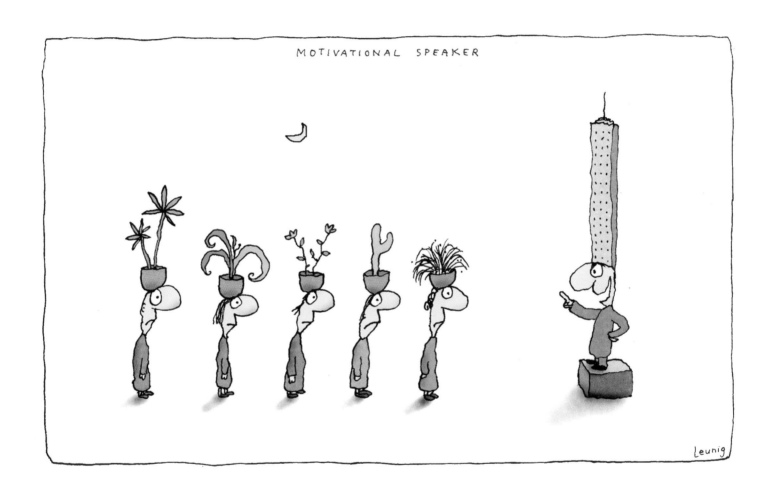

## CONVERT YOUR CAR TO AN ECO-FRIENDLY TOMATO HOTHOUSE ON WHEELS

PUT THAT EMPTY BACK SEAT TO GOOD USE. PLANT A CROP OF TOMATOES.

WATER REGULARLY AT THE CAR WASH OR AT THE SERVICE STATION.

WEED REGULARLY TO AVOID DRIVING VISIBILITY PROBLEMS.

IT WILL ALL PAY OFF WHEN YOU'RE STUCK IN A TRAFFIC JAM AND INSTEAD OF GETTING ANXIOUS YOU JUST LEAN OVER INTO THE BACK SEAT AND CHOMP INTO A BIG PLUMP JUICY RIPE TOMATO···· THE GOOD LIFE.

NETTING MAY BE REQUIRED TO PROTECT YOUR CROP FROM MARAUDING BIRDS AND POSSUMS.

NEXT YEAR, AVOCADOS, WATER MELONS, PASSION FRUITS. BUT YOU REALLY MUST DO THE WEEDING!

Leunig

His name is [N][O][R][M]

He's filling in his census [F][O][R][M]

In his [D][W][E][L][L][I][N][G]

Norm is telling

The government [S][T][A][T][I][S][T][I][C][I][A][N]

With absolute precision (and weary dumb persistence)

Some boring facts about his sad [E][X][I][S][T][E][N][C][E]

But half way through this pointless [E][X][E][R][C][I][S][E]

Norm has a heart attack and [D][I][E][S]

How typical of Norm that he has [C][A][R][K][E][D]

With half his boxes still [U][N][M][A][R][K][E][D]

Leunig

# THE EFFECT OF THE CARBON TAX ON YOUR SAUSAGE

The average citizen eats 312.7 sausages per year

The energy to produce, distribute and cook a single sausage will attract a carbon tax of .1 of a cent

Which amounts to 31.27 cents carbon tax per anum on average sausage intake

By an amazing coincidence, 31.27 cents is the average price of a single sausage

This means that the carbon tax impact on sausages can be neutralised by eating one less sausage per year.

COMING UP: How the carbon tax will strain the potatoes.

Leunig

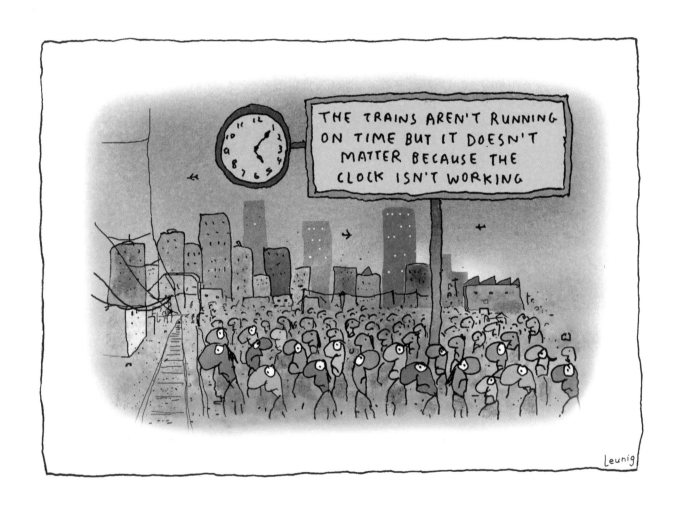

There was once an inventor whose work it was to invent new dances.

His aim was to invent the perfect dance which is, of course, an impossibility.

At the end of each day, enraged with frustration he would fling his day's work out to the street in disgust.

The peasants of the town would seize upon these imperfect dances and dance them with great joy and gusto.

The inventor worked on in earnest dedication. Alone.

The peasants danced their lives away. Together. Life goes on.

Leunig

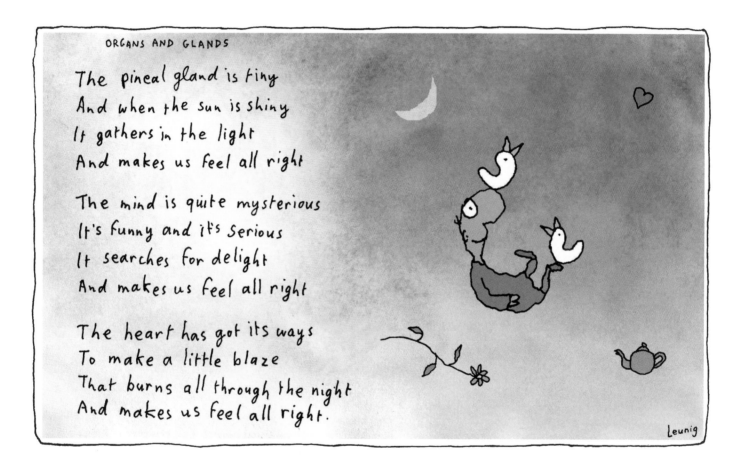

ORGANS AND GLANDS

The pineal gland is tiny
And when the sun is shiny
It gathers in the light
And makes us feel all right

The mind is quite mysterious
It's funny and it's serious
It searches for delight
And makes us feel all right

The heart has got its ways
To make a little blaze
That burns all through the night
And makes us feel all right.

Leunig

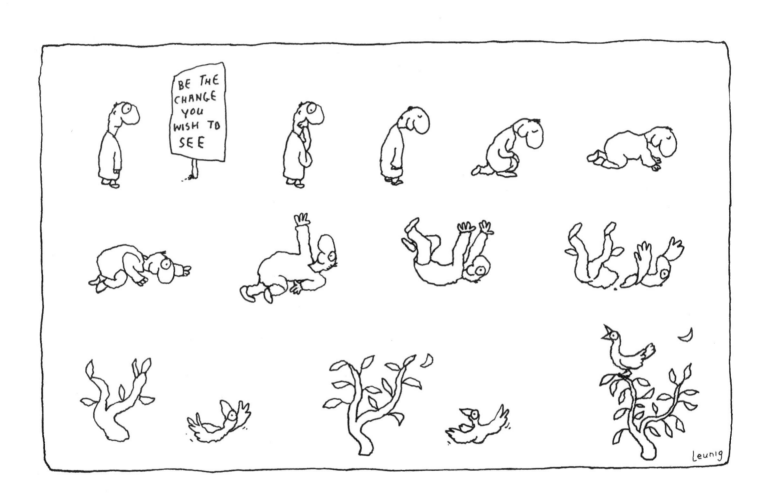

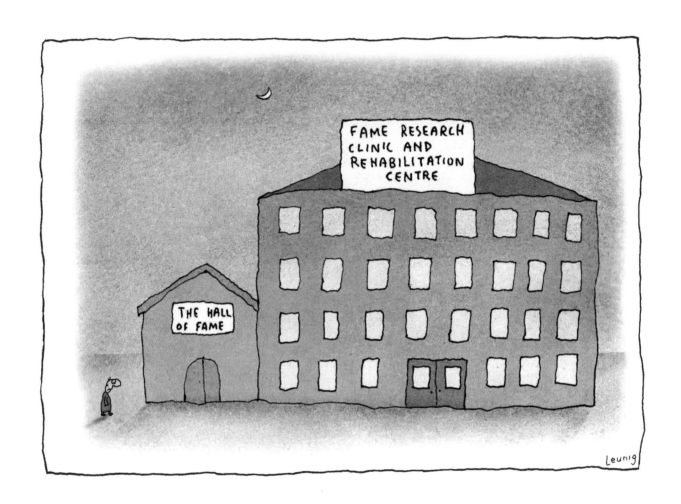

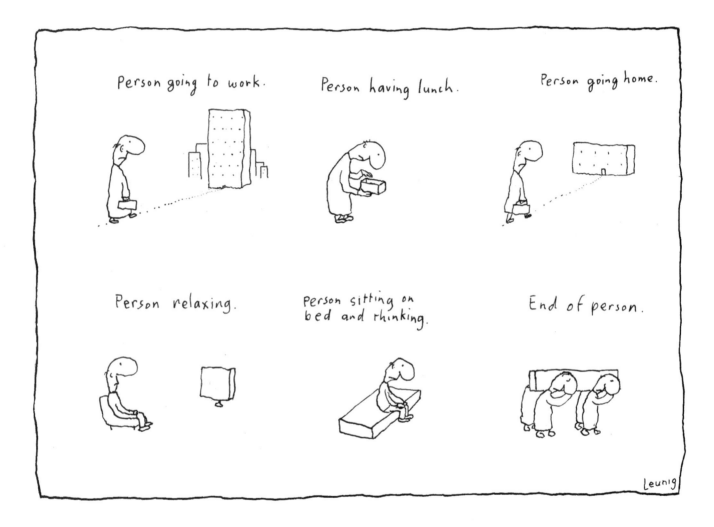

## OUTCOMES

The world is full of outcomes
Each day delivers more
At breakfast time there's only two
By lunchtime there are four
By dinner time there will be eight
At bedtime there's sixteen;
So many, many outcomes and
I don't know what they mean
And so we live our lives away
With outcomes big and small
Until the final outcome comes
With no outcome at all.

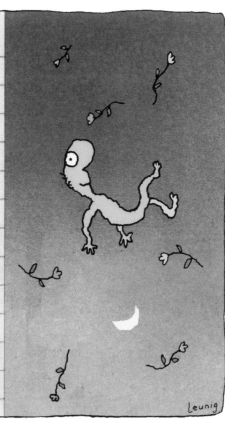

Leunig

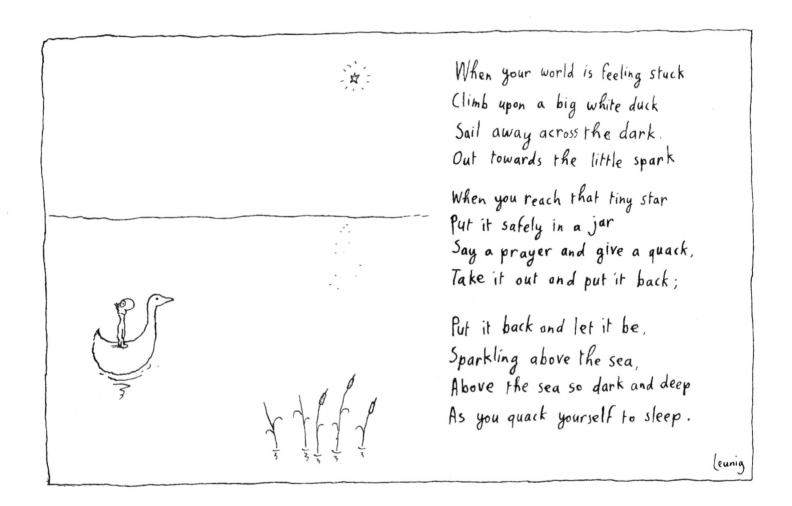

When your world is feeling stuck
Climb upon a big white duck
Sail away across the dark.
Out towards the little spark

When you reach that tiny star
Put it safely in a jar
Say a prayer and give a quack,
Take it out and put it back;

Put it back and let it be,
Sparkling above the sea,
Above the sea so dark and deep
As you quack yourself to sleep.

leunig

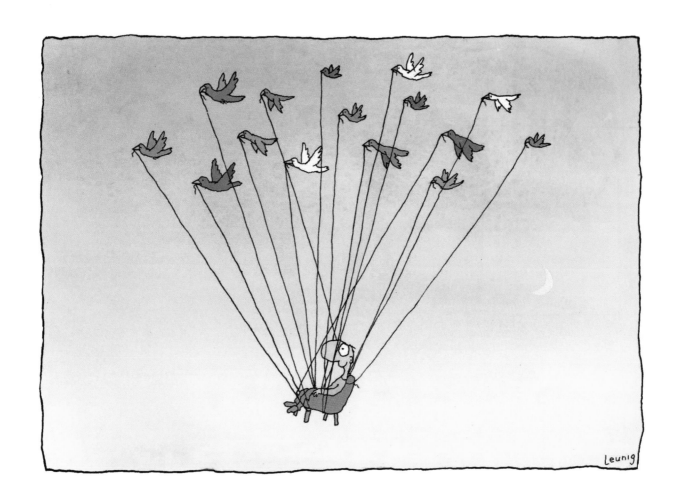

143

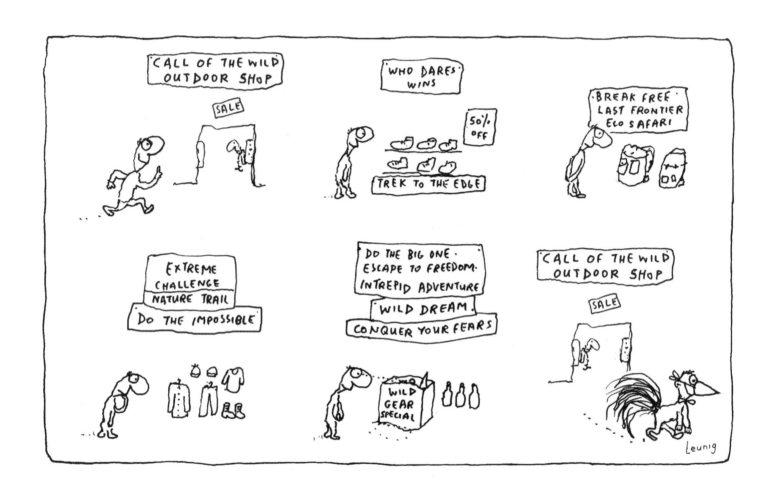

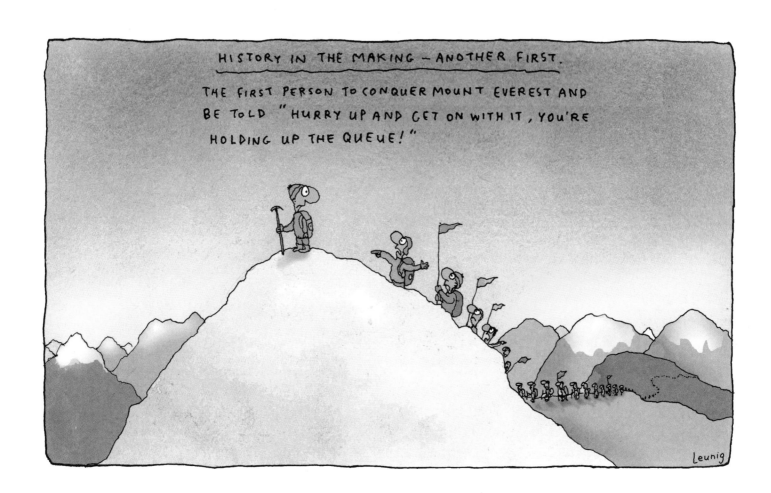

The word 'DRUBBING' has appeared extensively in the press in recent times.

BUT WHAT IS A DRUBBING?

DRUBBINGS MAY BE PHYSICAL, POLITICAL, EMOTIONAL or INTELLECTUAL. When all of these drubbings happen at once it is known as an UBERDRUBBING — which of course is a comprehensive broad spectrum drubbing.

A drubbing is an event that brings great glee and relief to all who have not received it.

When a good public drubbing occurs, those who do not receive it feel great relief and their tension eases considerably.

Every human that has ever existed has lived in fear of a good drubbing. This ancient universal anxiety is known as 'DRUBBOPHOBIA'

Sometimes the fear of drubbing is so intense that people take up 'SELF DRUBBING' to get it over with. Sometimes the entire nation appears to be drifting towards a policy of 'PRE-EMPTIVE SELF-DRUBBING"

Leunig

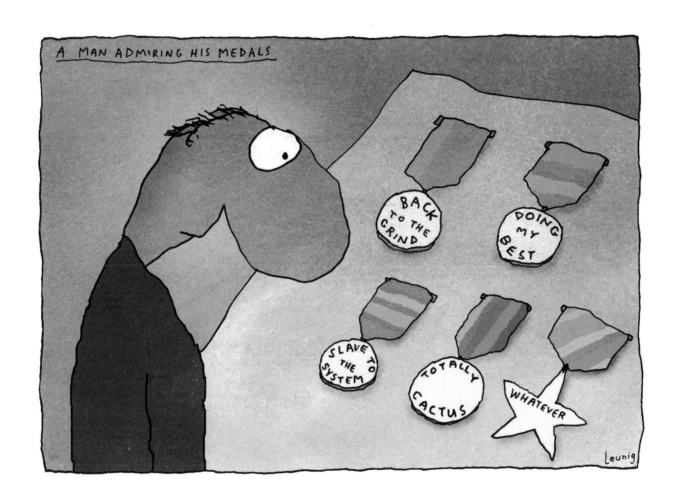

## SONG

I am a gruntled fellow
With a shirt of gruntled yellow
And I play a gruntled cello
To a mean disgruntled world.

And they boo me and they hiss me
They insult me and dismiss me
Yet the parrots like to kiss me
In this mean disgruntled world.

It's disgruntled, it's disgruntled
It's full-frontally disgruntled
Yet still the parrots kiss me
In this mean disgruntled world.

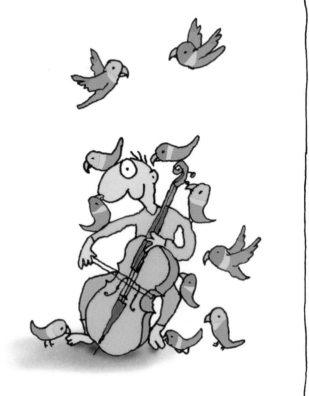

Leunig

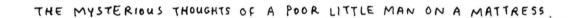

THE MYSTERIOUS THOUGHTS OF A POOR LITTLE MAN ON A MATTRESS.

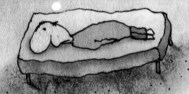

Leunig

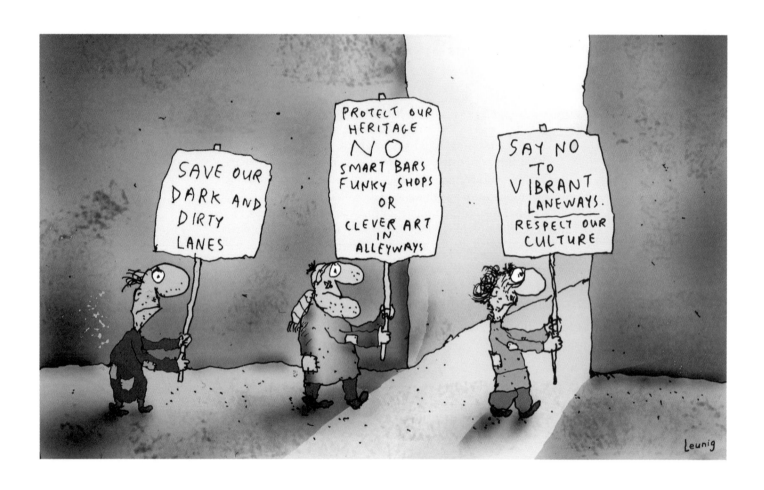

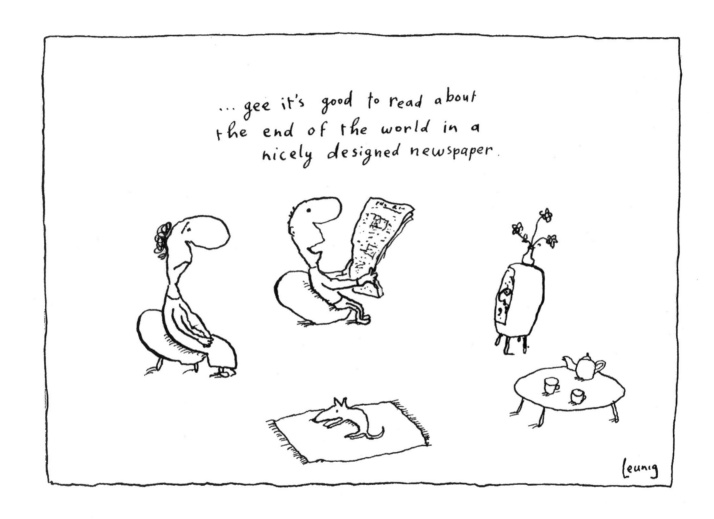

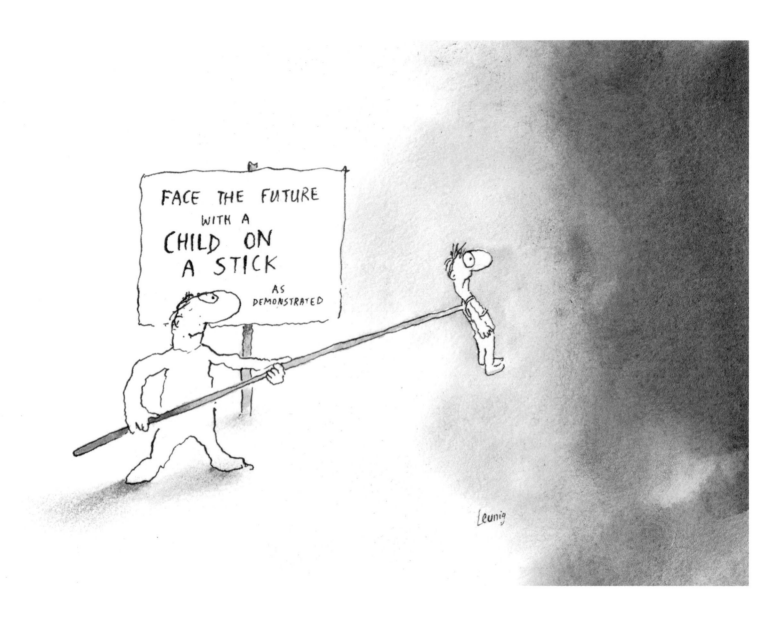

**DAWDLE:**
- To waste time
- To be slow
- To move slowly and idly.

**EKE:**
- Manage to support oneself but not easily.
- To make an amount of something last longer by consuming it frugally.
- Obtain or create but just barely.

### DAWDLING AND EKEING

I will dawdle, I will eke
I'm too tired and dumb to speak
I'm too sad for vanity
I will eke my sanity
I have now become primordial
I am ekeial, I am dawdial.

Leunig

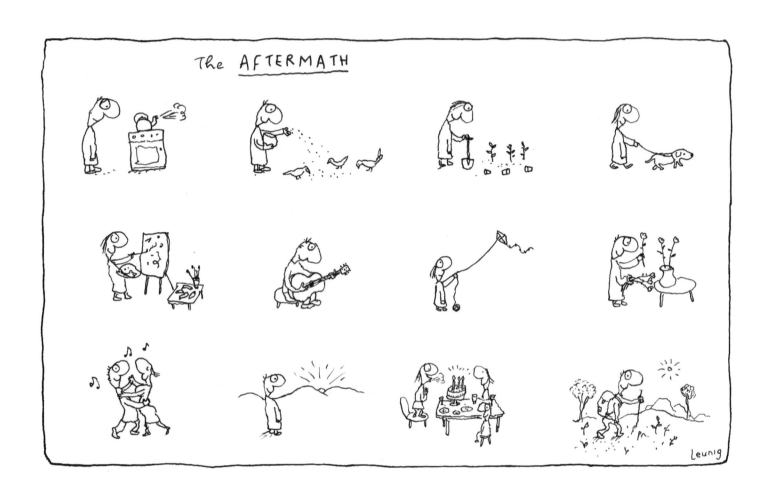

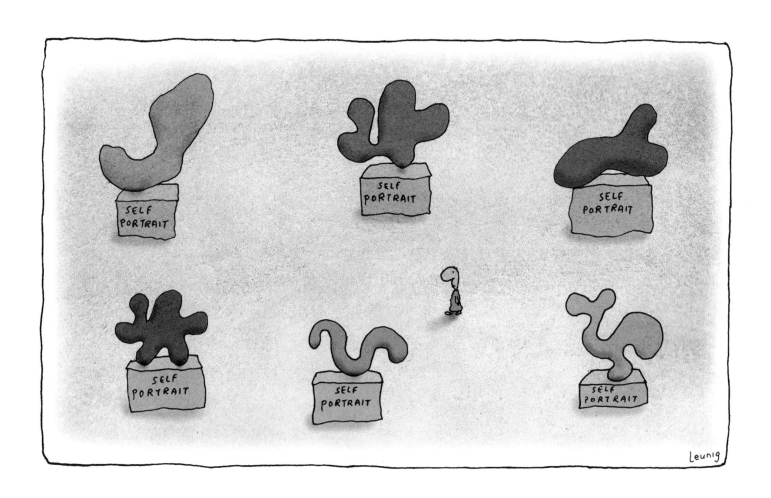

155

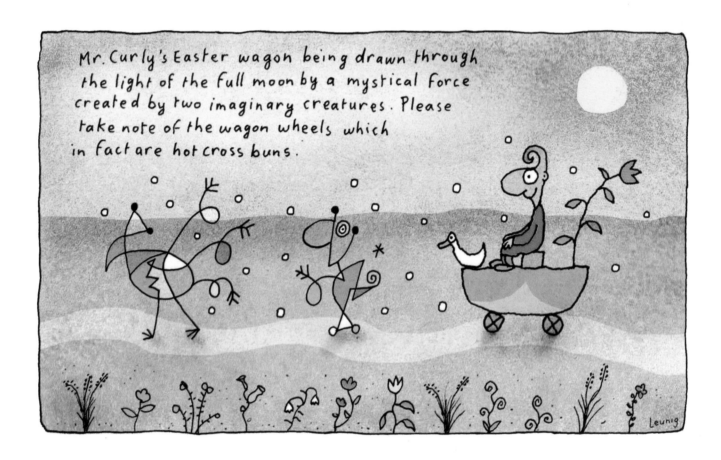

Mr. Curly's Easter wagon being drawn through the light of the full moon by a mystical force created by two imaginary creatures. Please take note of the wagon wheels which in fact are hot cross buns.

Leunig

The thing I love the most
Is to be undiagnosed
I want to be a mystery to myself
Unexplained and inconclusive
Unto myself elusive
Like a spirit or a pixie or an elf.

And this moonlit part of me
So untroubled and so free
Would never understand but could adore.
As I'd wander and I'd beam
With a deep unknowing gleam
And I'd see a world I'd never seen before.

Leunig

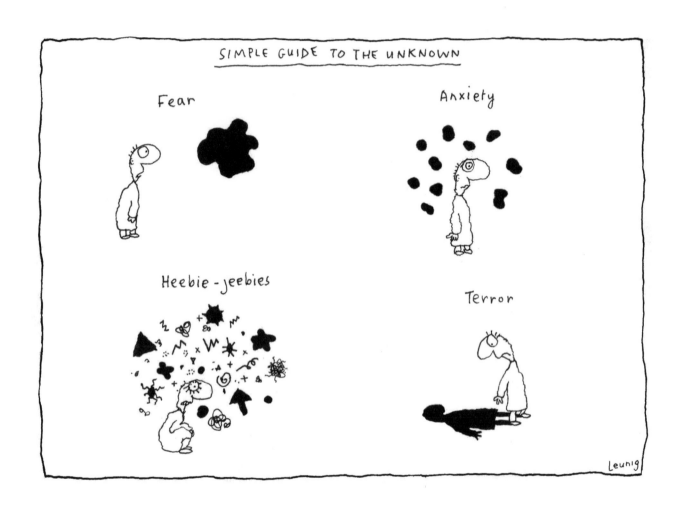

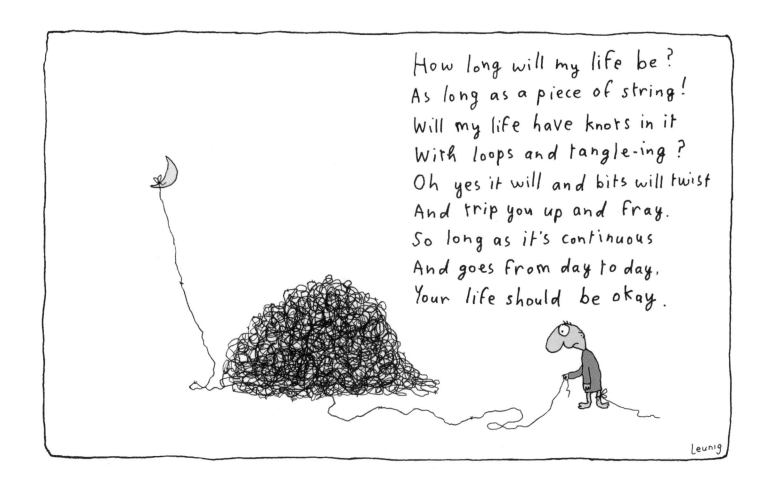

How long will my life be?
As long as a piece of string!
Will my life have knots in it
With loops and tangle-ing?
Oh yes it will and bits will twist
And trip you up and fray.
So long as it's continuous
And goes from day to day,
Your life should be okay.

Leunig

oh dear,
we're doomed;
the world's
getting hotter.

yes but it's getting
harder too; so it doesn't
feel the heat so much

...and it's getting faster too
which creates a bit of a
turbulent breeze which
cools things down a bit...

... and also, it's getting
madder which means
nobody cares or notices
very much.... so
everything's
normal
and quite
o.k.

Leunig

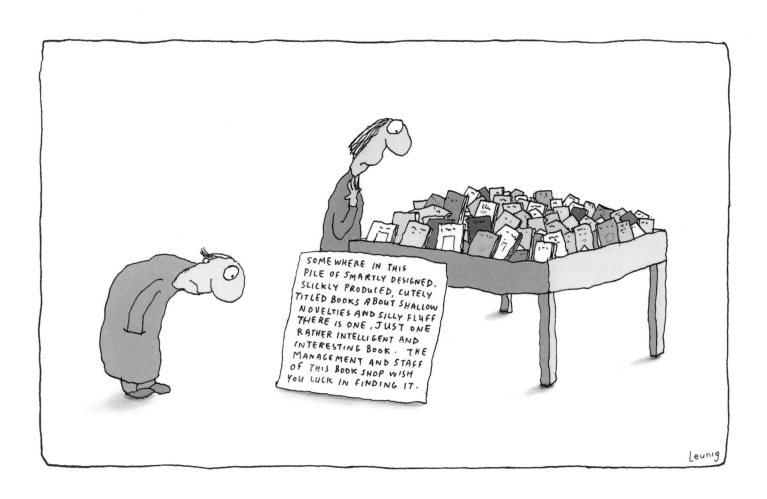

The lights changed to green but his foot was too slow in getting to the accelerator pedal.

The gap between the green light and acceleration was one fifth of a second. HE HAD DELAYED THE FLOW OF TRAFFIC BY ONE FIFTH OF A SECOND

Behind him car horns screamed, sirens wailed, alarms whooped and howled and the sky turned blood red.

Buildings roared like mad beasts, televisions and radios blasted at him from shops.

Exhausts growled and the earth shook as a huge hammer descended from the sky to crush him

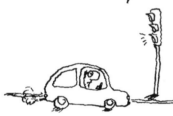

He shrunk below the window level and his car took off in terror

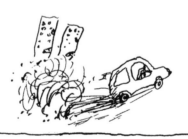

Like a meteor he hurtled blindly and wildly to the city rubbish dump where he was instantly bulldozed under tons of waste.

Entombed beneath the rubbish he reflected, in the reeking blackness, upon the shameful and stupid inefficiency of his accelerator pedal foot, his total unworthiness, his dullness and the just forfeiture of his place in society.

## MR. CURLY ON THE CAMPAIGN TRAIL

The paths of glory lead but to the gravy,
The campaign trail drives people up the wall,
The road to hell is paved with concrete pavers
And all of this leads nowhere much at all.

Leunig

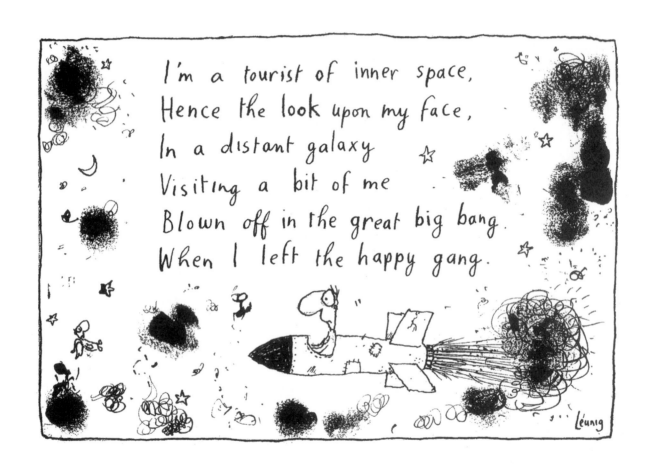

I'm a tourist of inner space,
Hence the look upon my face,
In a distant galaxy
Visiting a bit of me
Blown off in the great big bang.
When I left the happy gang.

165

THE TROUBLE WITH SHOPPING...

The shop was too elegant...

The changing room was too small... the trousers were too tight...

The mirror was too awful... the salesperson poked her head in too soon...

He tripped over too easily and rolled out into the shop too clumsily

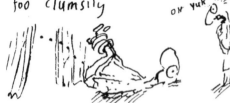

The cleaner swept him out too unthinkingly

He landed in the industrial waste bin too rapidly...

was dumped in the rubbish tip too brutally...

where he found a pair of trousers

...which fitted absolutely PERFECTLY!

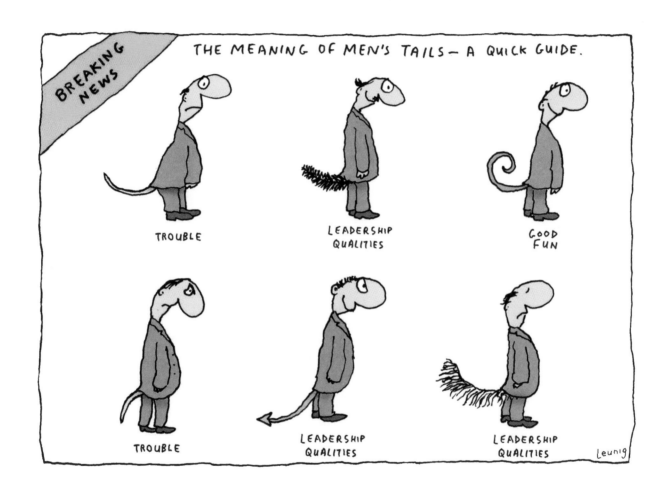

The cars are
too quiet

The river is
too clean

The air too fresh.
The food too
healthy.

The war too
brief. The
forest too vast.

The art too
joyful. The
leaders too wise,

..too kind, too
honest, too
humble. It's
all too DISGUSTING
and AWFUL.

Leunig

## THE LOST ART

Finger strokes on a screen of glass, on your device; a thousand strokes a day...

you could have done a wonderful painting with that agile finger, those sure and simple movements.

Flick flick flick tap tap flick tap tap flick...

You could have made a lovely wild and coloured thing;...

Swipe tap tap tap. Swipe swipe tap swipe...

...a happy mystery to hang on your wall; something to SMILE at...

Leunig

169

# Summer School

The summer school of sadness,
The master class beneath the moon,
The little drop of gladness,
Swallowed from a silver spoon.

The summer school of hoping,
The workshop underneath a tree;
Deep, creative moping;
Dreaming of the silver sea.

The summer school of staring;
The lesson of the tired hound;
The sky all hot and glaring,
Standing, staring at the ground.

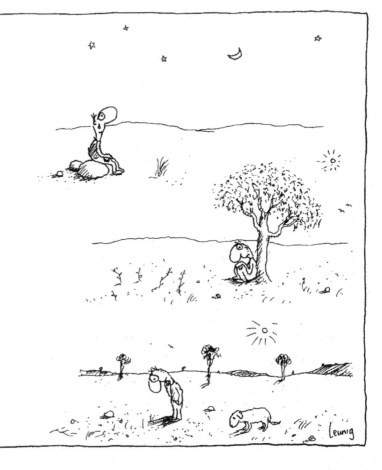

## SOLILOQUY FOR STRANGE TIMES

The leaders may not know what they're doing — but I do.

We'll keep each other company: this cup, this pot, this tea — and these parts of me.

I'm making tea. Tea _for two_!

Many things don't work or make sense these days — but the teapot does

One cup for the happy me and one cup for the sadder worried self.

It takes in.
It holds.
It makes.
It pours forth.

Leunig

# SOLEMNISATION

We are gathered here together to consolidate this person into a state of complete singleness.

If anybody has any problem with that, let's hear about it now or forever remain quiet

Do you take yourself to be utterly single, to the exclusion of all others forever?

 I DO.

WITH THIS RING I SINGLE MYSELF AND ALL MY WORLDLY GOODS ARE MINE AND NOBODY ELSE'S

I now pronounce you completely and utterly single.

① THE SINGLE HAS THE RIGHT TO KISS HERSELF OR HIMSELF AND TO SELF-SPRINKLE WITH CONFETTI.

② THE SINGLE HAS THE RIGHT TO THROW THE BOUQUET INTO THE CROWD

③ THE SINGLE HAS THE RIGHT TO A RECEPTION AND A HONEYMOON

④ SOMETIMES HONEYMOONS ARE A DISASTER PARTICULARLY WHEN SINGLES MEET OTHER SINGLES AND FALL IN LOVE; IN WHICH CASE THE SINGLENESS DOES NOT WORK AND MUST BE ANNULLED.

Leunig

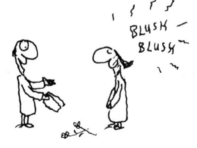

BLUSH — BLUSH

## The Summer Palace

Make a little garden in your pocket.
Plant your cuffs with radishes and rocket.
Let a passion fruit crawl up your thigh.
Grow some oregano in your fly.

Make a steamy compost of your fears.
Trickle irrigate your life with tears.
Let your troubled mind become a trellis.
Turn your heart into a summer palace.

Leunig

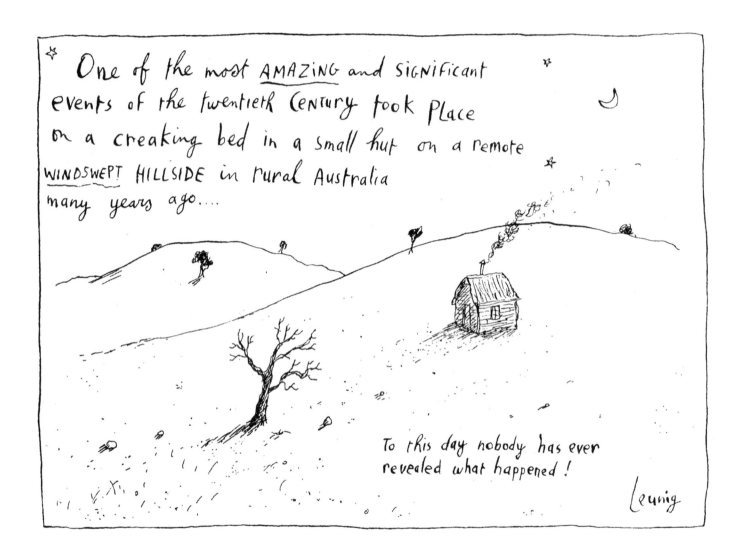

One of the most AMAZING and SIGNIFICANT events of the twentieth Century took Place on a creaking bed in a small hut on a remote WINDSWEPT HILLSIDE in rural Australia many years ago.....

To this day nobody has ever revealed what happened !

Leunig

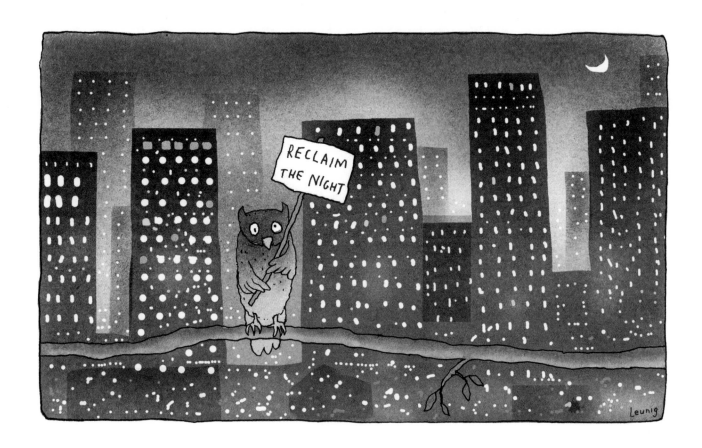

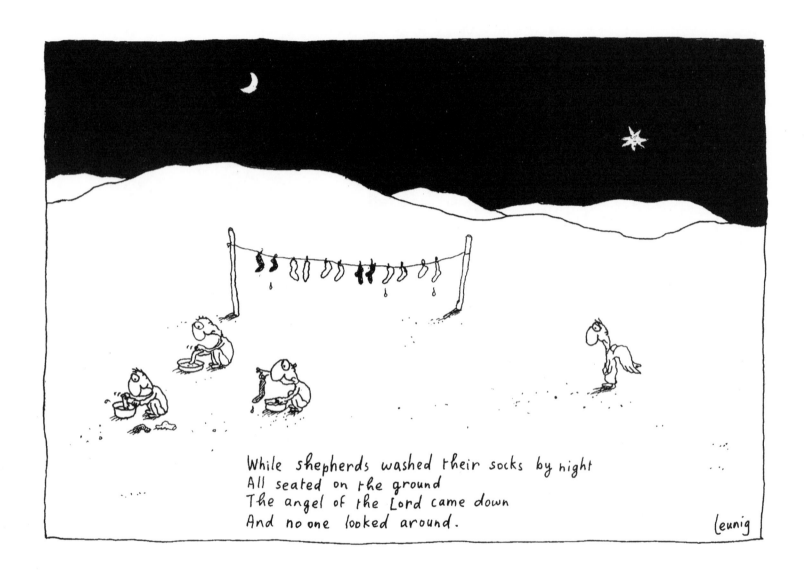

While shepherds washed their socks by night
All seated on the ground
The angel of the Lord came down
And no one looked around.

leunig

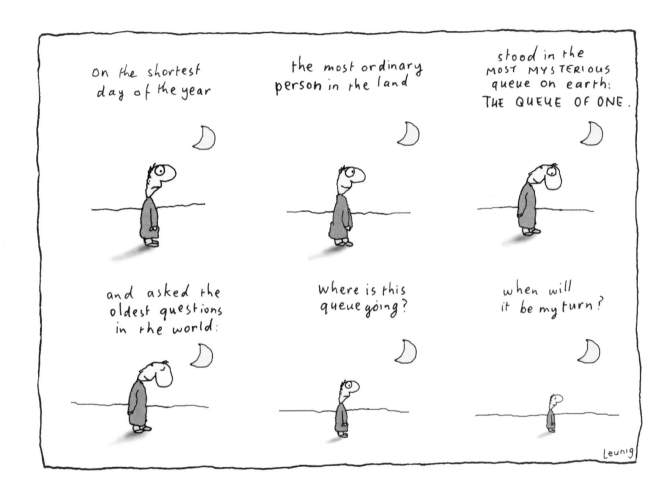

## SINKHOLES

A shock!
Your favourite
parkbench in the sun:
Swallowed by a <u>Sink hole</u>.

Slow and steady ways.
A quiet place, the
gentle gaze, the
civil truth.

Your old home.
A dear friend.
A great soul:
Sudden sinkholes
where they were.

The little park
The useful thing
The skillful man.
The earth opens up
beneath them.

The meaning of life.
A sense of your people,
A long-held hope:
Half in sink holes now.

And the government—
In all of this?
Triumphantly a
Sinkhole.
Proudly an abyss.

Leunig

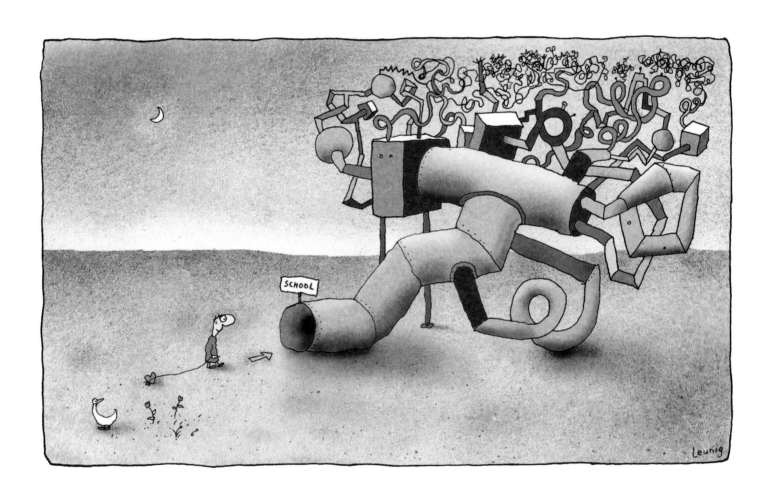

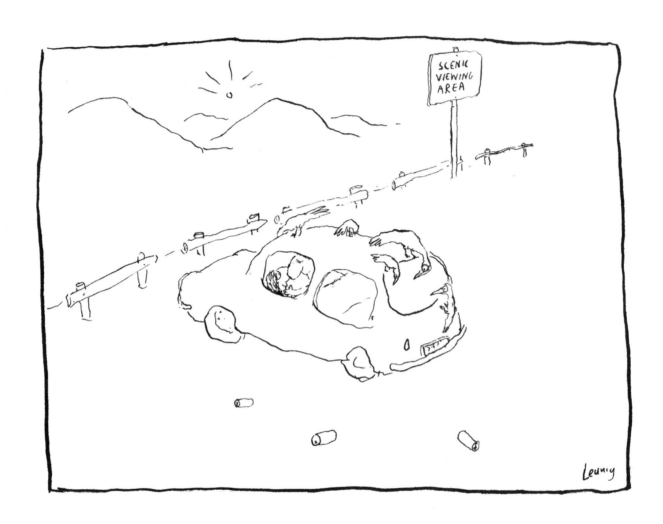

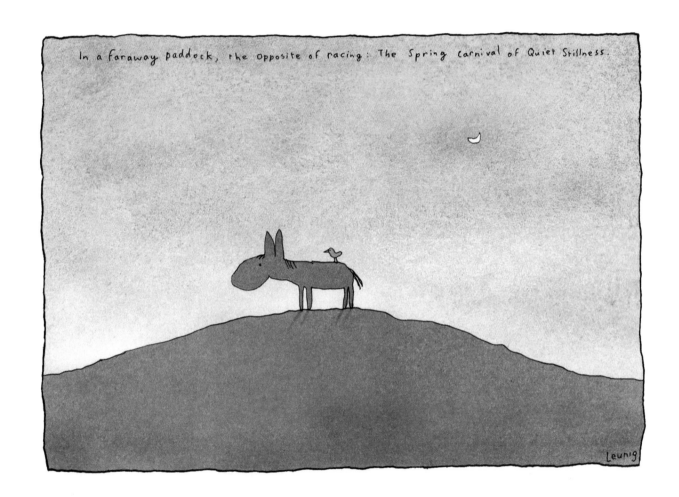

In a faraway paddock, the opposite of racing: The Spring Carnival of Quiet Stillness.

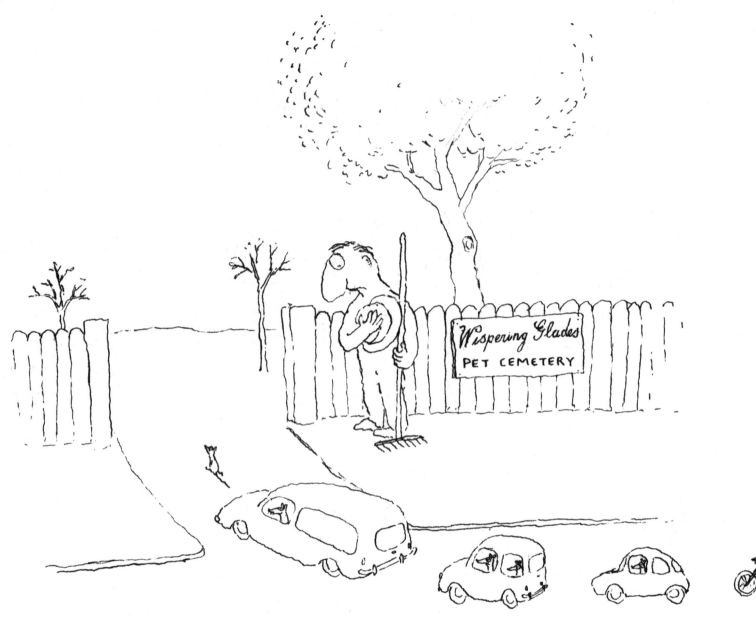

## WHAT IS 'ODD FOLKS SANS FRONTIERES' ?

'Odd Folks Sans Frontieres' is an organisation whose members have given up trying to understand what is happening in the world.

They simply do not believe the news and do not accept the definitions and categories by which the world is described.

In other words they have climbed over the walls and escaped. Basically they don't get it and think it's all fairly mad.

What do they do? Good question. A lot of them just shrug, others laugh and roll their eyes. Some shake their heads and smile... peacefully... Odd Folks Sans Frontieres!

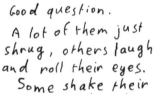

Leunig

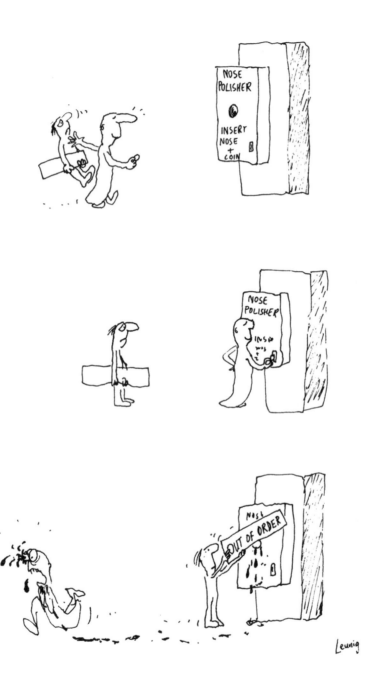

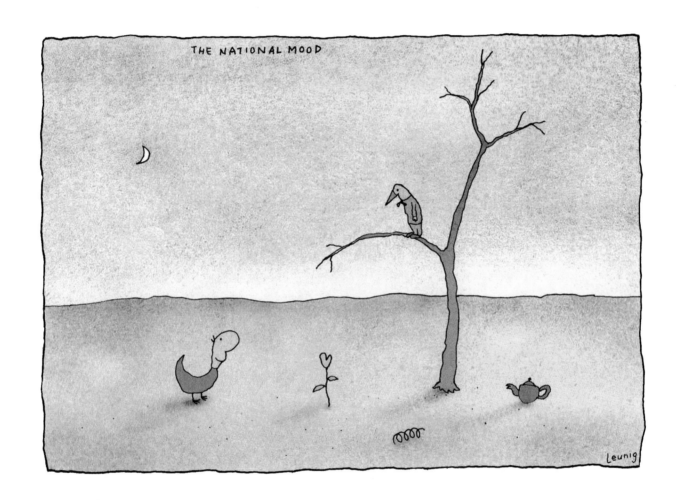

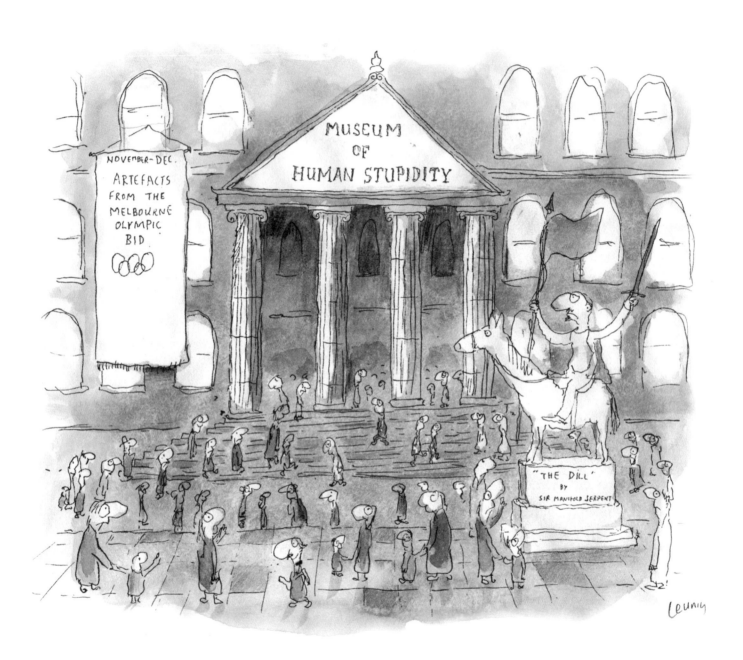

Humanity the narcissist
Wants to happily exist
Within its own reflection;
A type of self-infection.

The miracle of singing birds
Is overruled by human words;
The all too human views,
The sordid evening news.

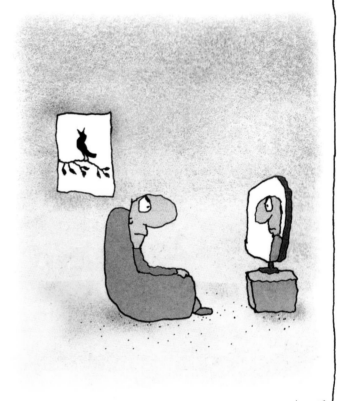

Leunig

## MOON LANDING

I remember the moon landing
On my dad as he was standing
On the porch one night and this
is what he said,
"Thats one small step for man, son,
Then you have to take the next one
And the next one and the next one
'til you're dead......"

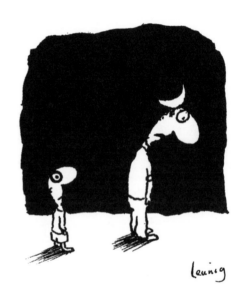

leunig

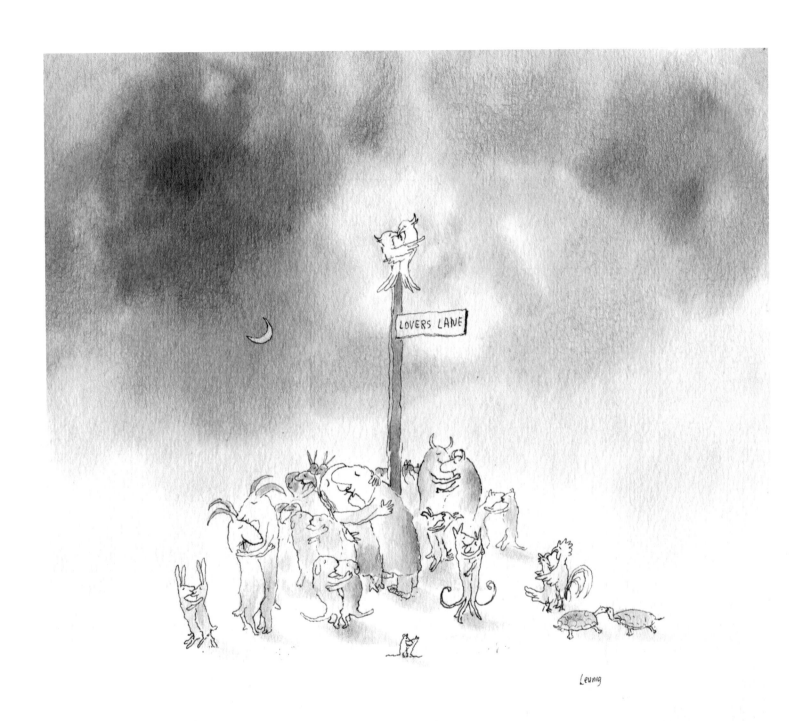

193

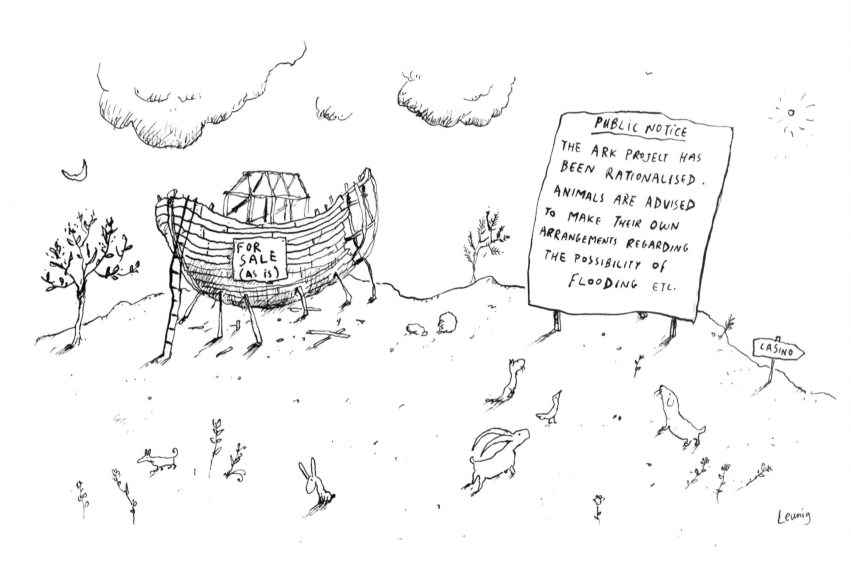

PUBLIC NOTICE

THE ARK PROJECT HAS BEEN RATIONALISED. ANIMALS ARE ADVISED TO MAKE THEIR OWN ARRANGEMENTS REGARDING THE POSSIBILITY OF FLOODING ETC.

FOR SALE (AS IS)

CASINO

Leunig

Feed the inner duck
Not with human news
Or greedy things that suck,
But give it quiet views;
Comments from the moon,
Opinions from the sky,
The insights of a tune,
The wisdom of a sigh.

...Women must be free
from the oppressive patriarchal
concepts of motherhood
and homemaking....

They must be free to pursue
professional careers in the
way that men do...

 OF COURSE

 YES
YES

... and have long
lunches like men do.
So let's eat!

ABSOLUTELY!
I KNOW A
GREAT LITTLE
PLACE....
COMPLETELY
AUTHENTIC

Oh yes...
...it smells
heavenly!

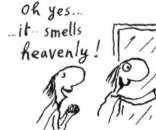

MAMA
PICCOLINO'S
TRADITIONAL
ITALIAN
HOME
KITCHEN

Leunig

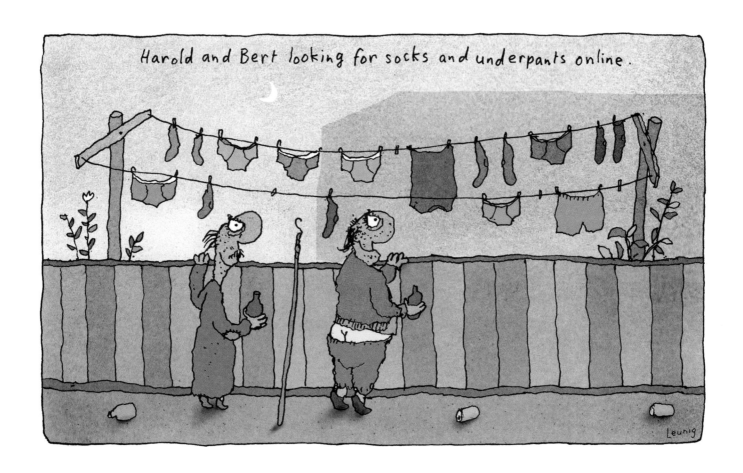

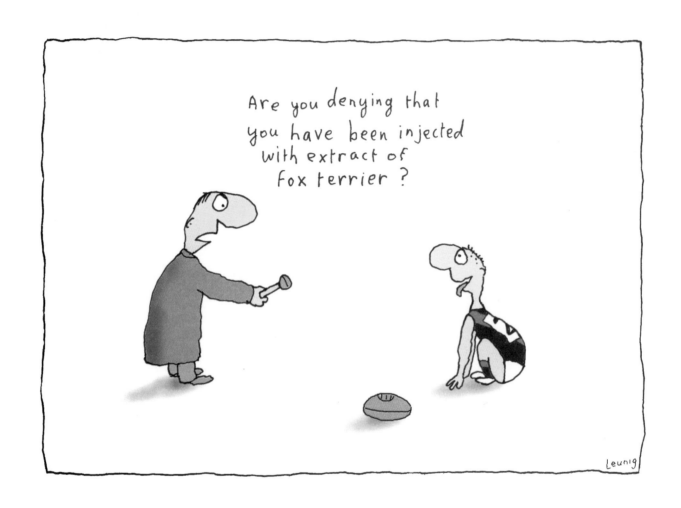

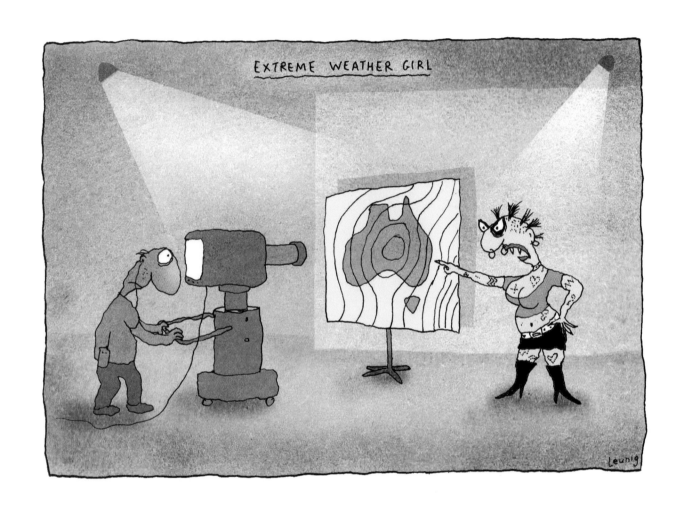

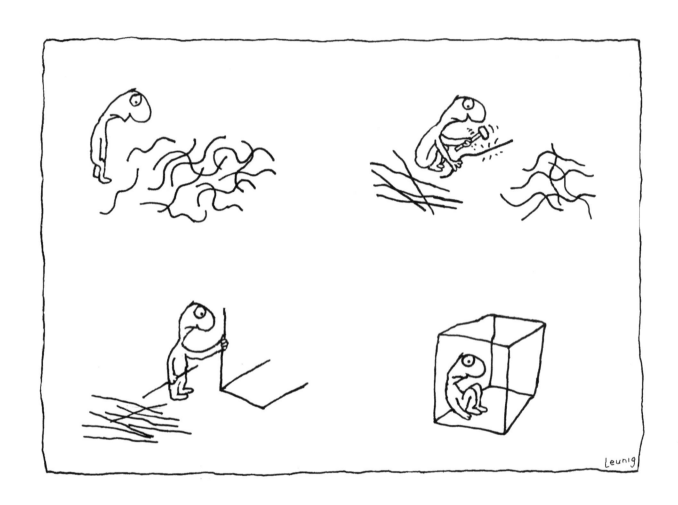

You are not
a person,
you are a
business.

Your mind is
a calculator.

You will not
express yourself,
you will advertise
yourself.

You will not
blossom,
you will compete
and accumulate.

When you open
your eyes, you
are open for
business.

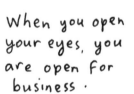

Leunig

Busy streets
surround his home

A flight path
in the sky above.

Beneath the house
a freeway tunnel.

Around his head
a storm of useless
information and
bad news.

In his phone and
computer; hackers
pests, trolls, snoops
criminals...

In his heart
a tree, a child.
a bird, the sky,
peace, freedom, grief.

Leunig

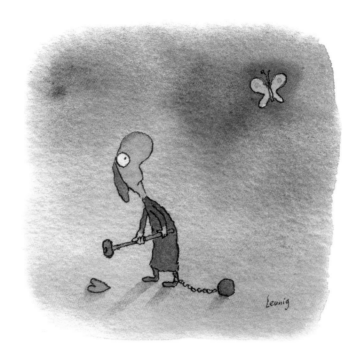

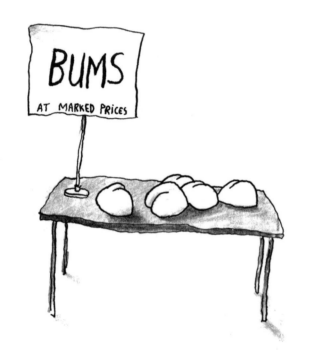

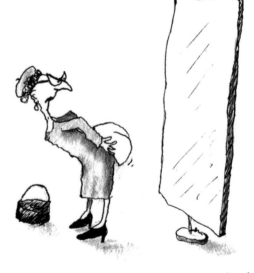

Leunig

Drifting slowly through the void
Is a tiny asteroid
On which we lie;
Just You and I.

It's very lovely being here
In the outer atmosphere;
The splendid views,
The lack of news.

When everything is said and done.
We cry our eyes out, just for fun.
The greatest mirth
Is not on earth.

Leunig

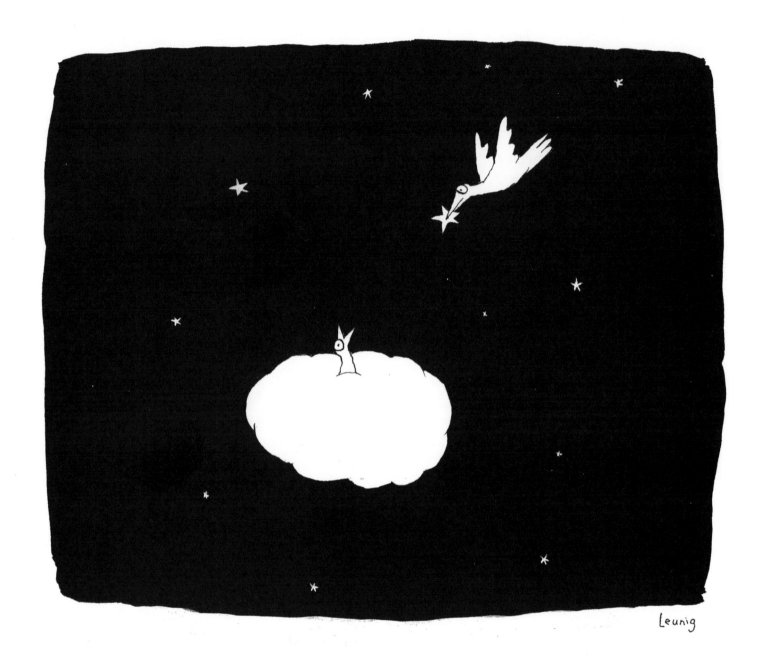

At last, a little car
has been landed
on Mars.

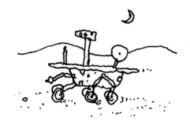

The mission is to see
if cars can survive
there, and be successful
in the Martian environment.

It would be futile to
put a human on Mars;
after all, planets are
for cars, not creatures.

We see this demonstrated
on planet earth where cars
are thriving and humans
are doing very poorly.

Leunig

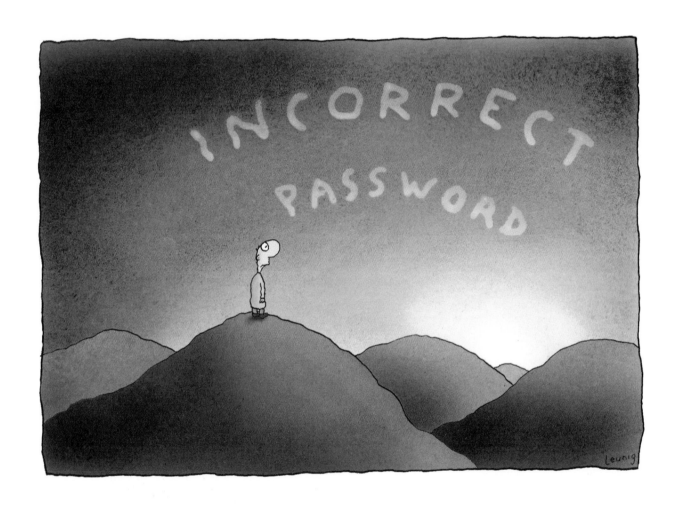

211

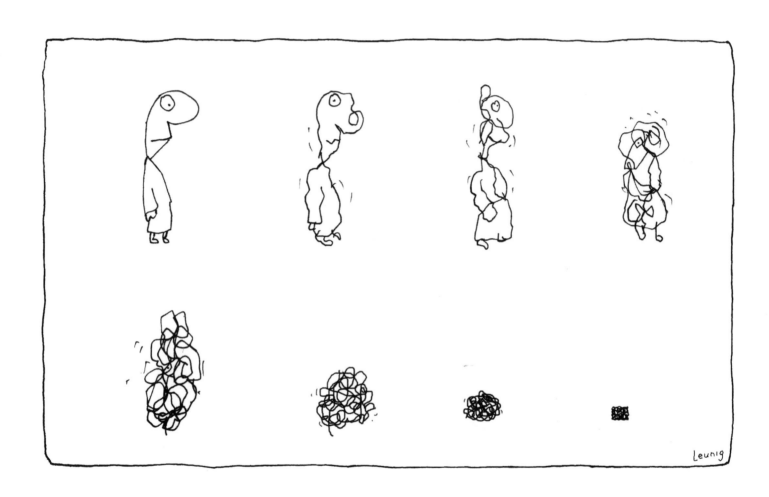

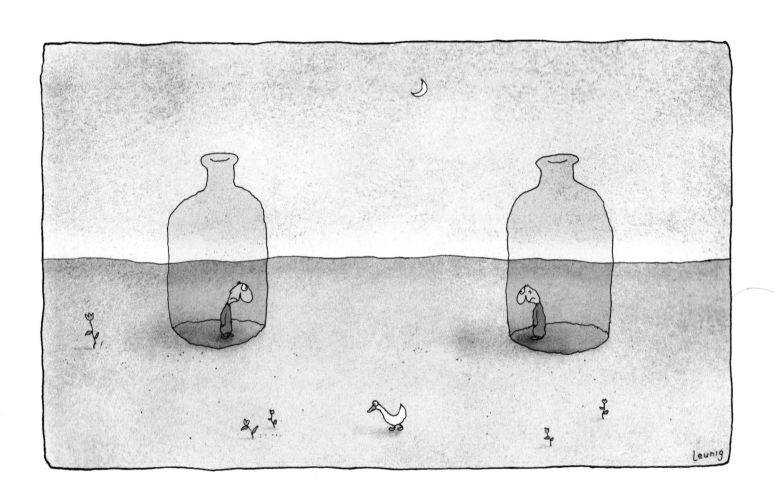

# The Democratic Way

And so we have democracy,
Whereby the people rule,
The wise and gentle thinker;
The greedy twisted fool.

The spiteful and the paranoid;
The morbid and confused;
The cruel, corrupt and ignorant;
The angry and abused.

Even men in ladies' clothes
Who make love to a goat,
While playing on a saxophone,
Are still allowed to vote!

And they shall make the people's choice
Upon election day;
How very, very strange indeed
This democratic way

Leunig

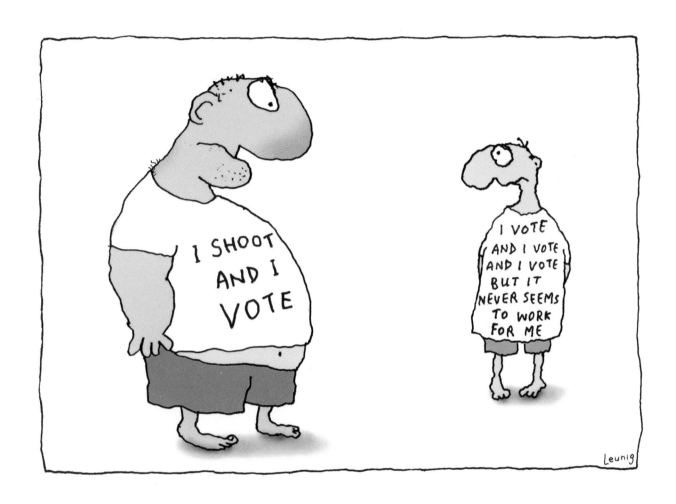

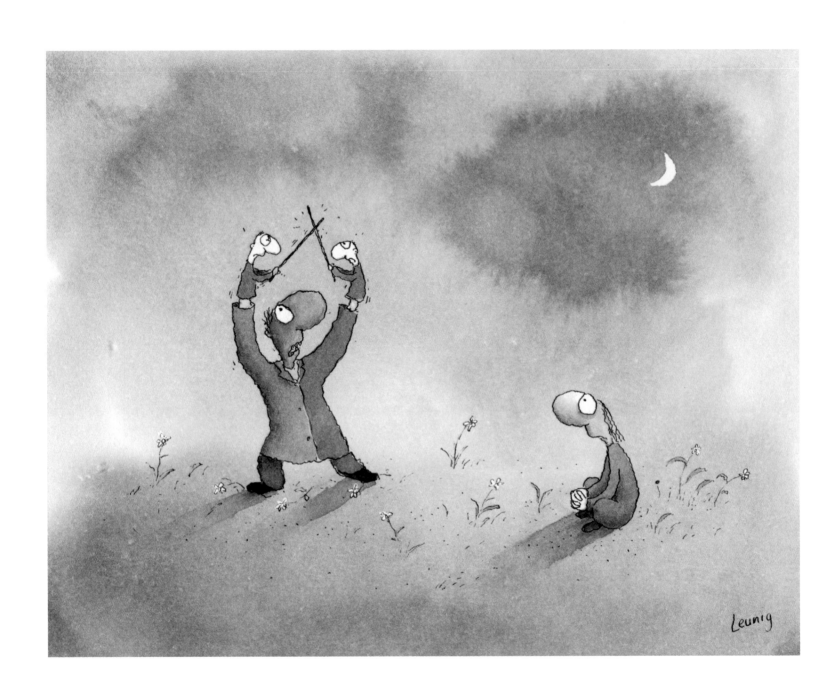

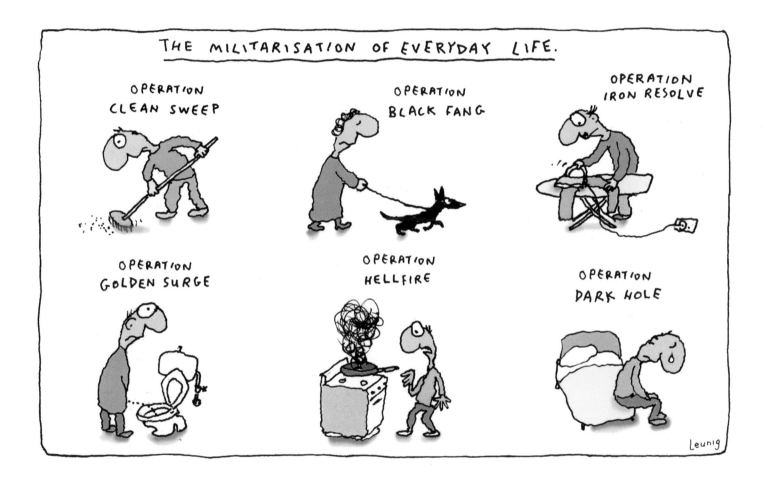

# GHOST MINISTERS IN THE CURRENT GOVERNMENT

The Minister for
Stopping things.

The Minister for
Cold Comfort.

The Minister for
Refusal.

The Minister for
Dismantling

The Minister for
Cutting and
ending things.

The Minister for
Harsh Measures
and Squeezing

Leunig

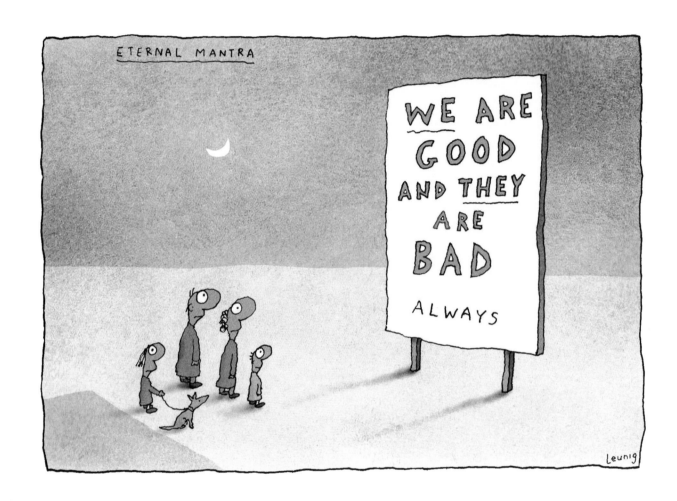

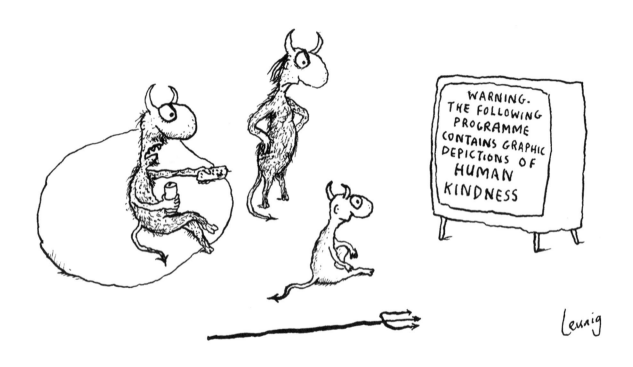

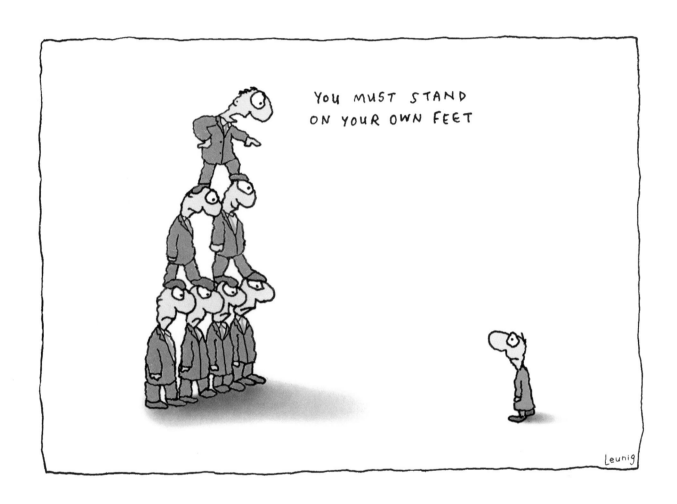

## THE LOST ART OF MOPING

Moping is a much neglected art form.

It requires skill and courage to mope in the classical way; to drift aimlessly alone on the great sea of despondency.

In a world congested with distractions and entertainments, old-fashioned moping has been largely abandoned.

There is much to mope about in the modern world yet the moping is not being done!

Moping is an ancient way of processing life's failures, misfortunes and overwhelming complications..

It's like when the dirty dishes are piling up and nobody is washing them.

Leunig

They took him on a stretcher
To The Home for the Appalled

Where he lay down in a corner
And he bawled and bawled
and bawled

"There's nothing wrong with
me", he wailed
When asked about his
bawling

"It's the world that needs attention
It's so utterly appalling"

"It's SO UTTERLY APPALLING"
He sobbed and cried
and called.

And the chorus rose to
join him
At The Home for the
Appalled.

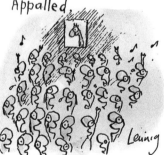

Leunig

223

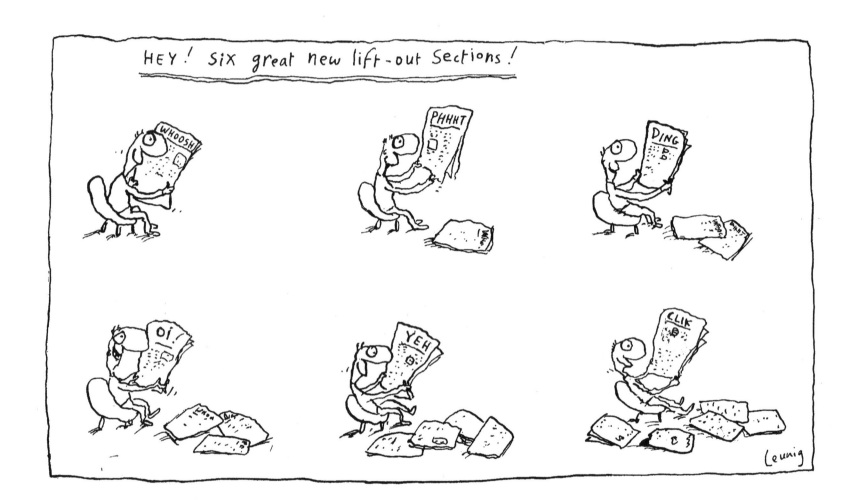

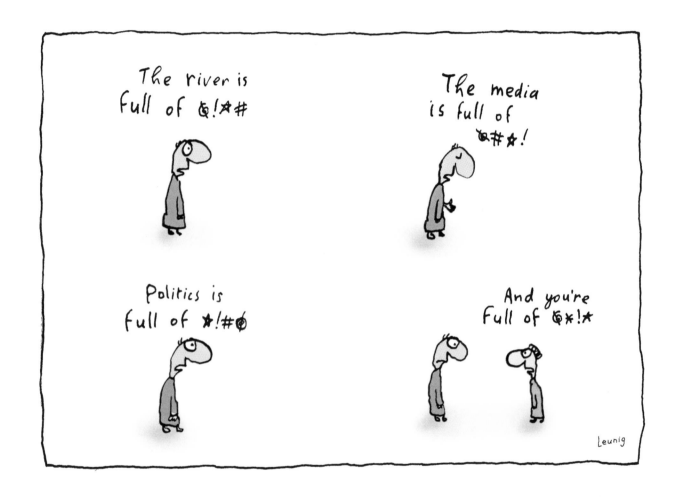

This is the time
of year when you
may rise gently
from the earth...

... and waves
of pure joy.

... and hover
thoughtfully over
the human
predicament.

You may look
down with
acceptance and
forgiveness for
all that you see.

you may feel
small pangs of
sweet sorrow
and loneliness...

Don't forget to turn
over and float face
upwards. You might
get a nice surprise.

Leunig

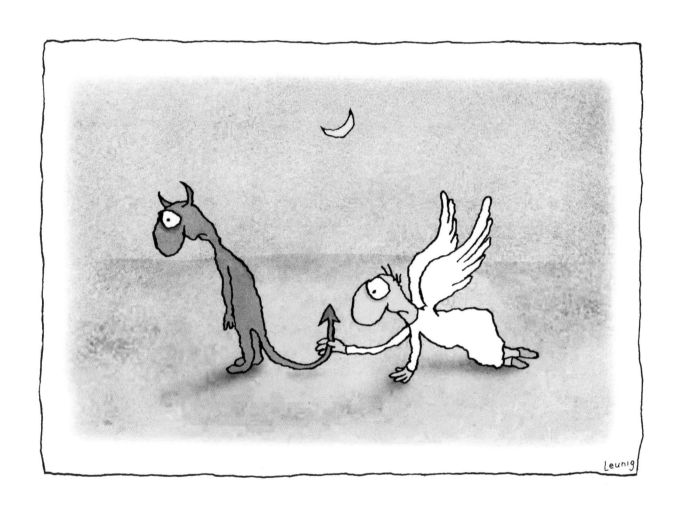

227

# A LAYPERSON'S GUIDE TO THE GOD PARTICLE AND THE THEORY OF EVERYTHING

SHE WAS WASHING
THE DISHES IN THE
KITCHEN SYNCHROTRON

HE WAS TELLING
HER THAT HER BRAIN
WAS A SUB-ATOMIC
PARTICLE.

FORCES IN MANY
INTERCONNECTING TUNNELS
THEN CAUSED THE
DISHES IN THE SYNCHROTRON
TO MOVE AT HIGH SPEED
IN A CIRCULAR ORBIT

UNTIL A COLLISION OF DARK
MATTER OCCURRED CAUSING
MOLECULAR STRUCTURE TO
SPLINTER AND DISPERSE AT
THE SPEED OF LIGHT

THUS MAN DISCOVERED THE
'GODDESS PARTICLE', A
BREAKTHROUGH WHICH LIKE
MOST SCIENTIFIC DISCOVERIES
WAS QUICKLY SEIZED UPON
AND EXPLOITED BY THE
ARMAMENTS INDUSTRY.

AND AS USUAL,
TO THE SOUND OF
COSMIC MUSIC,
EVERYTHING CONTINUED
TO GO DOWN THE
GURGLER.

Leunig

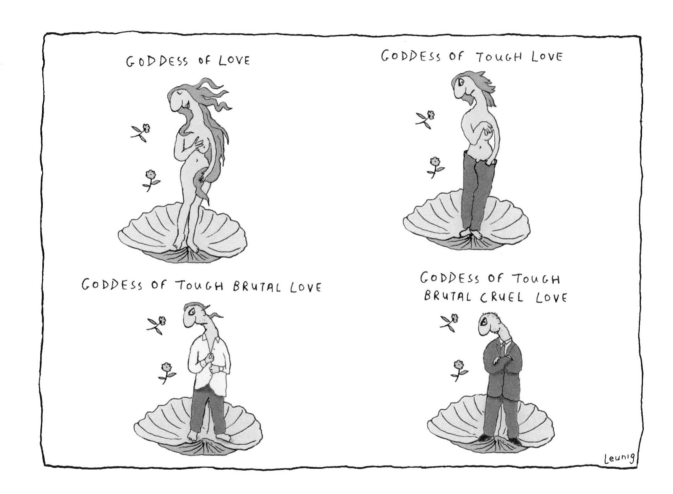

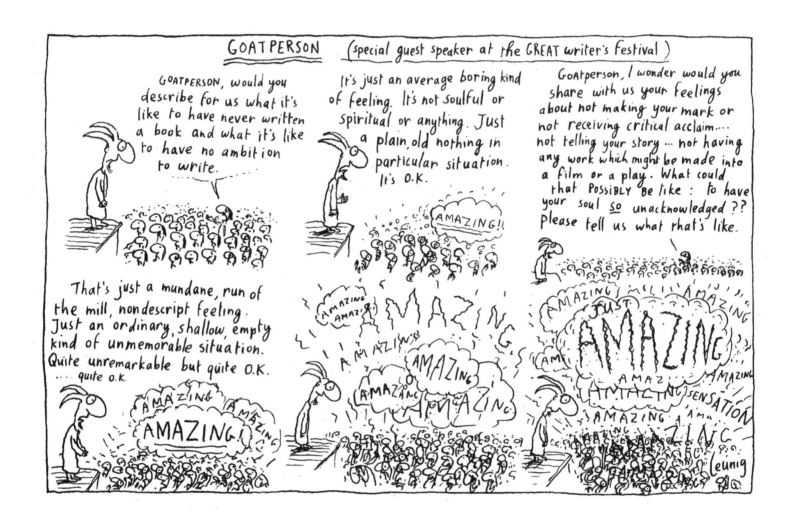

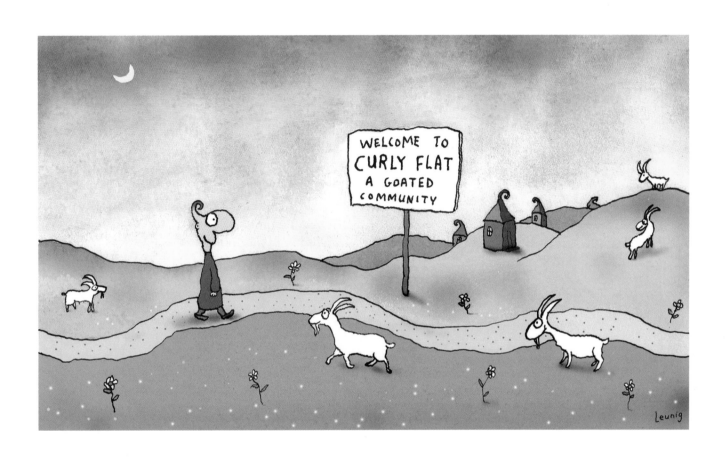

# TODAY'S STOMACH KNOTS

The knot that comes after waking up and remembering the facts of one's life.

The common family knot.

The morning news knot.

The shopping mall knot.

The peak hour traffic knot.

The urban "oh my God" knot tangled with the knot of political dismay.

Leunig

Man driving home
from work in the
gridlock position.

Man arrives home
locked in the
gridlock position.

Man has dinner
In the gridlock
position.

Man makes love
in the gridlock
position.

Man sleeps in the
gridlock position.

Man drives to work
in the gridlock
position.

Leunig

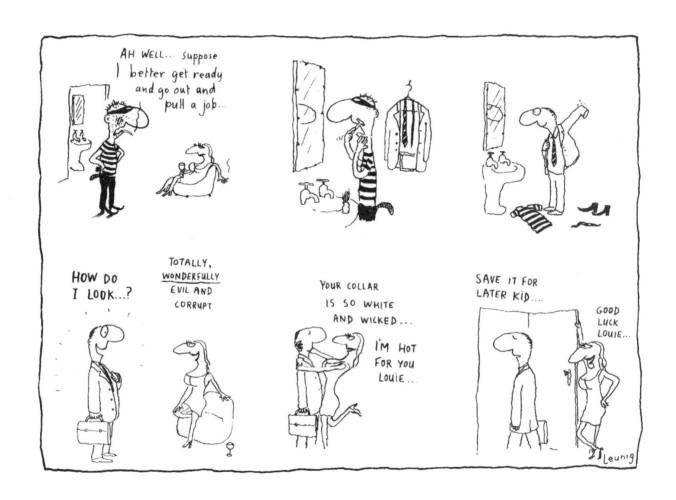

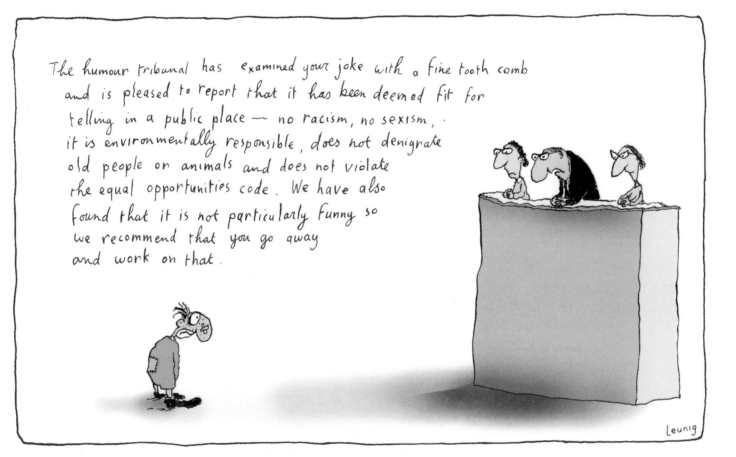

The humour tribunal has examined your joke with a fine tooth comb and is pleased to report that it has been deemed fit for telling in a public place — no racism, no sexism, it is environmentally responsible, does not denigrate old people or animals and does not violate the equal opportunities code. We have also found that it is not particularly funny so we recommend that you go away and work on that.

Leunig

This day before you now
Greet her with love and joy.
She is a fine strong person:
This precious living day
She is young and old
She is warm and cold
She is here for you
She will hold you well.
Make love with her
You'd be a fool to turn away
She is here. She is yours.
She is wise, she is hers.
She has dawned on you; this epic day.
Do not underestimate what she can do
Give thanks for her as you make your way.
Give thanks for the power and the kindness
Of this precious living day

Leunig

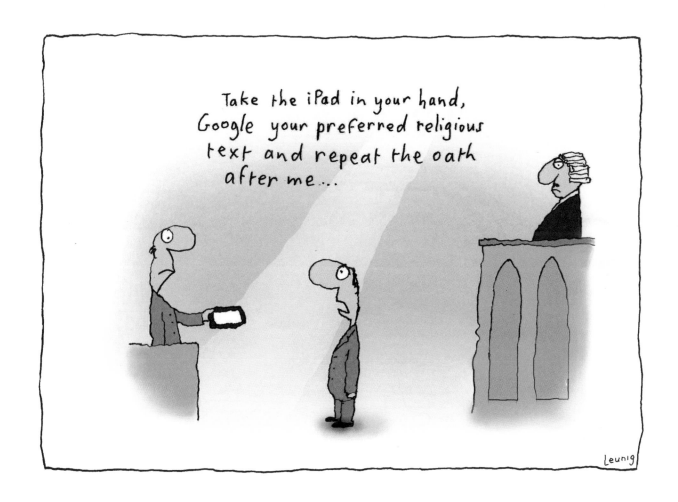

our way of life is
being threatened by
a dark force.

  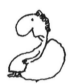

we must defend our
way of life.

WHAT IS THIS
DARK FORCE WHICH
THREATENS OUR WAY
OF LIFE?

it's our way
of life....

Leunig

238

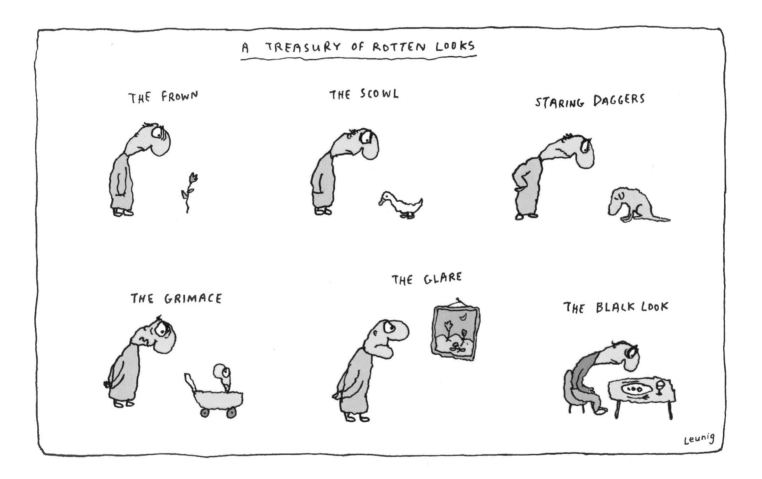

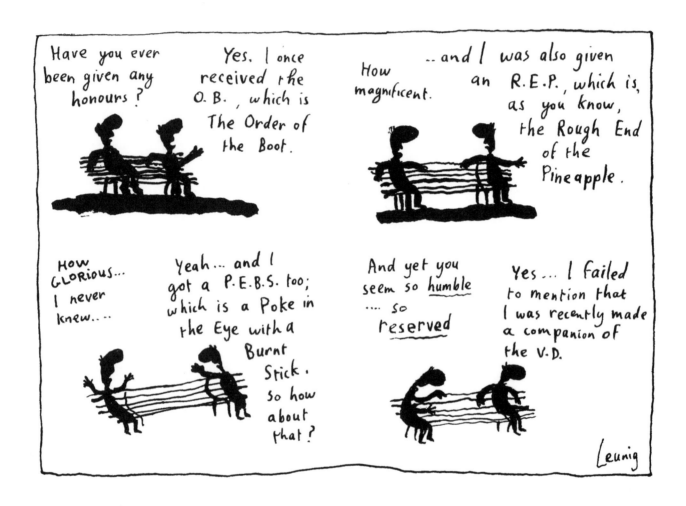

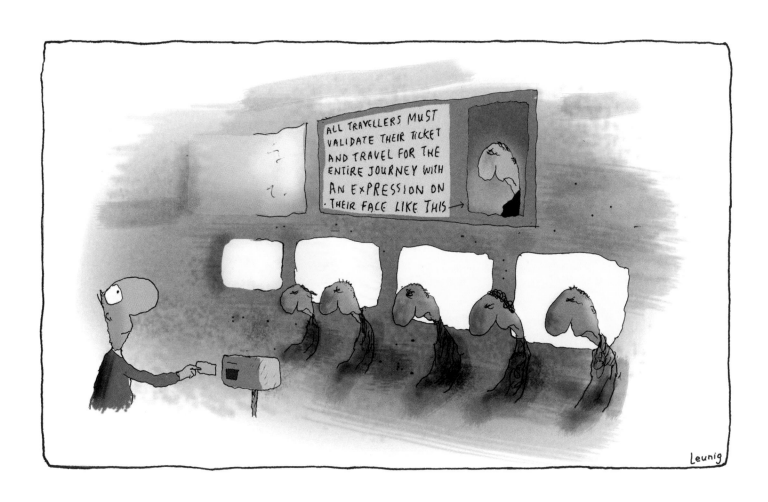

# To the Splendid Volunteers.

Communities of bygone years
Built by selfless volunteers:
The gossip and the village fool,
The town bike at the swimming pool,
The local drunk, the local perve —
Duty and need to serve
And spread the vital human glue —
A thing the government cannot do!

Leunig

♪ UNDERPANTS WHICH HAVE IN WINTER SAGGED (a hymn for spring)

Underpants which have, in winter sagged
And fallen into darkness and despond
Shall from their shame and loneliness be dragged
And laid upon the fern's emerging frond.
The frond shall gently rise to greet the spring,
Above the flowers, into the sun fantastic,
Where birds in praise of underpants shall sing
And life will be restored to old elastic.

Leunig

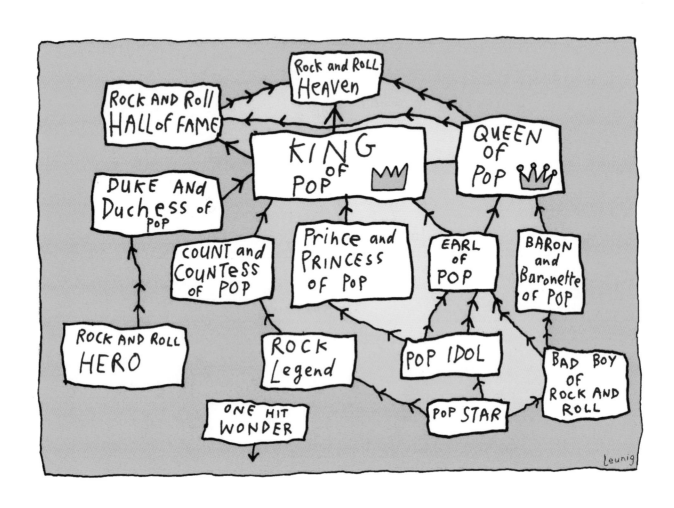

# A Quick guide to Six common Australian Uncles

### Uncle Dick:

an uncle Dick is often a bit scruffy and untidy but he's mostly in a good mood and is very loveable.

### Uncle KEN:

Uncle Kens can be terrible know-alls and a bit bossy but they actually are clever and generous and really nice deep down.

### Uncle BRIAN:

An uncle Brian is usually playing tricks and pranks and can be an exasperating dork but they're truly wonderful when all is said and done

### Uncle RON:

Uncle Rons are known for their odd opinions and astonishing theories about life; they're a bit of a worry yet they have such sweet natures.

### Uncle FRANK:

Uncle Franks are famous for being earnest and disapproving and yet, in the main, they have hearts of gold.

### Uncle BOB:

an uncle BOB is inclined to be extremely embarrassing — they simply don't know when to stop; but you have to love them because they're so cuddly and gorgeous!

Leunig

## TORTURE

There once was a man who was tortured to death,
And as he lay dying he took a deep breath,
And cried to his far-away father and mother,
"Oh why did we all have to torture each other?"

"And why did we have such a torturous life?"
He groaned as he turned to his poor, tortured wife;
Who gave her reply with a petulant pout,
"I really don't know what you're talking about!"

"And why did I torture myself even more?"
He cried to his little white duck on the floor,
Which quackled forgiveness and offered a shrug
And did the small blessing of ducks on the rug.

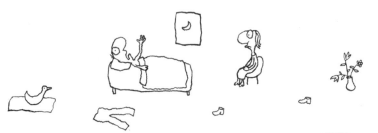

Leunig

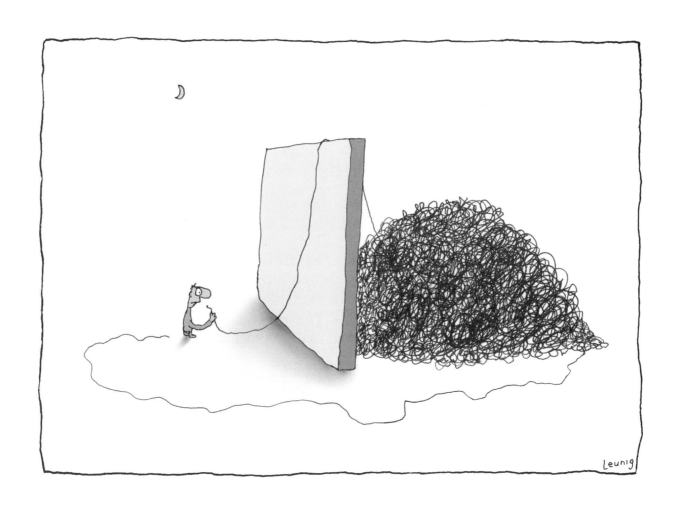

## THE DEFICIT

Mr. Curly owes much to his teapot. It has given him a lot.

For the joy they have given him he owes much to the trees and flowers.

He is in debt to the moon and the stars.

To the table, the chair, the cat, the dog, the vase, the mandolin, the duck, he owes a large debt.

His debt to the birds is huge.

Can he ever repay? Well of course he can! That's the whole point of his life.

Leunig

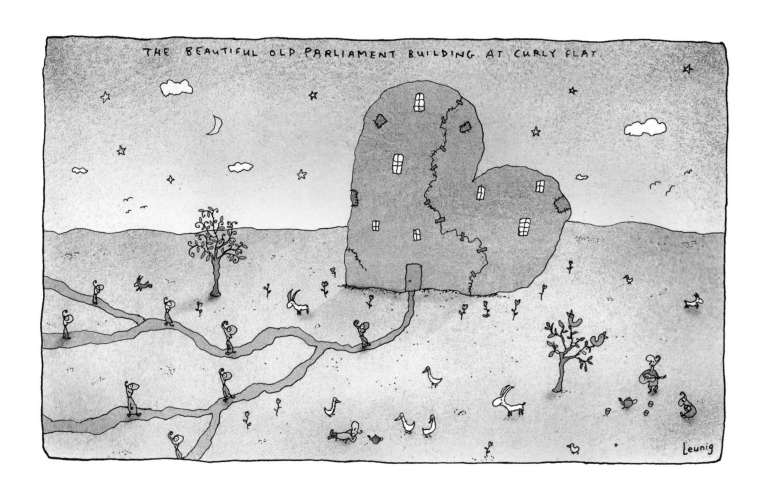

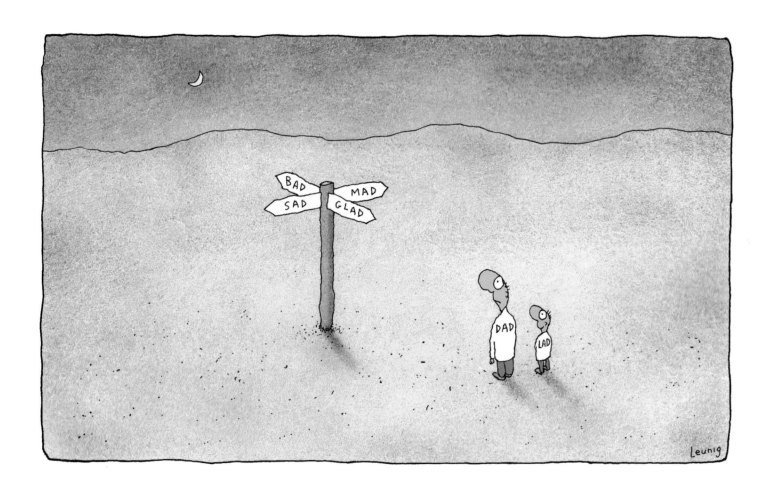

## DAYLIGHT SAVINGS

Have a little sleep-in
Have a little weep-in
Have a little peep-in
To what's deep inside the hole.

Have a little lie-in
Have a little sigh-in
Have a little fly-in
To the sky around your soul.

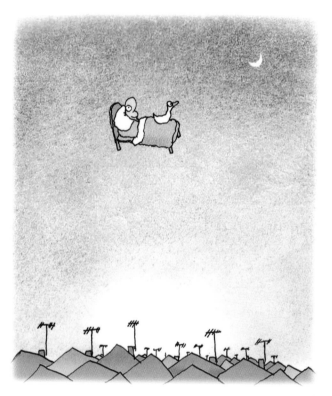

Leunig

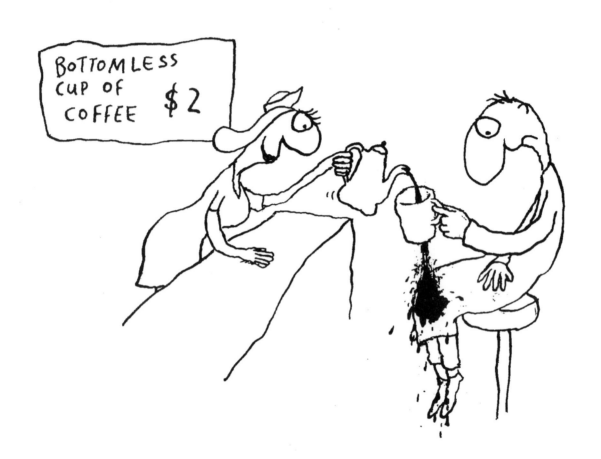

Ah waiter.... We're having our big Saturday night bash and we need a meal that packs a punch.

Well — we have a knockout dish tonight: Smashed avocado, smashed potatoes and smashed peas with torn basil and cracked pepper.

Sounds awesome. Then we're going to a poetry slam because Jessica's busted with her partner who broke her heart and she wants to get ripped and wasted because it's crunch time with illusions that need to be shattered.

So JUST confirming— that's BASH, PUNCH, KNOCKOUT, SMASH, SMASH, SMASH, TEAR, SLAM, BUST, BREAK, RIP, WASTE, CRUNCH, SHATTER. AND... CRACK. <u>BEAUTIFUL</u>! ...BEAUTIFUL

Leunig

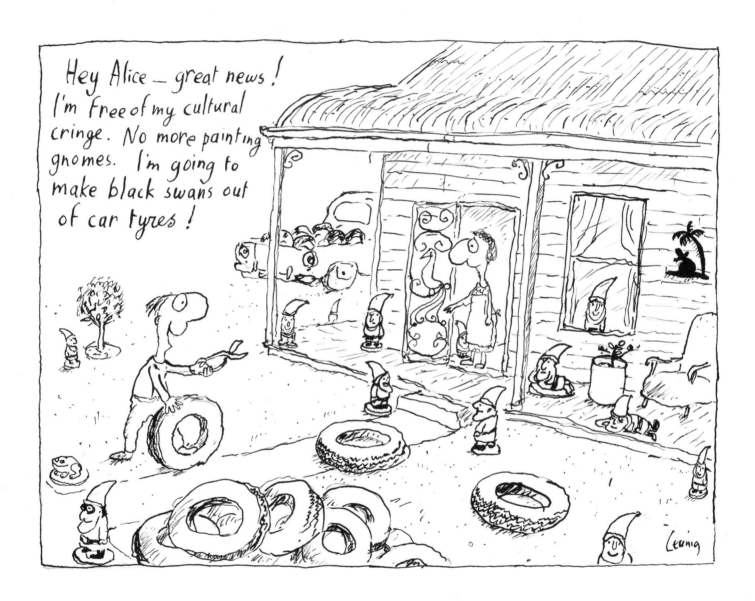

## SUMMER DRINKING GUIDE

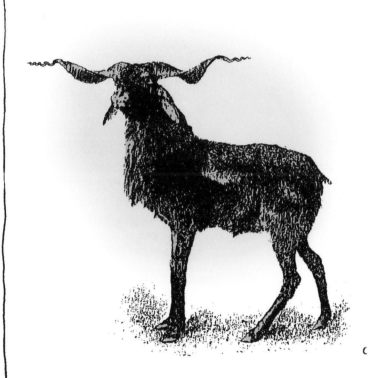

One of Melbourne's smartest and busiest wine bars has imported a rare Macedonian corkscrew goat (PICTURED LEFT) to work in its Flinders Lane premises this summer. The goat was cleared from quarantine last week and is expected to begin pulling wine corks on Monday. This ancient breed can open two bottles at once and is well suited to working between the tables and servicing separate, adjacent customers with the one action. The animal has been fitted with small rubber shoes to prevent it from slipping on the mosaic floor as it brings into effect these astonishing and physically flamboyant dual extractions.

"An increasingly sophisticated wine public is demanding authenticity and regional character so we're providing it" said the manager last night.

Leunig

Suddenly it's the
SILLY SEASON and
nothing matters

Nothing except your
DEEP WEARINESS and your
pre-Christmas crack-up.

The silly season
pushes all worldly
things aside...

and creates a large
empty space for your
AMAZING
pre-Christmas CRACK-UP

The crack-up arrives,
mostly when you are
not expecting it....
BUT IT ARRIVES!
OH YES.

The good old fashioned
pre-Christmas Crack-up:
INEVITABLE, COMPULSORY,
ASTOUNDING and a total
Inconvenience BUT...
AN ABSOLUTELY
ESSENTIAL EPIPHANY

Leunig

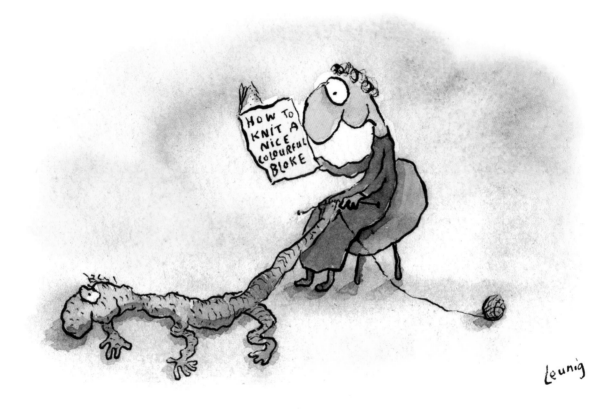

259

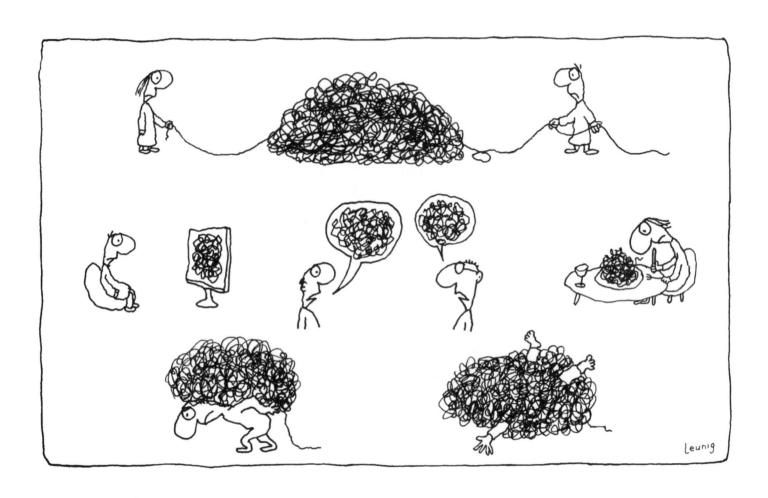

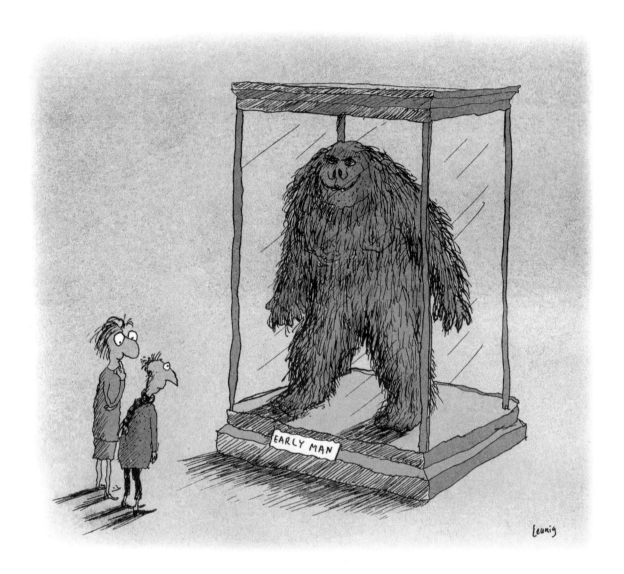

EARLY MAN

Leunig

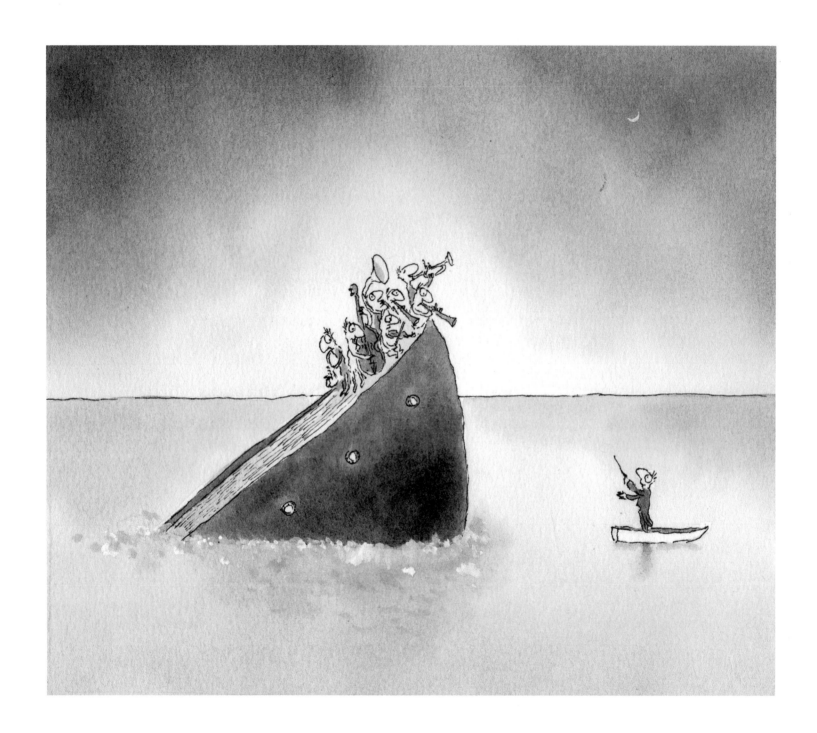

262

Tired of dawdling pedestrians blocking
the footpath and slowing you down?
TIME IS MONEY! Shift those boring
nuisances with the new, eco-friendly, solar
powered PEDESTRIAN SUPER TOOTER from

HORN BLASTER TECHNOLOGIES — THE HURRY EXPERTS.

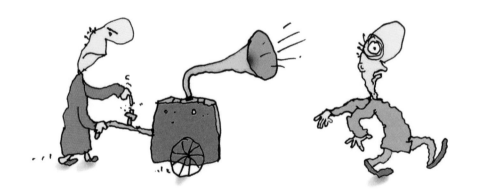

Leunig

YOU ARE CRUISING TO A MYSTERY DESTINATION. MID OCEAN.... NIGHT TIME. YOU ATTEND A GLITTERING OCCASION IN THE BALLROOM.

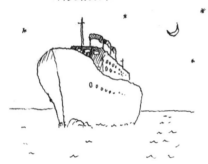

YOU NOTICE A WOMAN WHO IS SO RARE AND BEAUTIFUL TO YOU THAT YOU GROW WEAK.... LONELY... ECSTATIC. SHE DANCES WITH THE CAPTAIN AND SOME OFFICERS

DAZED WITH A STRANGE RESIGNATION. YOU MOVE OUT TO THE RAIL AND DROP LIMPLY OVERBOARD. YOU SWIM AWAY FROM THE SHIP TO WONDER AT IT ALL FROM AFAR.

IN THE BLACKNESS A SHARK BUMPS INTO YOUR LEG AND FROM A MILE ACROSS THE WATER YOU HEAR MUSIC, LAUGHTER.... THE CLINK OF GLASSES. YOU SEE THE TWINKLING LIGHTS. THE OCEAN FLOOR IS A THOUSAND FATHOMS BENEATH YOU. YOU FEEL MYSTICAL..... UNAFRAID.

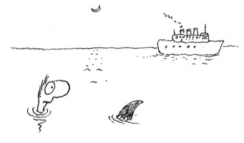

THEN YOU SWIM BACK TO THE SHIP AND ONLY JUST MAKING IT YOU CLAMBER UP A ROPE.... EXHAUSTED. <u>THE WOMAN IS ON THE DECK</u>....ALONE. SHE HAS BEEN SEARCHING FOR YOU, WORRYING FOR YOU. SHE HELPS YOU OVER THE RAIL. SHE WARMS YOU IN HER ARMS. A TEAR OF RELIEF ON HER CHEEK, <u>SHE KISSES YOU</u>...

YOU NEARLY FAINT WITH JOY. A CLOCK STRIKES TWELVE. THE SHIP TURNS INTO A LIVE SHEEP TRANSPORT. YOU ARE KISSING A SHEEP...! <u>YOU ARE BOUND FOR LIBYA</u>. EVERYTHING SMELLS.

leunig

264

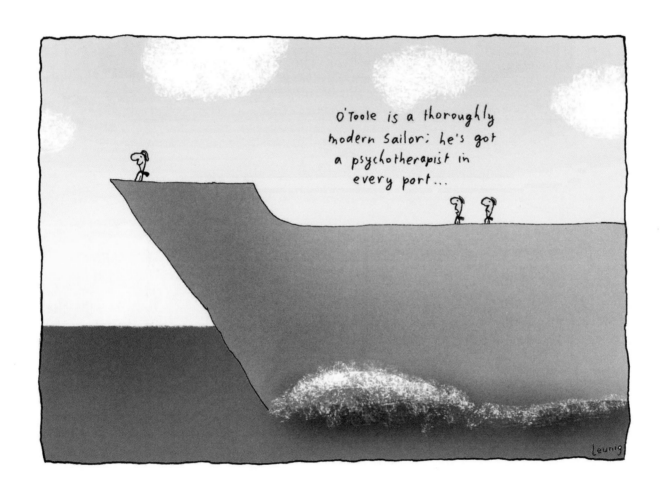

# A GOOD BED

A good bed is like a grand piano...

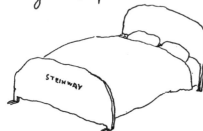

...upon which the great sleeps may be performed..

Yes, it is from the great sleeps which the most moving and wondrous dreams arise.

The great performance is attended by an audience of adoring angels who hover and watch in rapturous silence

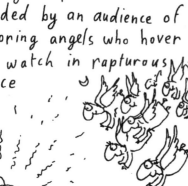

Finally the great sleep ends and the sleeper awakes. There is a moment of silence. And then the applause — the vibrant, joyous applause of angels, streaming down from heaven.

The performer steps down from the grand bed and bows to the audience. The day has begun. A good bed is like a grand piano.

Leunig

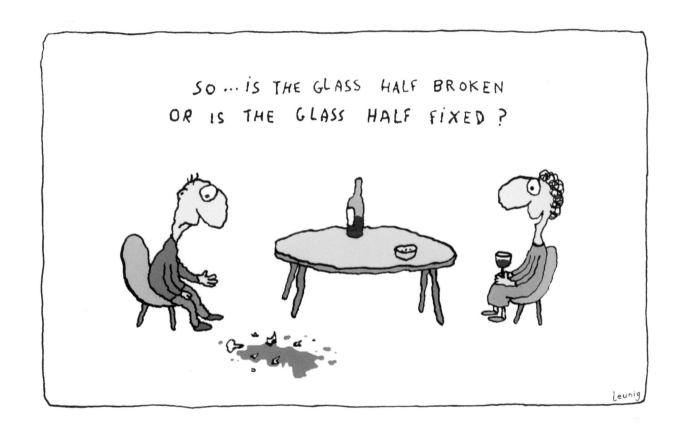

COVERED IN GUNK, HE VISITS A WISE ELDER TO DISCUSS THE MYSTERIOUS SUBSTANCE WHICH COVERS NOT ONLY HIS BODY BUT THE ENTIRE WORLD.

I feel like my whole life — my thoughts, my feelings, my actions — are covered with an invisible, numbing, clammy sludge. How can this be? What is this GUNK?

Gunk is the material which holds the modern world together. Certainly it is an encumbrance but without it our lives and our civilisations would probably fall apart. Gunk is the glue of existence!

There's an awful lot of it about. It seems to get worse every day. Has the world ALWAYS been covered in gunk?

Good heavens no! The world used to be held together with INNER structures and as you can tell, gunk is an external surface matter. It holds things together from the OUTSIDE

It's like a packing material which stops everything cracking and breaking — it's a sort of shredded waste which surrounds everything and everybody and keeps things from actually touching.

The trouble is — it's very stifling! Very gooey!.

YES! I feel like I'm stewing in my own juice all the time — and everybody else's AS WELL!

WELL WHAT'S IT MADE OF THIS PACKAGING MATERIAL... THIS COATING... THIS GUNK?

Forgive me if this seems a bit crude but gunk is a mish mash blend of a million and one varieties of one hundred percent bullshit and we're all absolutely covered in it!

Leunig

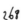

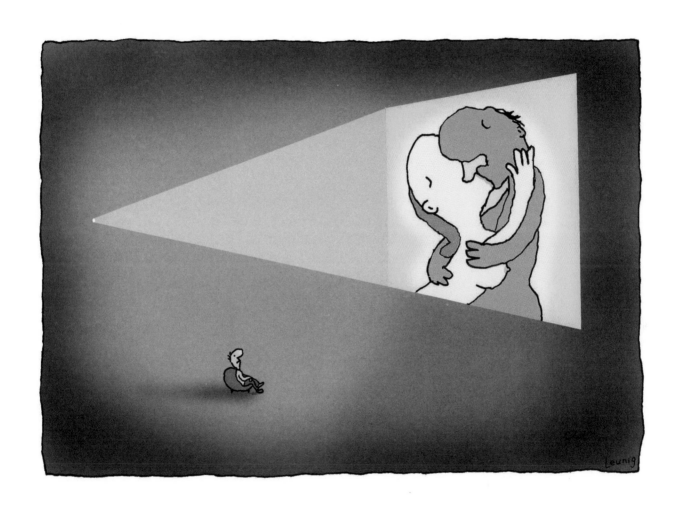

269

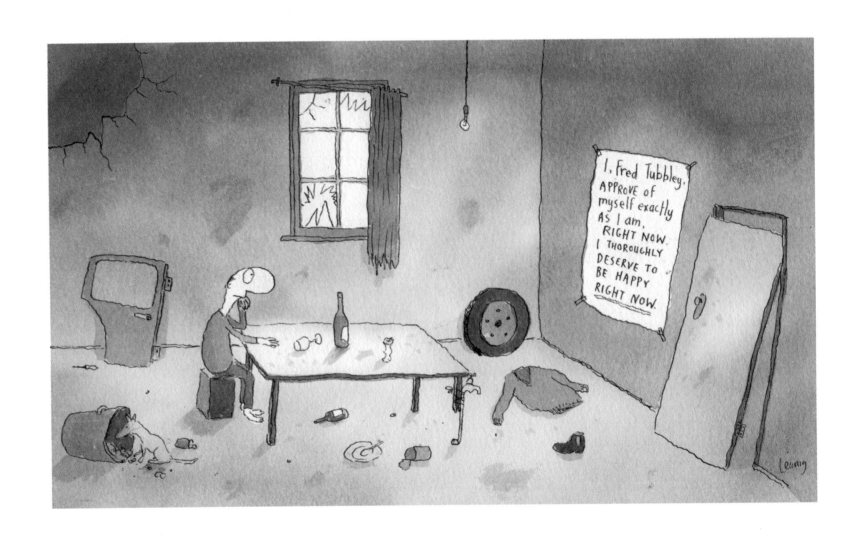

# MAKE YOUR OWN LEGAL PERFORMANCE ENHANCING ORGANIC FOOTY SUPPLEMENT
## OLD SECRET BUSH RECIPE – AMAZING RESULTS.

**INGREDIENTS:**

Ten used leather footy boots. CIRCA: 1950's
One bottle of tomato sauce. One bucket
of water. One pint of urine from the
milkman's horse.

**METHOD:**

Chop boots into tiny pieces and boil in
water. When mixture is cool, add sauce
and urine into the bucket and stir.

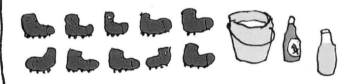

Place bucket in the woodshed and allow
to ferment for THREE WEEKS. Strain
mixture, bottle liquid and store in
cool place.

Take a warm bath on the night before match.
Add one cup of mixture to bath water.
Drink another cup of mixture next day
immediately before match. Good luck.

Leunig

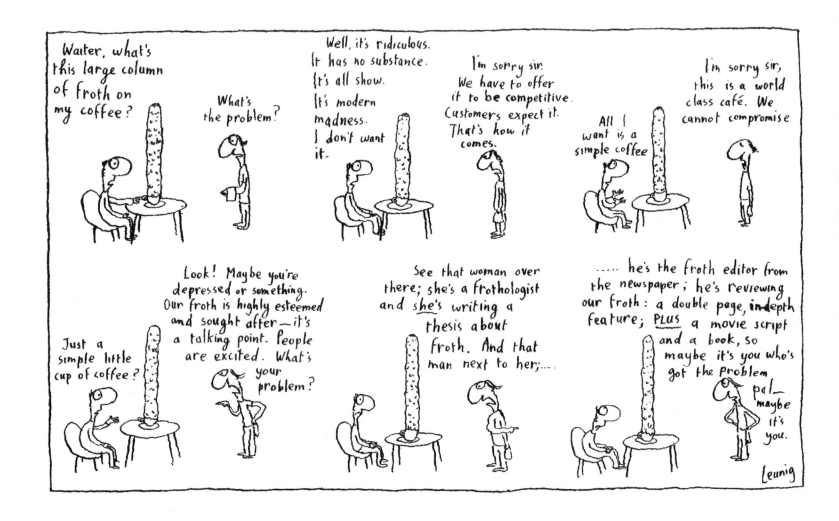

272

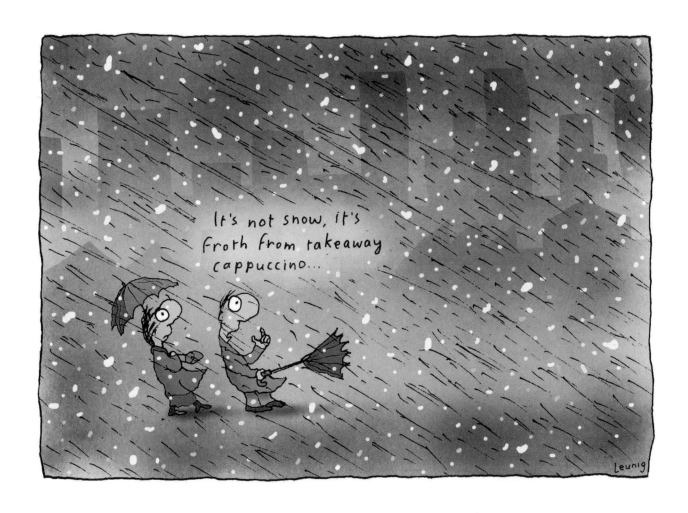

273

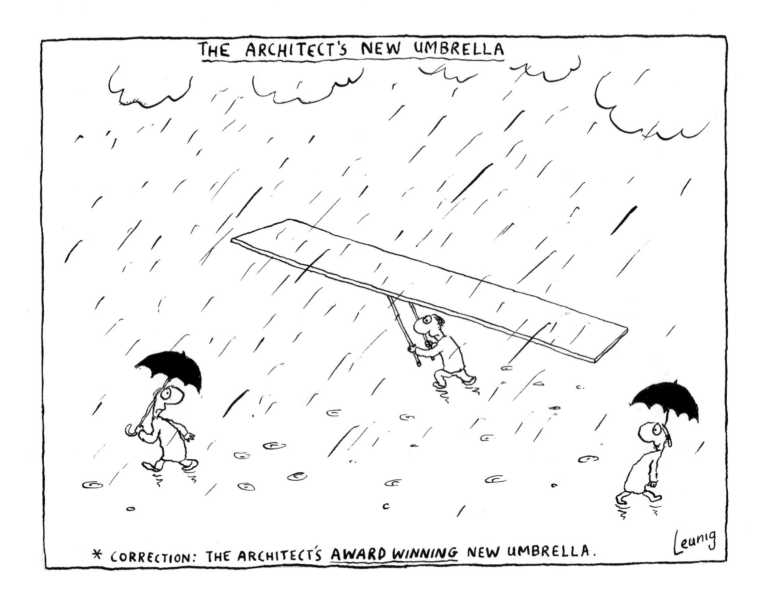

THE ARCHITECT'S NEW UMBRELLA

* CORRECTION: THE ARCHITECT'S _AWARD WINNING_ NEW UMBRELLA.

Leunig

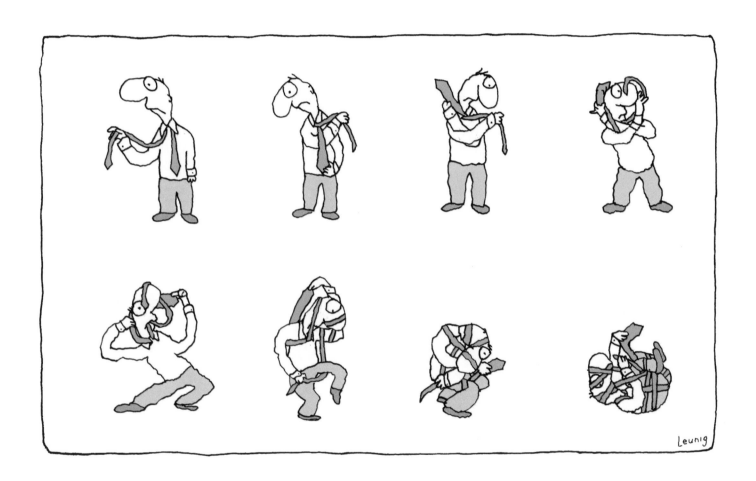

See the groovy architects; what a busy bunch,
Planning public buildings while they're having lunch;
Menu on an angle, wine list on a lean;

Matchbox on a pack of smokes; what a nifty scene —
Then the waiter cops a blast, (wine has come too early)
"Get that corkscrew out of sight — the bloody thing's too curly!"

Leunig

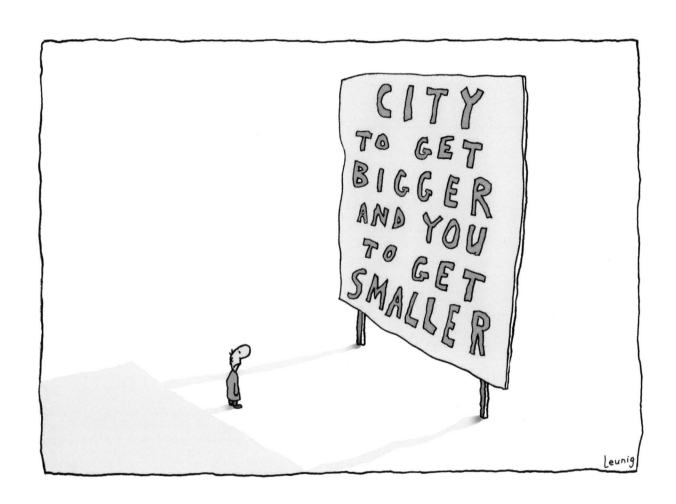

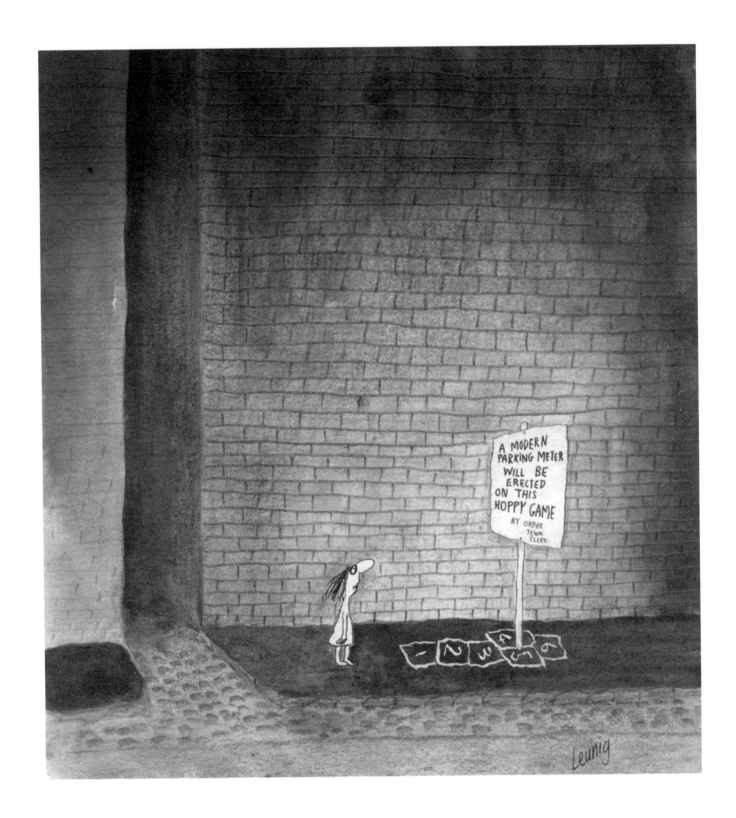

278

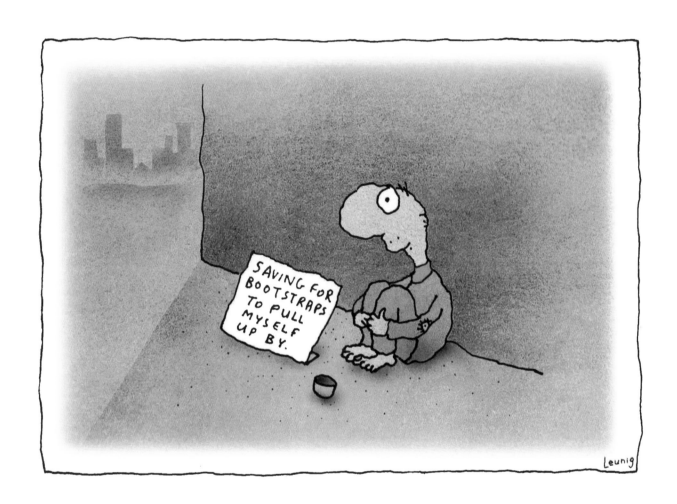

279

## A Tunnel

A tunnel is a horizontal hole;
You need to dig a tunnel for your soul
Through the mud of cruel and crazy things
Through cleverness and everything it brings,
Through the pretty lies that turned to stone,
Through tomahawks and bits of broken bone,
Through paragraphs and paragraphs of smoke,
Through the awfulness of some good bloke,
Through committee meetings in the rain,
Through and through and down and back again
Each and every single, soulful day
You need to scrape a little more away
And dig this makeshift, horizontal hole
Which is the noble journey of the soul.

The Minister for Big Things listens as the architect
presents his plans for the amazing new building.

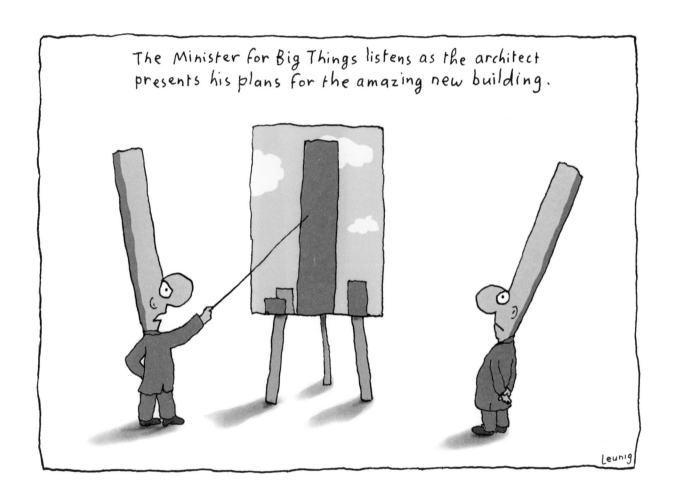

Leunig

Quite suddenly, all the good ideas had been used up

So the world turned to bad ideas, of which there was a cheap and plentiful supply

Well actually, not so much used up as badly used; misused and abused in fact...

It was soon realised that bad ideas cannot be ruined or abused because they are awful to begin with.

...to the point where they didn't work. The good ideas had become dysfunctional. They had broken down.

So the world set to work putting them into practice. Sustainability had come to the earth at last.

leunig

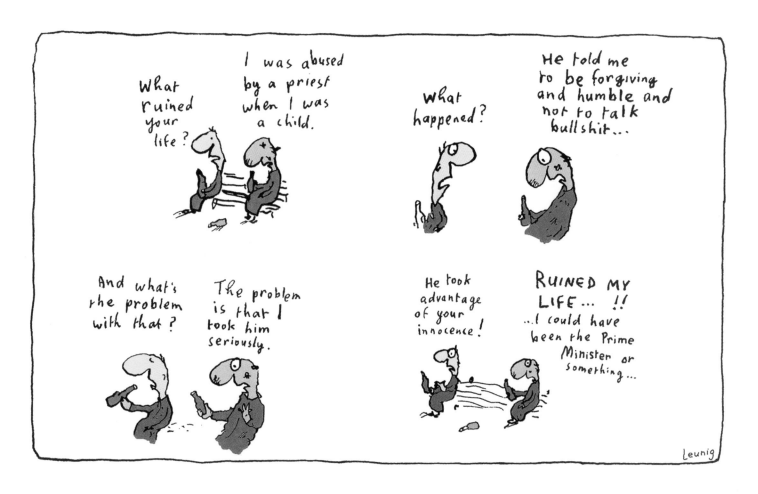

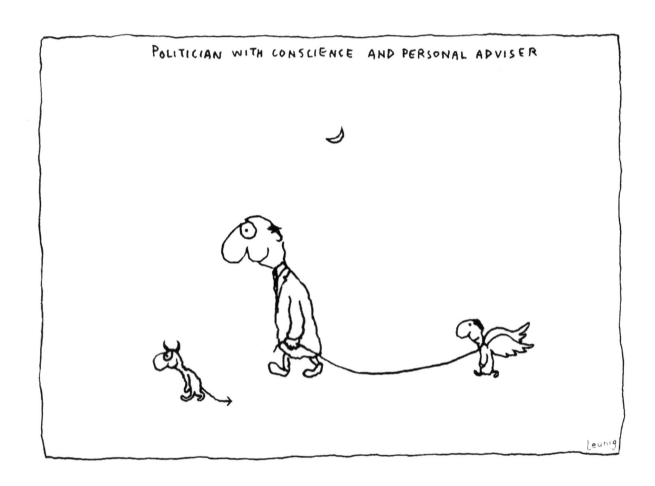

POLITICIAN WITH CONSCIENCE AND PERSONAL ADVISER

## SELF-COMPOST

TOO MUCH HAS BEEN
MADE OF GROWING
BIG AND STRONG

Onto this heap it all
goes; everything belongs
there: the achievements,
the disasters. Memories,
anxieties.... THE LOT.

BUT WHO UNDERSTANDS
THE JOYS OF LETTING
YOUR LIFE BREAK DOWN ?

The stories, the hopes
the wounds, the jokes...
...Socks, trousers and
sentimental objects.

Decomposing down into
SIMPLE DARK MATTER.

THIS PROCESS IS CALLED
'SELF-COMPOSTING'. It
means turning your mind
and your entire situation
into a compost heap.

SUCH WONDERFUL STUFF, this
simple dark matter —
rub it on your skin,
sprinkle a bit on the garden
mix with a little water and
paint a picture with it.

VERSATILE AND BEAUTIFUL
SDM: Simple Dark Matter.

Leunig

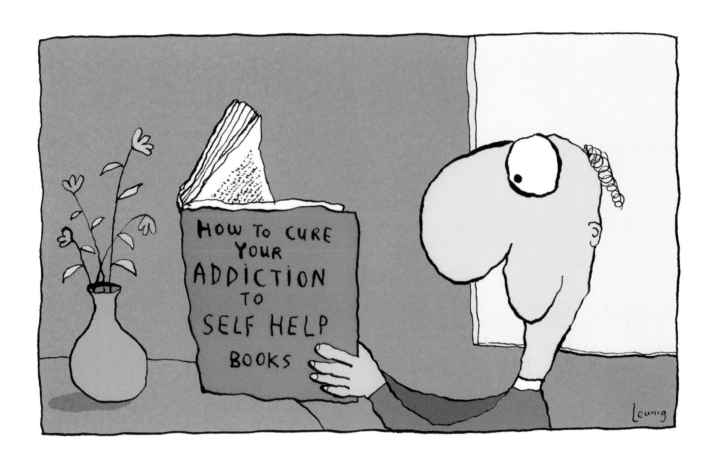

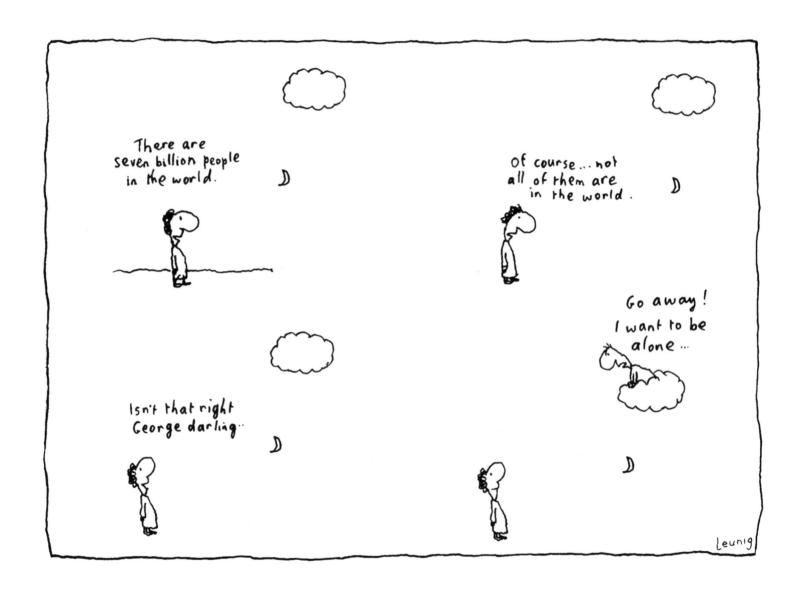

Into weariness and woe
I am bound to simply go,
Understanding less and less
Of this existential mess.
Not to stagger or to stoop
But to bear this bowl of soup
With careful steadiness and cheer;
This soup I made, this bowl so dear,
This time on earth, these bits I found,
The trembling heart, the shaky ground,
The fading light, the wistful moon,
My winding path, my wooden spoon.

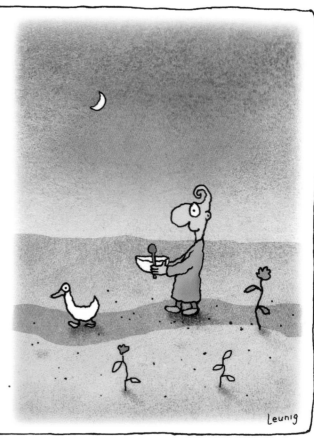

in a world so
badly shaken...

...is it wise
to <u>shake</u> hands ?

perhaps a gentle
steady holding...

...would be a
happier thing...

Leunig

## SPRING LOVE SONG

Life is just a little branch
we land on;
A tiny perch to stand on as
we fall down from the sky;
A springy twig, a flower we
hadn't planned on
To love with sweet abandon
while we live and as we die.

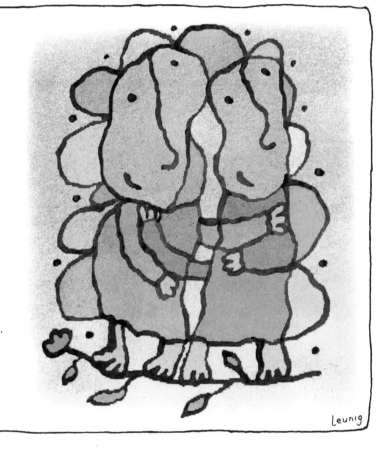

When I was just a boy of four
I was sexually abused by the girl next door
Who lured me with her fairy spell
And she was only four as well.

We crept into a darkened shed
And there we made a pixie bed.
She folded back my trembling wings
And did three little mystery things

"It rarely gets as rude as this"
She whispered as she placed a kiss
Upon my tiny magic wand
To seal our dreamy secret bond.

How true; it seldom gets as real
As what two naughty pixies feel
And life becomes a broken spell
In mourning for the magic dell.

I want to be sub-human
And be a lesser man
Humans are too much for me
Too much to understand
They're too much for each other
And too much for the earth
They're too much for themselves as well
Much more than what they're worth.
They want too much, they do too much;
Too much, too much for me
I want to be less human now
And be more <u>creaturely</u>.

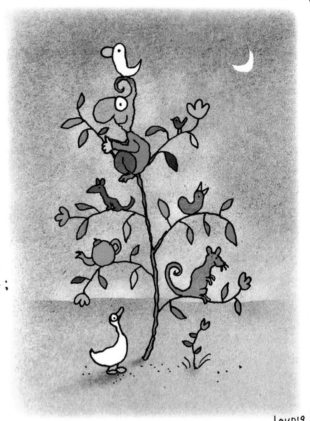

Leunig

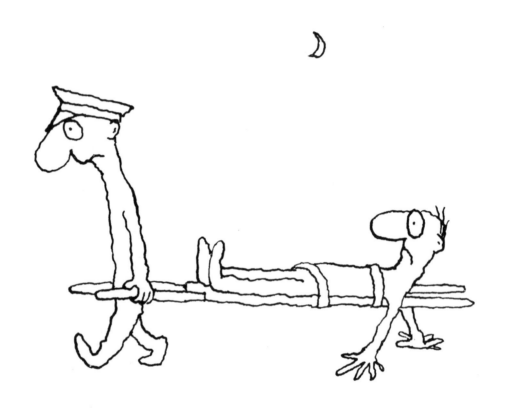

leunig

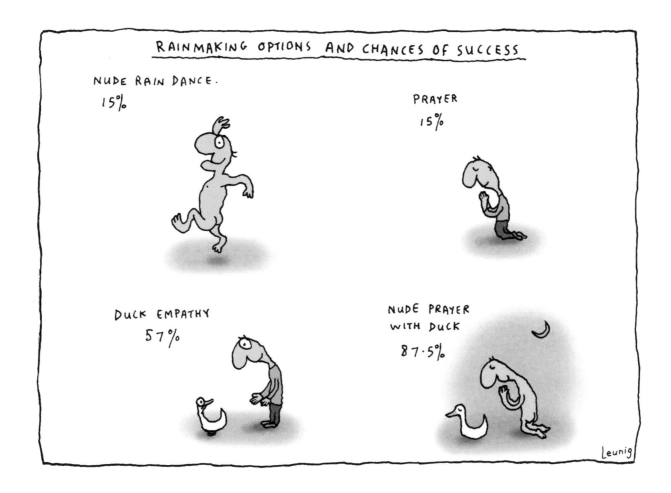

295

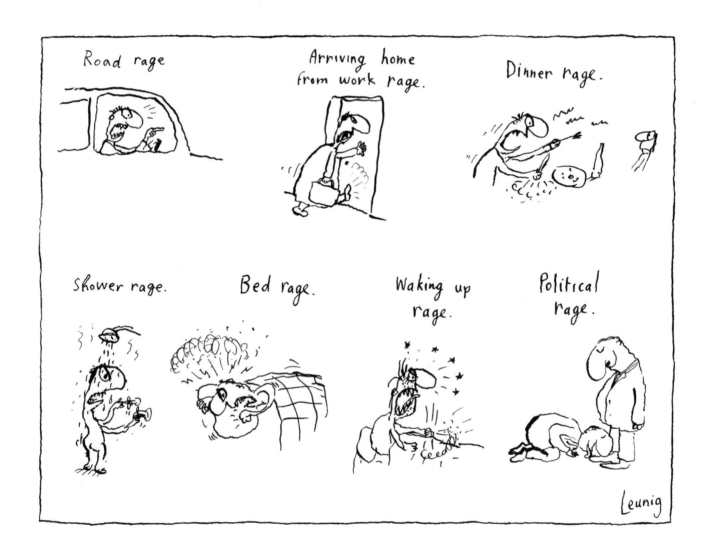

The rivers of grog are deep and wide
They keep the nation well supplied;
Canberra, Melbourne, Sydney town;
The rivers of grog flow quietly down

Down and down the throats they run;
Mother, father, daughter, son;
Black and white all stupefied;
The rivers of grog are deep and wide.

Leunig

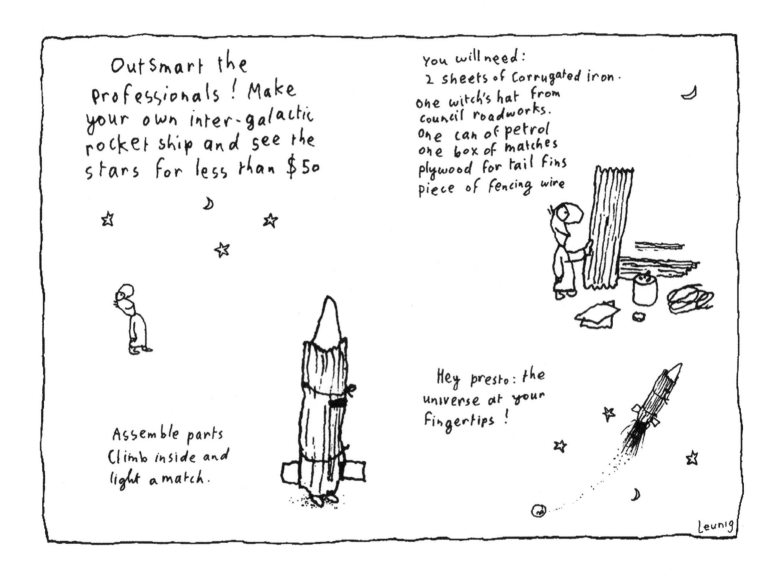

Outsmart the Professionals! Make your own inter-galactic rocket ship and see the stars for less than $50

You will need:
2 sheets of Corrugated iron.
One witch's hat from council roadworks.
One can of petrol
One box of matches
plywood for tail fins
piece of fencing wire

Assemble parts Climb inside and light a match.

Hey presto: the universe at your fingertips!

Leunig

LEARNING TO READ — THEN AND NOW.

The cat sat
on the mat.

...The military
option is on the table.

Leunig

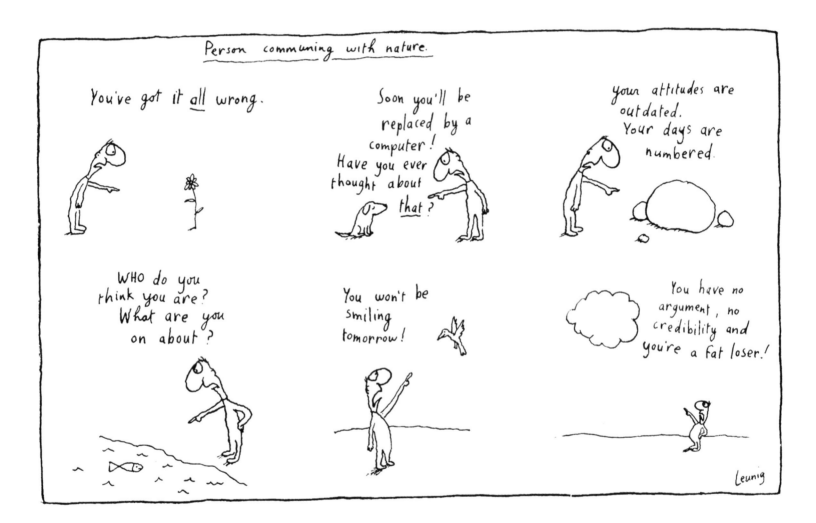

OH PLEASE!
No more leafy parks
for the city...
ENOUGH IS ENOUGH.

If people must
have parks then let
them buy the new
PARK app for their phones.

What the city needs
is more crappy shops
with blaring music.

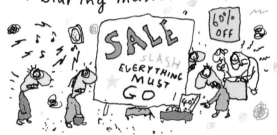

PARK lite for the
go-getter who doesn't
use parks very much
and PARK pro for the
true nature lover.

Leunig

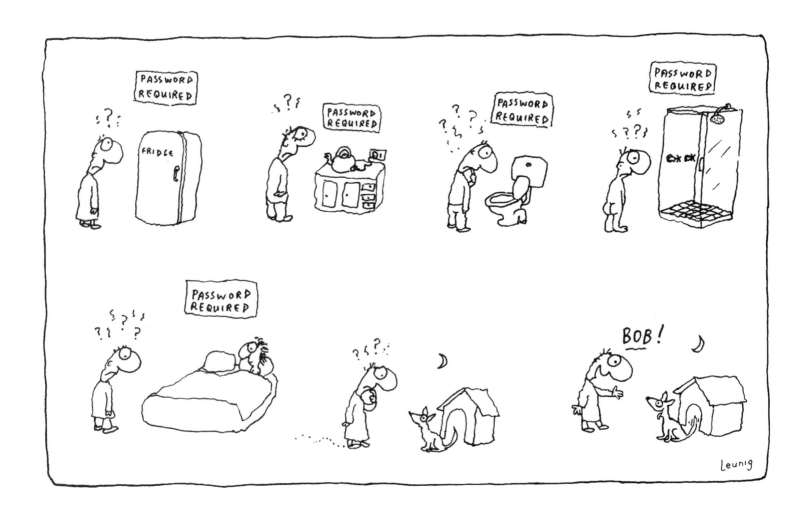

## HOW TO PAY YOUR WAY AND STAND ON YOUR OWN FEET

God's grace, nature's blessings, free music from the birds — these mollycoddling handouts make us SOFT and UNCOMPETITIVE. It's time to get real and become A SELF-MADE WINNER!

Then it's just a matter of putting in the HOURS and the HARD WORK and watching the whole thing multiply.

First you must create your own AIR and WATER; so you will need a large, reliable chemistry set and some strong STORAGE VESSELS.

And until you have done all of this; and until you have spurned all those subsidies from heaven: the moonlight, the flowers, the sunrise etc. (which weaken us so), and until you have made it entirely

ON YOUR OWN...

Then you must provide your own SUNLIGHT and SOIL; and for this you will require HUGE QUANTITIES of various inflammable gases and a box of matches plus a secure LAVA supply and machinery for crushing and GRINDING.

...YOU are not real.

Leunig

## DUCKWHISTLE POLITICS.

In every human being
Is something we're not seeing
Down there in the muck
It is the inner duck!

So blow the duckwhistle gently
At least you can blow it mentally
And what you thought was lacking
Will gladly rise up quacking

And with this joyful meekness
And rounded yellow beakness
So beautifully unfurled,
Go out and love the world!

Leunig

HERE IT IS:
THE BUSH.

AND HERE'S A PERSON
WHO LIVES IN THE BUSH

EXCUSE ME — WHAT'S IT
LIKE LIVING IN THE BUSH?

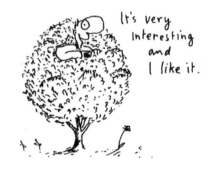

It's very
interesting
and
I like it.

IS IT TRUE THAT, IN THE BUSH,
YOU DON'T NEED TO
LOCK YOUR DOORS?

AND DO YOU FEEL
NEGLECTED IN THE BUSH?

WHAT DO YOU DO
IN THE BUSH?

I haven't
got any doors.
I just come
and go through
the foliage.

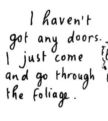

Most people don't
notice I'm in here
but that's not
neglect; that's
just being
unaware of
something.

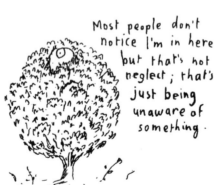

I live
here!

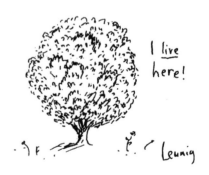

Leunig

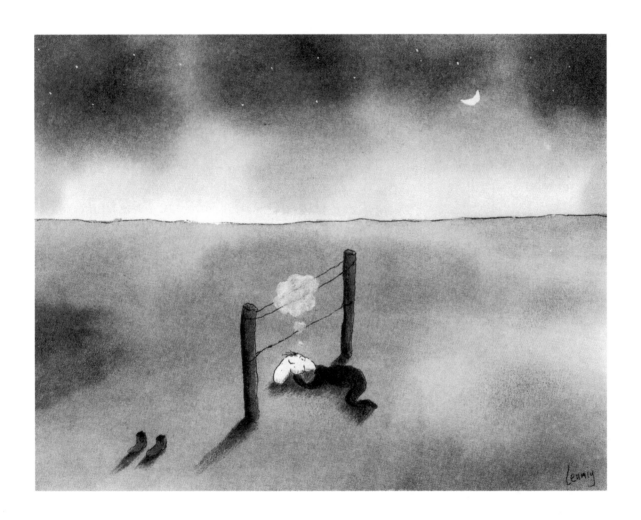

## WORD OF THE DAY
(PLUS POLL)

# why

- for what reason or purpose
- the reason for which

**POLL**

Human society gets stupider every day doesn't it? Really, the whole thing is a total madhouse and nobody with any authority will come out and admit it publicly; right? And nobody on the planet can understand what the hell is actually going on – it's a ridiculous out of control fiasco posing as civilisation; a massive appalling failure smothered in deceptions and idiotic ideas. Right?

⭕ Yes

⭕ No

**Vote**   View results

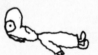

Poll closes in 2 days.

Leunig

## FAVOURITE FOOTBALL RECIPES

Take one
football.

Stuff it down
your throat.

Grab ANOTHER football
and shove it down
your throat.

Stuff as many footballs
down your throat as you
can until you are bursting
with FOOTBALLS.

GET LOTS OF FOOTBALLS
and STUFF them down
everyone else's throats

Keep on stuffing
footballs down as
many peoples throats
as you can......
AND DON'T STOP !

Leunig

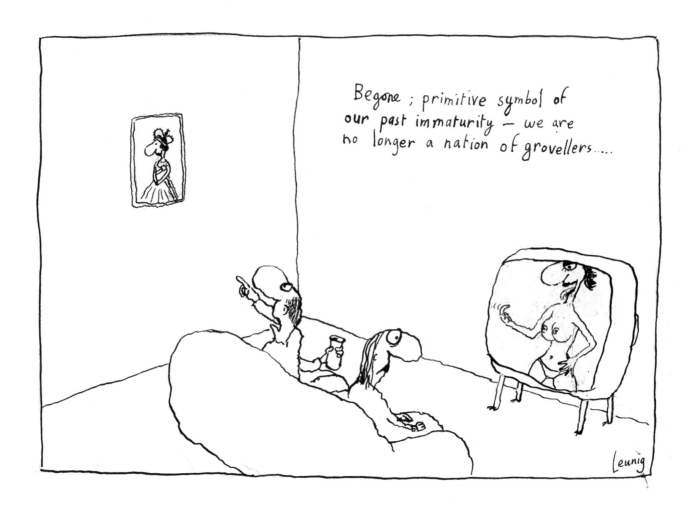

Begone; primitive symbol of our past immaturity — we are no longer a nation of grovellers.....

Leunig

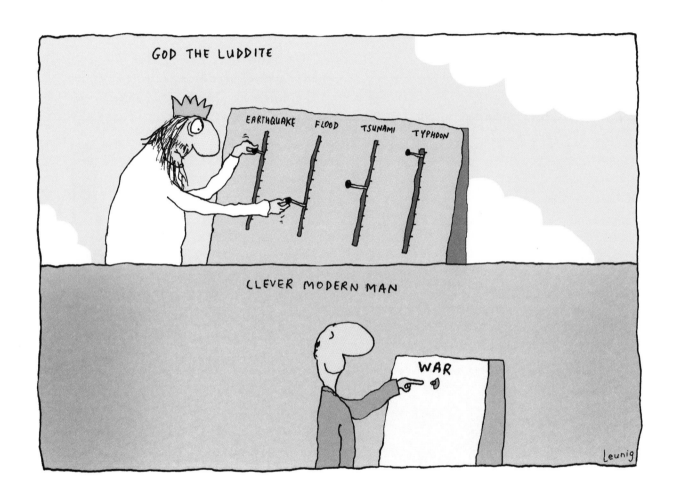

# The LOST ART OF DOOM AND GLOOM.

In more humble and frugal days gone by, 'DOOM AND GLOOM' was so normal that nobody noticed it very much.

Nobody was particularly afraid of doom and gloom because it was considered entirely natural.

Living with doom and gloom was an art form; it was a creative act - even though the words 'art' or 'creative' were not common.

Now our relationship with doom and gloom is more neurotic — but then again, most art has become neurotic. We're doomed!

Leunig

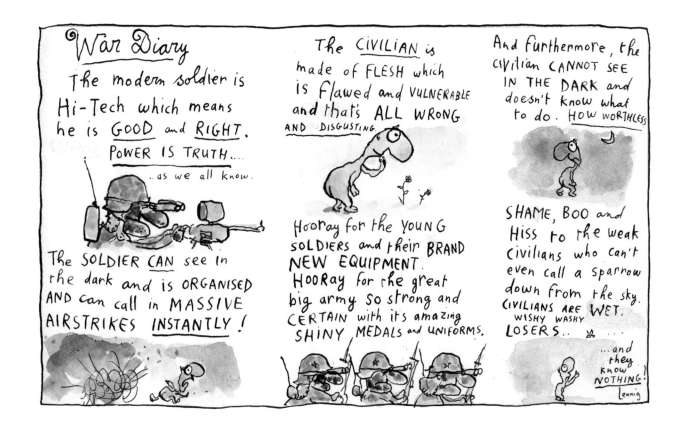

War Diary

The modern soldier is Hi-Tech which means he is GOOD and RIGHT. POWER IS TRUTH.... ..as we all know.

The SOLDIER CAN see in the dark and is ORGANISED AND can call in MASSIVE AIRSTRIKES INSTANTLY!

The CIVILIAN is made of FLESH which is Flawed and VULNERABLE and that's ALL WRONG AND DISGUSTING.

Hooray for the YOUNG SOLDIERS and their BRAND NEW EQUIPMENT. HOORay for the great big army So strong and CERTAIN with it's amazing SHINY MEDALS and UNIFORMS.

And furthermore, the civilian CANNOT SEE IN THE DARK and doesn't know what to do. HOW WORTHLESS

SHAME, BOO and HISS to the weak civilians who can't even call a sparrow down from the sky. CIVILIANS ARE WET. WISHY WASHY LOSERS.. ... ...and they know NOTHING!

Leunig

YOU CAN RELY ON IT; THIS little group — this HOUSEHOLD is 100% SANE.

The woman is 40% SANE

The man is 30% SANE

The hound is 30% SANE....

.... making a collective, working sanity of exactly 100% (OPTIMUM)

If one of the group has an "episode" causing, for example, a 10% loss of sanity, the remaining two will set about making up the shortfall.

By a supreme effort of will, discipline and concentration the remaining two will each generate an extra 5% sanity. The problem is that the effort involved may cause the eyes to bulge in such a manner that the entire situation looks TOTALLY MAD.

Leunig

314

In the abattoir of war
Man the constant carnivore
Licks his lips and gives a grin
Then climbs into the offal bin.

And there amidst the body parts
He feasts upon the tender hearts;
To taste the sadness in each one
And stomach what he has become.

The owners of the slaughterhouse
Are far away, they feed on grouse
And caviar and vintage wine;
Their table manners are divine!

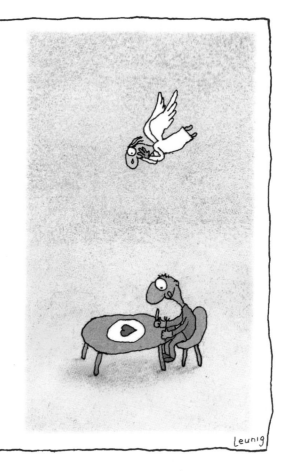

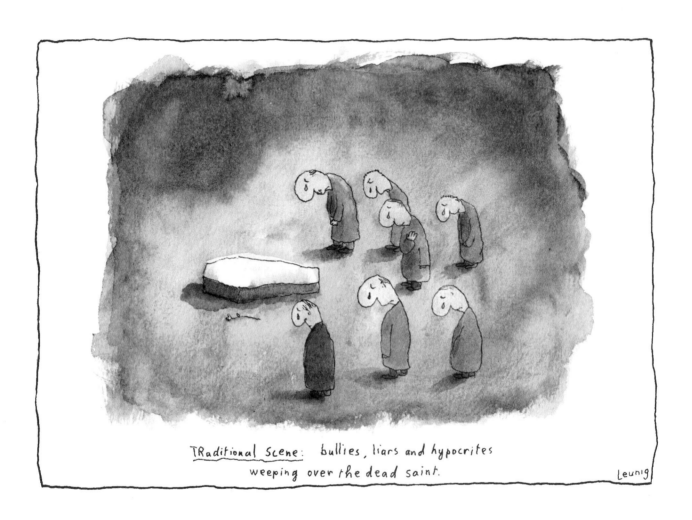

TRaditional Scene: bullies, liars and hypocrites
weeping over the dead saint.

Leunig

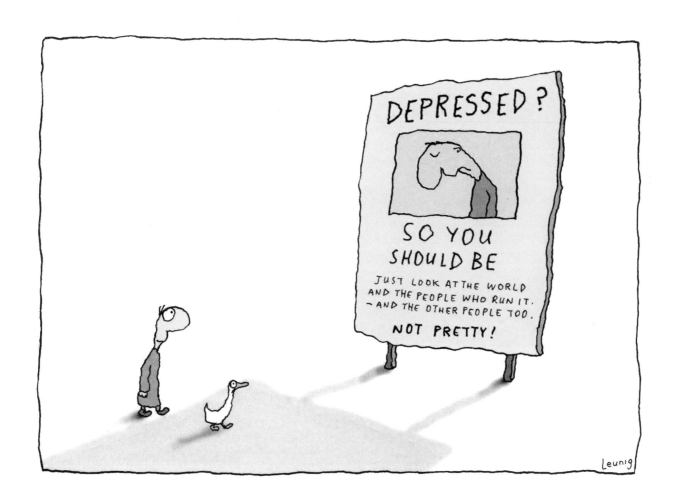

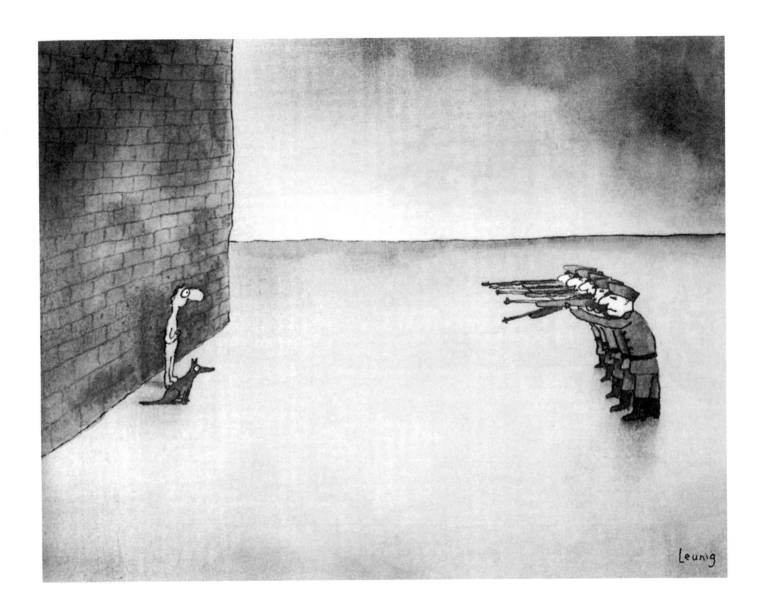

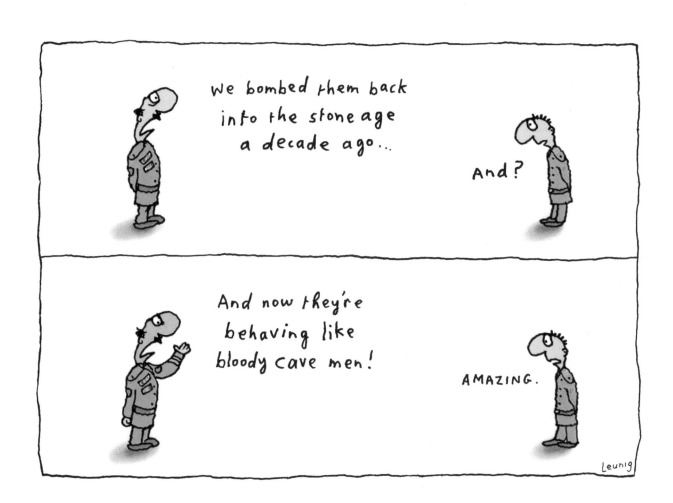

GLOBAL WARMING

IT IS TIME TO
LEARN THE GREAT
ART OF CHEERFUL
SADNESS.

THIS IS MEDITATION
THIS IS YOGA
THIS IS PRAYER

DOGS CAN SHOW
YOU HOW IT'S DONE.
DUCKS ALSO.

CHECK YOUR REFLECTION
IN A PUDDLE. YOU WILL
SEE THE SWEET, HEARTBREAKING
FOOLISHNESS IN YOUR EYES
AND IN YOUR SMILE.

EMPATHISE WITH
THEM. STARE INTO
THEIR EYES.
CHEERFUL SADNESS WILL
BEGIN TO FLOW.

WHAT YOU TELL YOUR
GRANDCHILDREN WILL
NOT MATTER SO MUCH;
THEY WILL JUST STARE
INTO YOUR EYES
AND DREAM OF DUCKS
AND DOGS.
THIS WILL HELP A BIT...

... SURELY ?

Leunig

APPS FOR TROUBLED TIMES    HELPING YOU THROUGH THE CRISIS    BED TIME DELUXE

### QUACK PRO DUCK TRANSLATOR

Ever wondered what your ducks are talking about? Find out with Quack Pro Duck Translator.

### TEA BREAK

Click on this app and your device shuts down for fifteen minutes. and will not restart.

Sick of clever commentary going nowhere? Of course you are. Listen to four old reliable bed time stories and go to sleep: Little Red Riding Hood, Jack and the Bean Stalk, Goldilocks and the Three Bears, The Tortoise and the Hare.

### PINKY-PURPLES

Gaze in silence at a host of pleasant pinkish purple shades and be well pleased.

### PORRIDGE MUSIC

Fifty rousing tunes to go with your morning porridge featuring the Big Breakfast Brass Band.

### EARTH WORM

One hundred famous poems in praise of our friend, the humble earthworm.

Leunig

321

## GALLIPOLI COCKY (A SULPHUR-CRESTED COCKATOO MAY LIVE FOR MORE THAN A HUNDRED YEARS)

As a fledgling she was rescued from her broken nest and taken in by soldiers who were training by the Goulburn River.

As a mascot she was smuggled to Galipolli, where in the trenches she learned to swear and raise her crest in the darkest, most mad and miserable moments.

She reminded the boys of home: of freedom, innocence and the great spirit. She witnessed the misery of war, and huge failure, suffering and courage in the face of an impossible situation.

She was taken back to Australia and lived in many homes with many keepers. The years passed and she stared brightly and deeply through the bars of her cage and through the meanness and madness of human society.

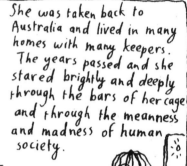

She saw the world grow faster and louder and harder. She would raise her crest and swear and try to remind them of home and freedom and the great spirit but people were too busy and faithless to understand the wisdom of an old cockatoo.

By the 1990's she found herself caged as a novelty outside a pet shop in a busy suburban shopping centre where shoppers mocked her wretched condition as they struggled for bargains and parking spaces.

Then a young boy named Ted began to visit her. His eyes sparkled with the great spirit and she raised her crest to him. One afternoon he arrived with wire cutters and quickly set to work on her prison.

She clambered to freedom and rose into the evening sky, and as she set her course for the old river she looked down to see the small boy being led away to face a very dire and difficult situation.

Leunig

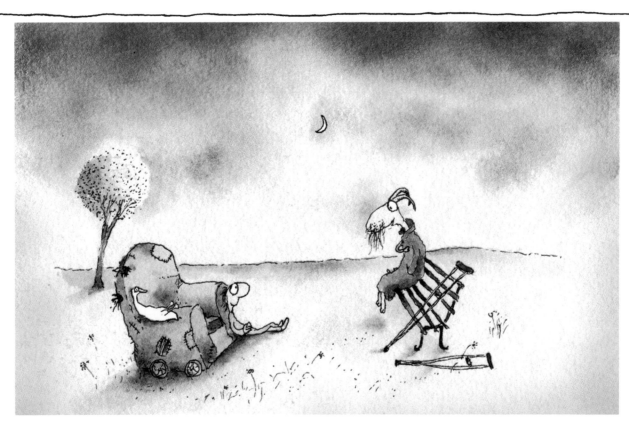

The scapegoat teaches Vasco Pyjama the art of
'copping it sweet'; the opposite of self-defence.

Leunig

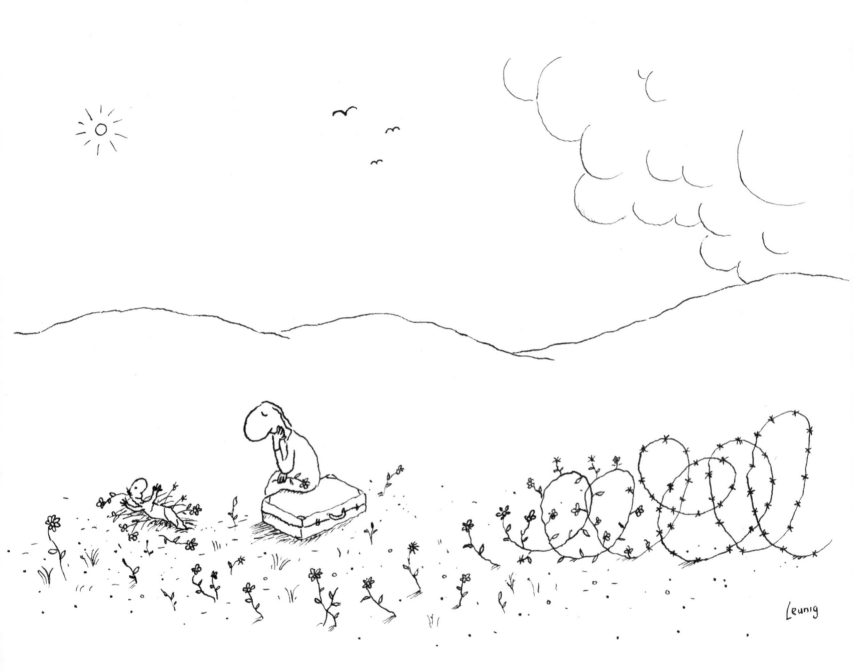

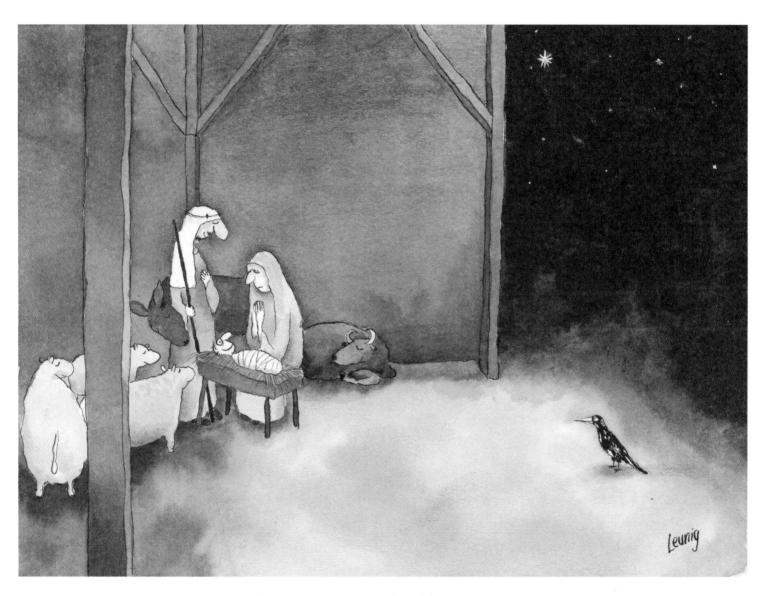

The Adoration of the Magpie.

I waited for a lovely thought
To come and comfort me
But sadly nothing of the sort
Would come and set me free.

So in my sadness I was caught
But little did I see
That sadness was the lovely thought
That came to comfort me.

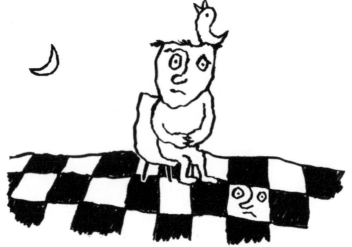

Leunig

# THE MEANING OF LIFE..... THE BAG OF ROOSTERS THEORY.

LIFE IS LIKE A BAG OF NOISY, STRUGGLING ROOSTERS.

IT IS ENTRUSTED TO US BUT IT IS DIFFICULT TO HOLD.

SOMETIMES WE LOSE OUR GRIP AND THE ROOSTERS ESCAPE

THEY DISPERSE IN A WILD PANIC.....

....AND FOOLISHLY WE SPEND THE REST OF OUR DAYS TRYING TO ROUND THEM UP.

WORSE STILL: AS WE SEARCH WE DRAG THE EMPTY SACK BEHIND US AND OBLITERATE OUR FOOTSTEPS....

*N.B. NO CORRESPONDENCE WILL BE ENTERED INTO. THE SUBJECT IS CLOSED.

Leunig

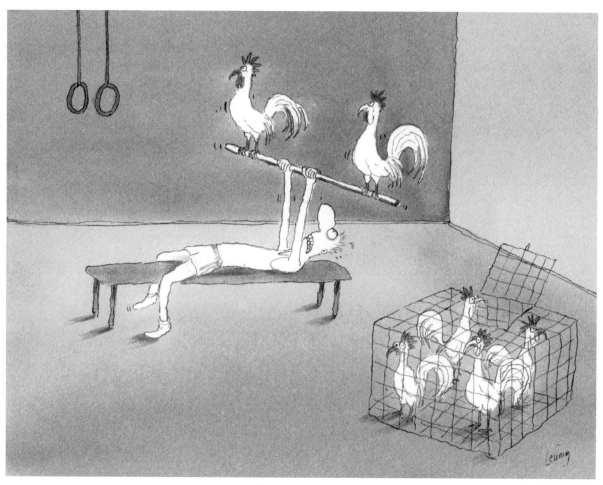

Pumping Roosters in the Gym.

# EXCLUSIVE INTERVIEW WITH THE PIECE OF STEEL WHICH FELL OFF THE GREAT FOOTBALL STADIUM.

Piece of steel, why did you detach yourself from the GREAT FOOTBALL STADIUM and fall to the ground?

I GUESS I WANTED MY FREEDOM

But you had everything! Fame, glamour, excitement; and you belonged to a powerful empire of wealth and certainty. What went wrong?

I WANTED PEACE AND HUMILITY AND MY OWN UNIQUE TRUTH.

And what is your unique truth?

IT IS SIMPLE. I WAS RIPPED FROM THE EARTH AND CAST INTO A BLAZING FURNACE. THEN I WAS SHAPED TO SERVE THE AMBITIONS OF MEN. THIS SADDENED ME. I WANT MY TRUE AND NATURAL DESTINY.

And what do you think that will be?

IF A CHILD WAS TO FIND ME ON A SCRAP HEAP AND PLAY WITH ME — THAT WOULD BE NICE; BUT ULTIMATELY I WANT TO JUST RUST AND RETURN TO THE EARTH AND BE A PART OF THE GREAT CYCLE. PERHAPS I'VE FOUND GOD.

Leunig

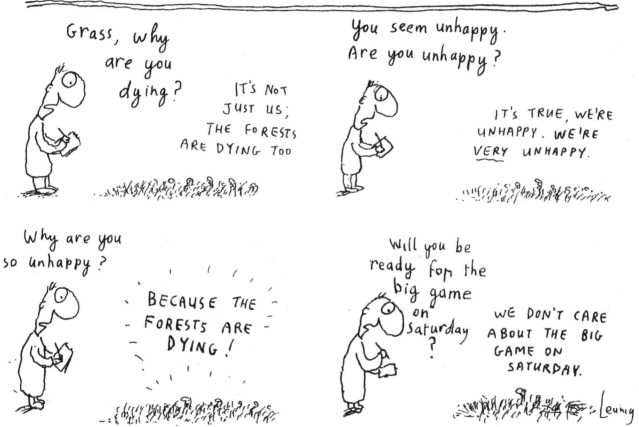

HUSHED SPECTATORS WATCHING THE FINISH OF THE MAVIS CUP.

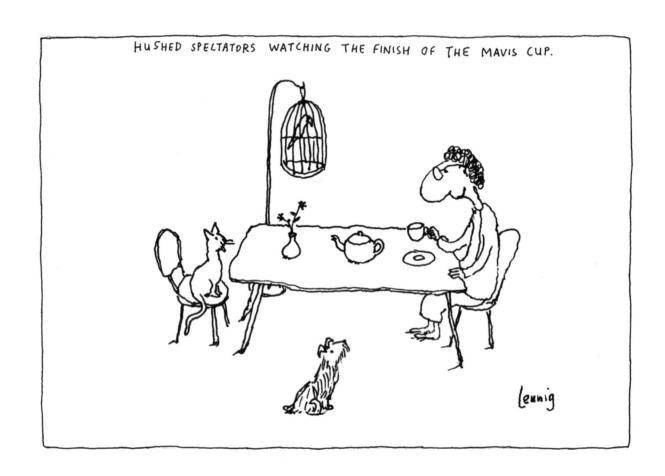

leunig

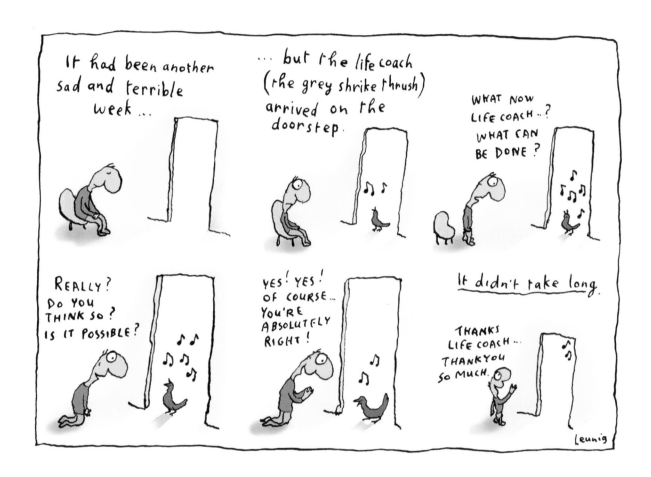

OVERLOOKING MY LIFE SO FAR

In my life I had accumulated many things in my head......
TOO MANY THINGS...!

Memories, tunes, facts, fears, visions, loves... etc. etc...as many as possible

In a fertile mind such things will interbreed. mongrel visions are born .... hybrid memories.... inbred, idiot love.... It gets very <u>CONFUSING</u>

I decided it was time for a good cleanup so I emptied it all out of my head and pushed it up in a big heap to sort it out.

There it was.... everything that was me, all in a big jumbled heap. I walked around it. What a mess..!

Then suddenly I saw it in silhouette and realized what it was....
IT WAS A HEAP....
A SIMPLE HEAP...!
you don't sort it out.. you climb it.... you climb it because it is there..

Excitedly I clambered to the summit and raised a flag. I was now looking beyond everything that I knew.

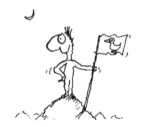

THE VIEW WAS SIMPLY <u>MAGNIFICENT</u>

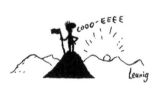

COOO-EEEE

leunig

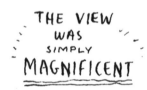

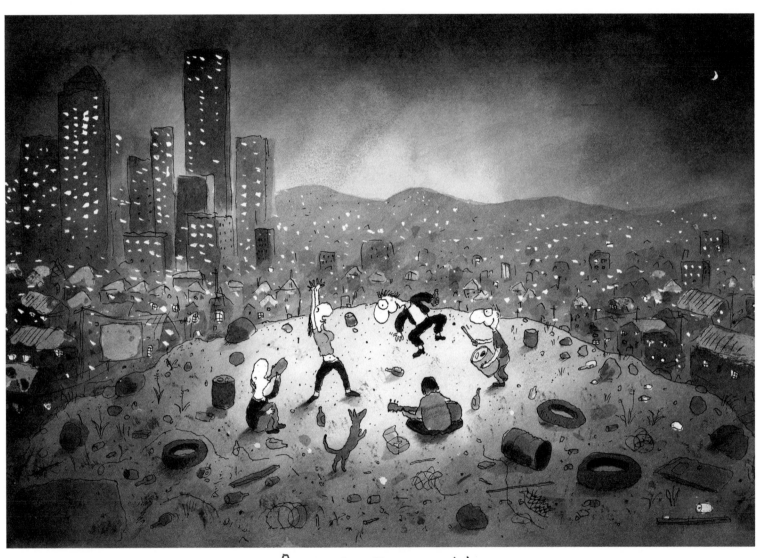

Peasants Merrymaking

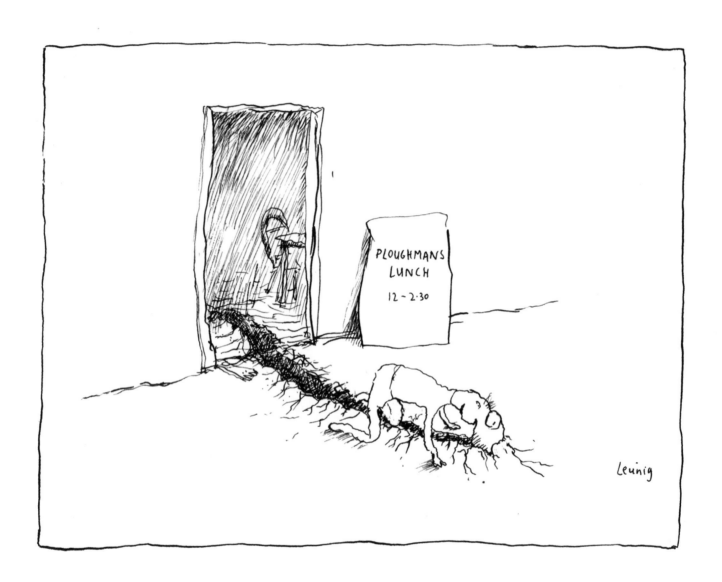

PLOUGHMANS
LUNCH
12 – 2.30

Leunig

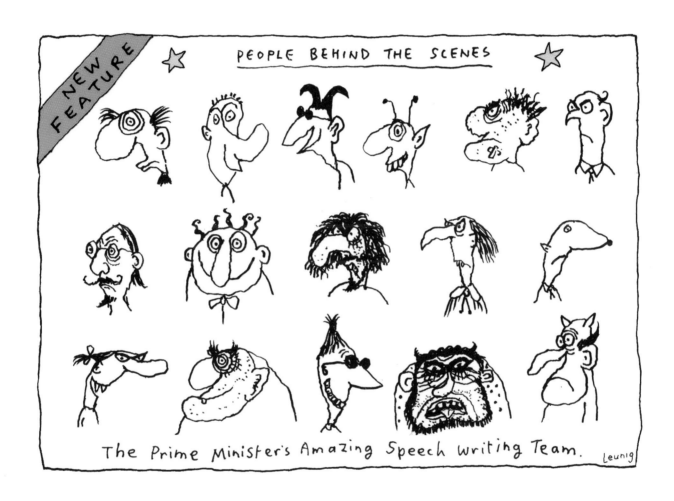

The Prime Minister's Amazing Speech Writing Team.

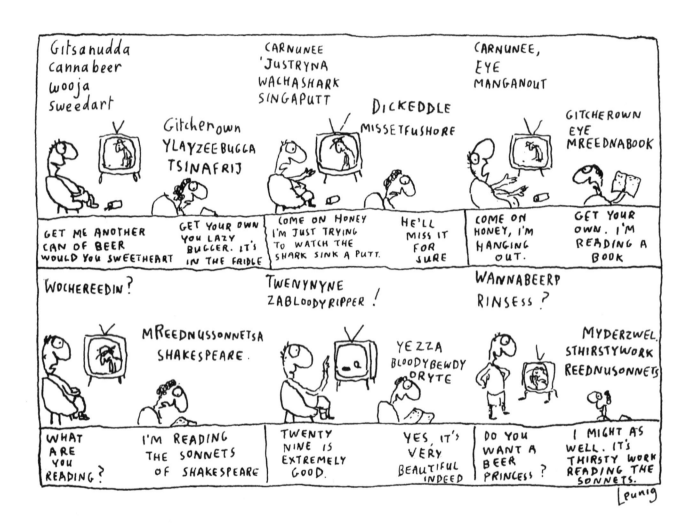

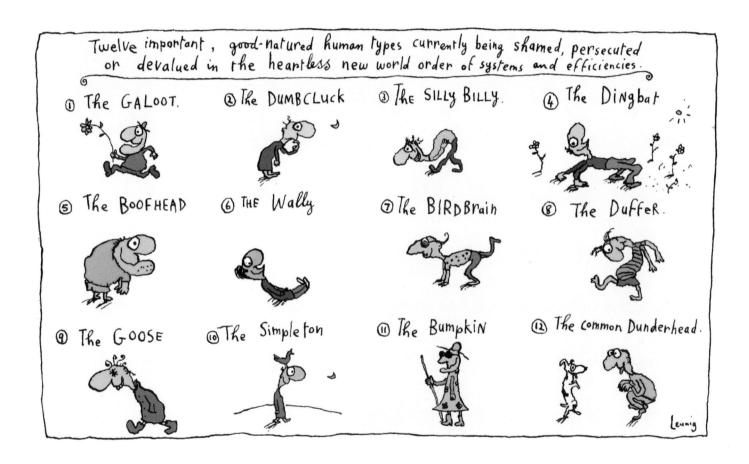

339

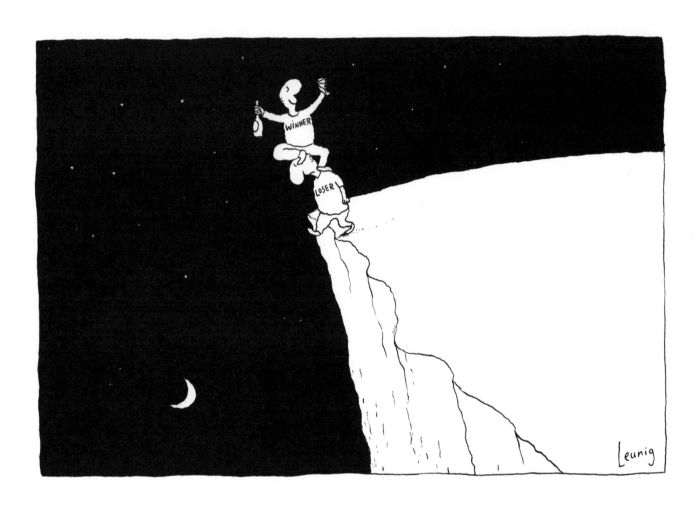

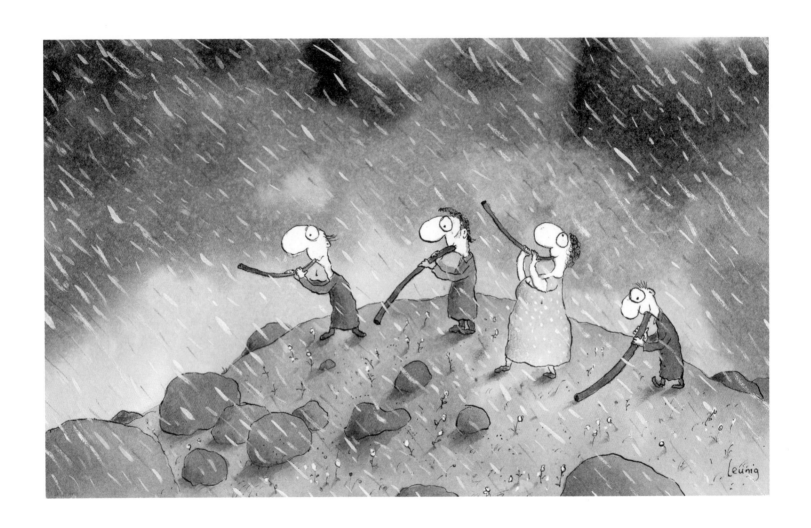

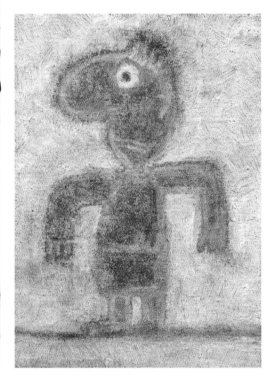

One of the world's most beautiful things
Is the sight of a gentleman drying his wings
As he prepares for his flight to the sun;
Poor little innocent, dear little one.

Sad is the wondering look in his eye
Lingering there at the edge of the sky.
Why did it happen? How was it done?
Poor little innocent, dear little one.

Leunig

## Welcome to the Club.

Suddenly, unexpectedly, you're in the club.

The club you dreaded.
The club you mocked.

It's your turn now.
You've joined the club.

And then, around you, you begin to discover others who are also members of the club and you see a sweetness in them that you hadn't seen before.

And you enter into a new world of telltale signs; of gentle knowing looks, little smiles of recognition and fellowship; and you begin to see what a HUGE club this is ...

...what a HUGE, OLD, STEADY, club this is. How tender and deep its wisdom; how quiet its strength; how gracious and consoling its motto, " RISUS OMNIA — INCRUMENTUS PER DEDECUS— SAPIENTIA PER DAMNUM "
(EVERYTHING IS FUNNY — GROWTH THROUGH HUMILIATION and WISDOM THROUGH LOSS )

leunig

345

Winter's come and I am glum
And that's a lovely thing.
It clears away the sheer dismay
That stupid humans bring.

Winter please, just make me freeze
And cool my burning brain:
My overheated, much repeated
Existential pain.

Make me feel intensely real
And lash me as you choose
So I won't dwell, upon the hell
Of people in the news.

Leunig

Hurtful people go away
I am going out to play
With my pixie hat and bell
With the goat I love so well
With the duck of wistful prayer
With its wise and lovely stare.
With our friend the honey bee.
We will make our monastery.

Leunig

## Scientists Discover "Lost World"

SCIENTISTS DISCOVER
"LOST WORLD",
LOVELY WORLD,
WORLD OF WISDOM.

GENTLE SOULS, GLORIOUS PEOPLE,
HUMBLE, PEACEFUL, LOVING PEOPLE.
SWEETHEARTS, EVERY ONE.

BRIGHT, SIMPLE, NATURAL SPIRITS.
TRUTHFUL PEOPLE, MUSICAL PEOPLE;
LOVELY, LOVELY, LOVELY CREATURES

SCIENTISTS DISCOVER "LOST WORLD".
SCIENTISTS MAKE SECRET PACT.
SCIENTISTS TURN AND WALK AWAY.
AWAY. AWAY. AWAY. AWAY.

Leunig

## WORD of the DAY

# lost

missing, mislaid, misplaced, vanished, disappeared, gone missing, gone astray, forgotten, nowhere to be found, absent, not present, strayed, irretrievable, unrecoverable, off course, off track, disorientated, having lost one's bearings, going around in circles, adrift, at sea, astray, neglected, wasted, squandered, down the drain, departed, forgotten, consigned to oblivion, extinct, dead, gone, defunct, destroyed, wiped out, ruined, wrecked, hopeless, futile, forlorn, failed, beyond remedy, beyond recovery, damned, fallen, irredeemable, condemned, cursed, doomed.

Eg: *The politicians were lost, the media was lost, the citizens were lost; education, art, architecture, medicine, economics, and football were lost but thank heavens there remained a violinist, a duck, a cat, a tree, a moon and a gardener who were not lost.*

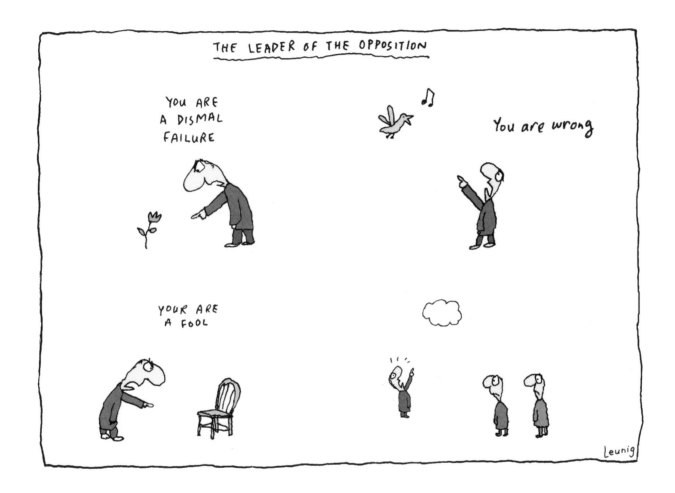

# The Empty Jeff Syndrome.

An empty Jeff came through the clouds.
And hung there for a minute:
A vacuum in the shape of Jeff
With no Jeff in it!

"The empty Jeff, the empty Jeff!"
The people cried in awe,
All staring at the space where Jeff
Was very much no more.

Leunig

ON THE FENCE POST, NEXT TO THE RAIN GAUGE IS THE OLD HAPPINESS GAUGE.

IT MEASURES THE LITTLE DROPLETS OF HAPPINESS THAT FALL DOWN UPON YOUR LIFE... IN CASE YOU NEED TO BE REMINDED

IT'S A SMALL GAUGE BECAUSE IT RECORDS LITTLE THINGS.
YOU DON'T NEED MUCH TO KEEP THE GARDEN GROWING.

SOMETIMES THE GAUGE FILLS AND ALL THE WILDFLOWERS COME UP.

Leunig

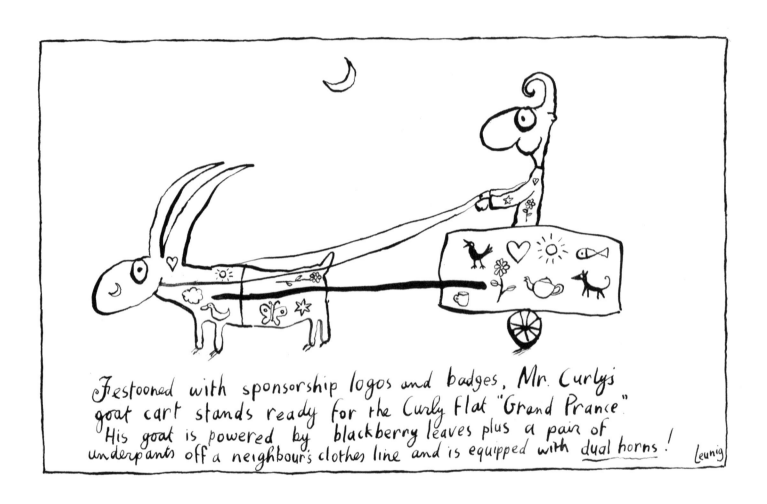

Festooned with sponsorship logos and badges, Mr. Curly's goat cart stands ready for the Curly Flat "Grand Prance". His goat is powered by blackberry leaves plus a pair of underpants off a neighbour's clothes line and is equipped with <u>dual horns</u>!

Leunig

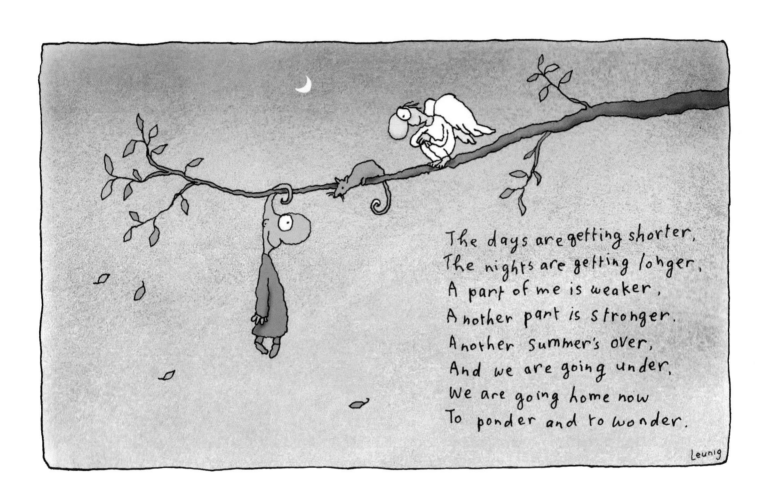

The days are getting shorter,
The nights are getting longer,
A part of me is weaker,
Another part is stronger.
Another summer's over,
And we are going under.
We are going home now
To ponder and to wonder.

Leunig

# WE WERE WRONG

In a previous issue we said, "SEIZE THE DAY". This was a mistake.

What we meant was, "HOLD THE DAY CAREFULLY, GIVE THANKS FOR THE DAY. THE DAY IS A PRECIOUS AND BEAUTIFUL THING....

....EMBRACE THE DAY TENDERLY. SHARE THE DAY AMONG YOURSELVES AND ENJOY IT REMEMBERING THAT OUR DAYS ARE NUMBERED"

When we said, "SEIZE THE DAY", we don't know what came over us. We apologise.

Leunig

RECENT ONE-PERSON CONVOYS PAST THE FRONT WINDOW

The convoy of
no-confidence

The convoy of
total amazement

The convoy of
sweet nonchalance

The convoy of
utter bewilderment

The convoy of
amused disbelief

The convoy of
oh well, ho hum.

Leunig

## SHOPPING PROVERBS

● Better to have shopped and lost than never to have shopped at all ● SHOPS WILL BE SHOPS ● Shopping is the best form of defence. ● FOOLS RUSH IN WHERE ANGELS FEAR TO SHOP ● The leopard does not change his shops. ● WHEN THE CAT'S AWAY THE MICE WILL SHOP ● Shopping is the infinite capacity to take pains. ● ANY SHOP IN A STORM ● There is always room at the shop. ● SHOPPING MEN TELL NO TALES ● Shopping is stranger than fiction ● HELL HATH NO FURY LIKE A WOMAN SHOPPING. ● The husband is always last to shop ● TO SHOP IS HUMAN. ● Shop and the world shops with you, weep and you weep alone. ● THE CUSTOMER IS ALWAYS SHOPPING ● Whom the gods would destroy they first send shopping. ● WHEN THE GOING GETS TOUGH THE TOUGH GO SHOPPING ● He who hesitates is shopping. ● SHOP AND LET SHOP ● A little shop is a dangerous thing. ● SHOP AND YE SHALL FIND. ● Empty shops make the most sound. Leunig

Christmas was fast
approaching and everybody
was happy and everybody
was sad.

Everyone was glad
and hopeful.
and everyone was
full of regret.

Everyone was excited
and everyone was
totally exhausted.

Everybody was irritable
and everybody was kind
and caring.

Everyone felt lost and
lonely. and everyone
felt peaceful and joyous.

Well, not EVERYONE.
There were those who
just sat there grinning.

Leunig

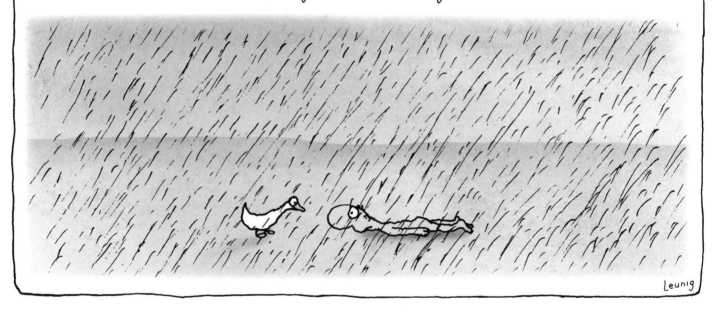

SELF ESTEEM (A WINTER POEM)

My self esteem is low,
There's far too much I know
About myself for it to grow.

Leunig

when my Albert died I had
an impression of him woven into
this rug... and now when I walk all over
him I remember the happy days when
I used to walk all over him...

Leunig

## MOTORING NEWS

Mr. Curly, in his goat assisted pedal car is asked
by a police officer to blow into a tin whistle, whereupon
it is discovered that he is driving under the
influence of poetry. For this he gains ten merit points.

Leunig

Mail to be relied upon,
Not tampered with or spied upon
May be written on a paper smidgen
And carried by a trusty pigeon.

P-Mail is the safest way
To send the words you want to say
Winging out across the blue:
"Mother Nature, I love you."

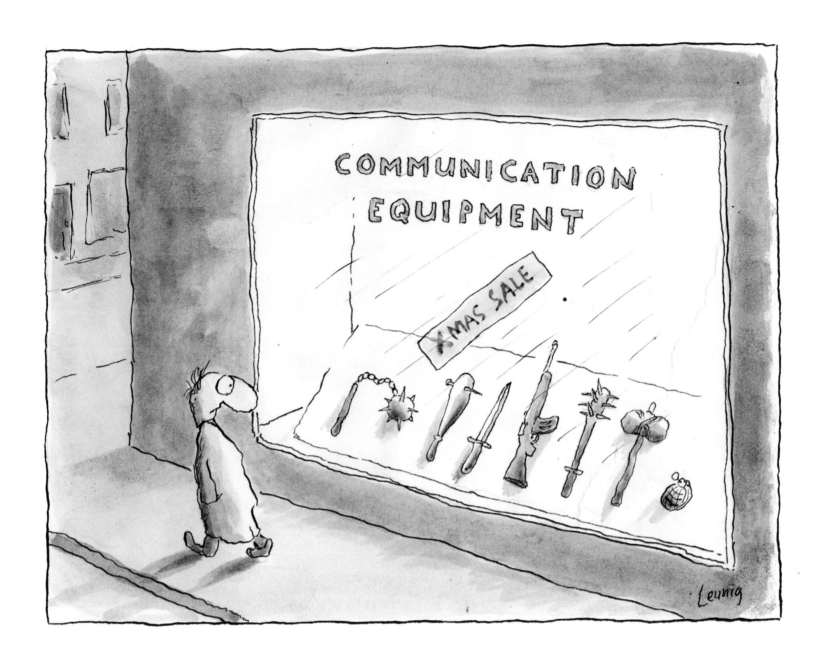

365

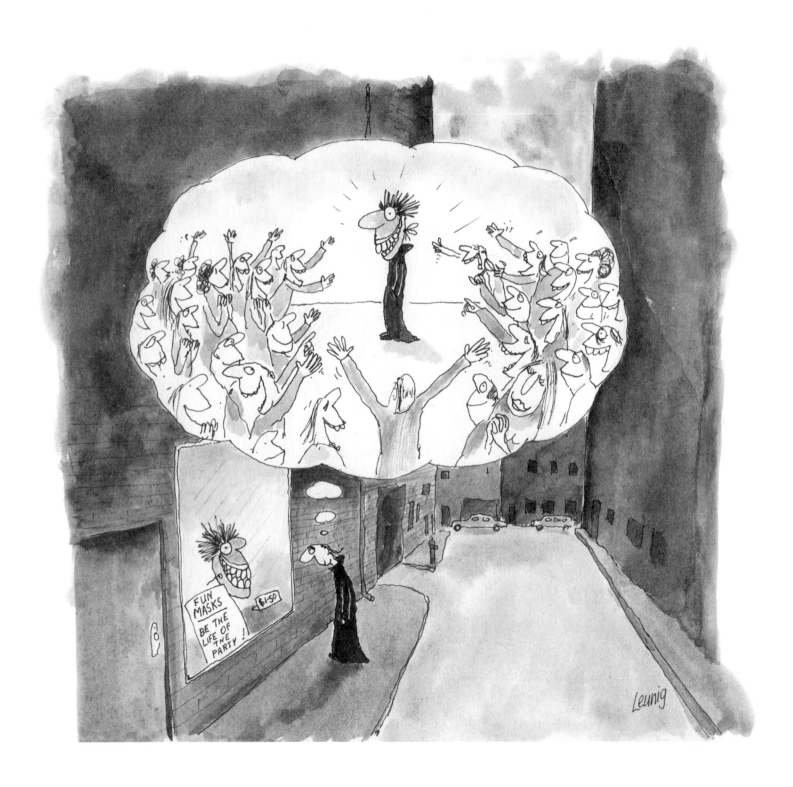

366

## PRAYER FOR FATHERS DAY

Our Father
Who art uneven;
Mellowed be thy name,
Thy kingdom come and gone,
Thy will has been a bit worn down
Here on earth, so far from heaven.
Give us this day our daily joke
And forgive yourself for telling it
As we forgive you for telling it.
And lead us, not particularly,
But deliver us your dear self
For thine is the thingdom,
The flower and the story
Forever and ever,
Ah men.

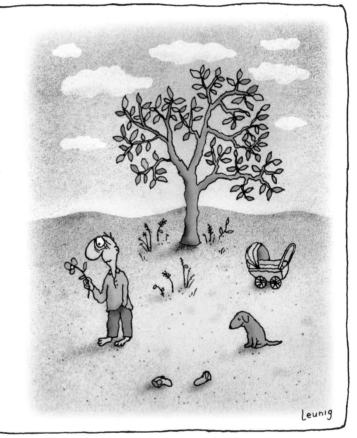

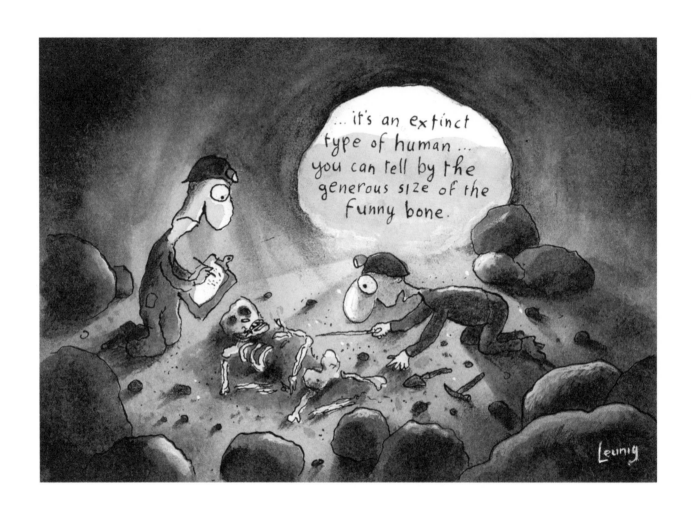

## THE AUDACITY OF GLOOM

A bit of pessimism
Is a useful sort of prism
To keep beside your bed

It takes the morning light
And separates the bright
From all the dread.

And then from out of dreamland
To gloomland and to gleamland
You have to go

How joyous, how depressing
That life is such a blessing
And such a blow.

Leunig

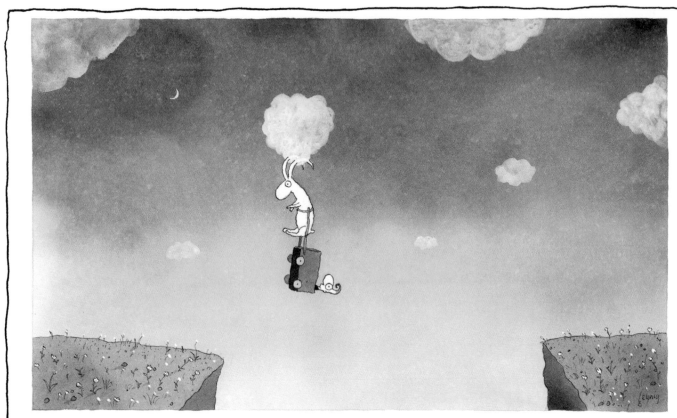

How Mr Curly crossed 'The Great Ravine' in his goat cart.

Leunig

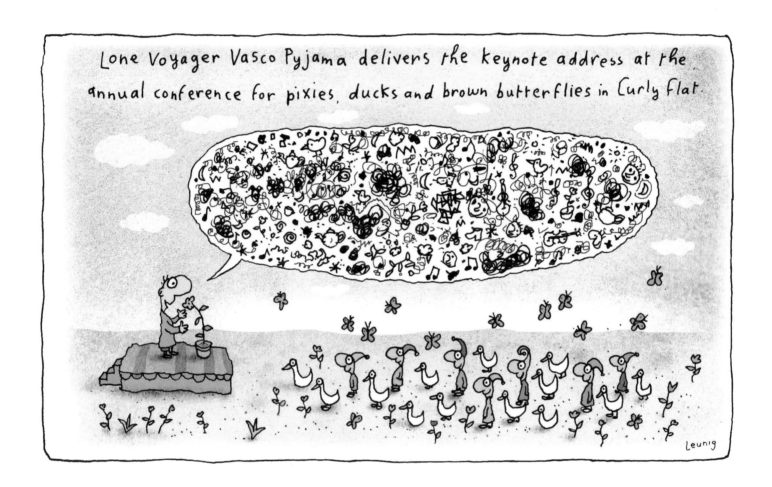

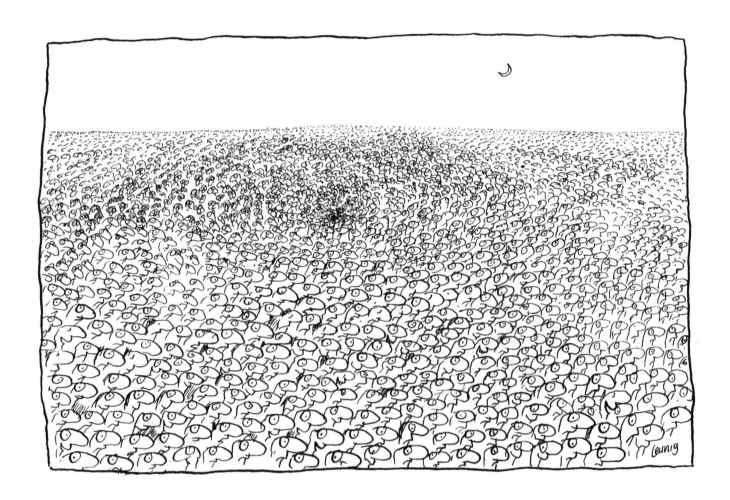

## Starer Down

Starer down, for goodness sake,
Go and stare into the lake
Stare into an olive tree
Contemplate the honey bee
Go and have a good lie down
Stop this staring people down.

Starer down don't be so hard
Stare into your own back yard
Stare into the cloudy murk
Look at mother nature's work
Go and ease your worried frown
Stop this staring people down.

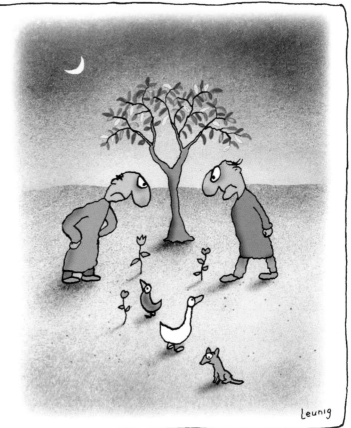

Leunig

# SuMMer Diary

Yesterday, normality was supposed to return but it didn't.

"There was no such thing as normality" said a smart looking fellow "it was all a bloody lie" He was so sure of himself.

.."it's not coming back" said a man in the street, "..It's all finished; kaput!"

I believed in it, although I couldn't really prove it existed — nor could I describe it very well..

"They've stopped making it," said the lady in the shop, "..discontinued! people weren't using it, too slow!"

...except to say that it seemed to hold everything together more or less.
Anyway I'm going to miss normality for the time being but I'm not giving up hope. I <u>need</u> it.

Leunig

The heart sings —
A lullaby
To good natured things,
As there they lie;
Innocent and weary deep inside;
Worn out by the rushing tide
Of madness that has nearly drowned the day;
The clever malice that has had its way,
The bitterness and poison from above...

Rest your wings dear little dove.
The heart still sings to you of love.

Leunig

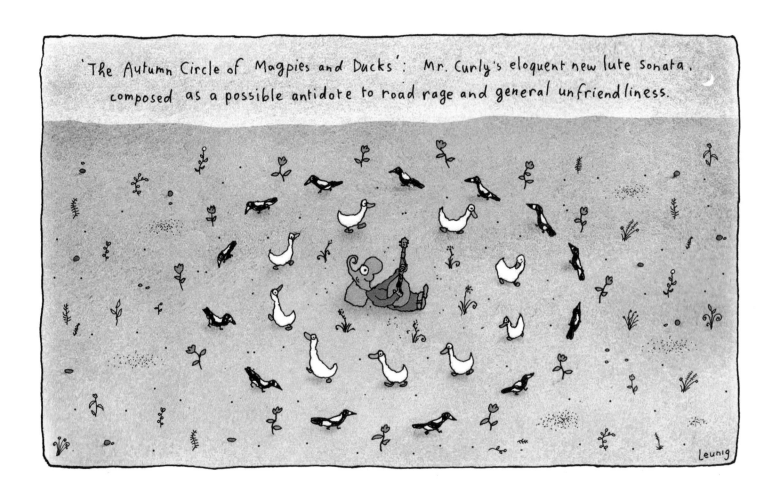

'The Autumn Circle of Magpies and Ducks': Mr. Curly's eloquent new lute sonata, composed as a possible antidote to road rage and general unfriendliness.

Leunig

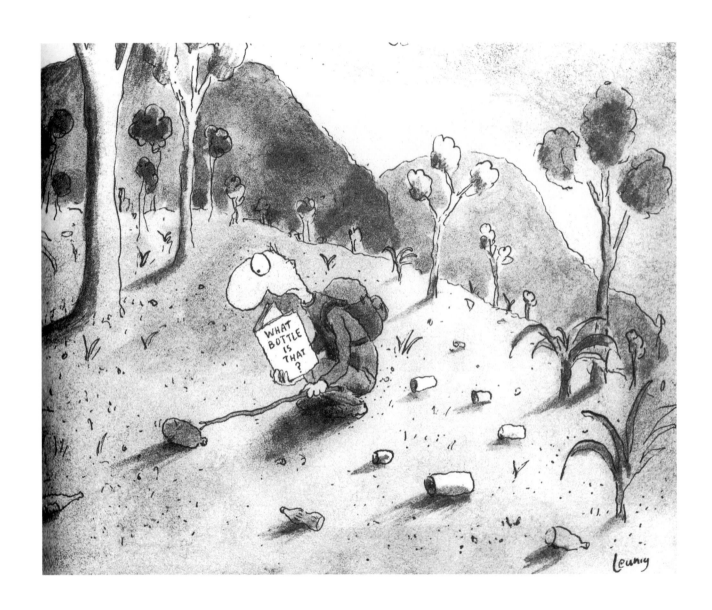

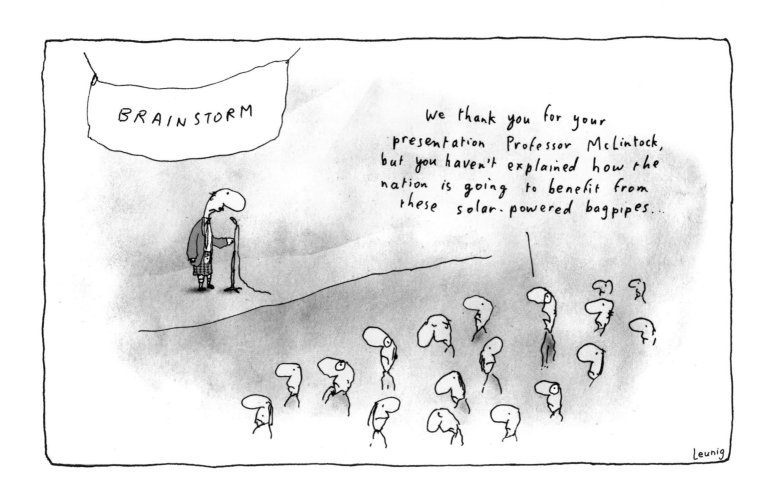

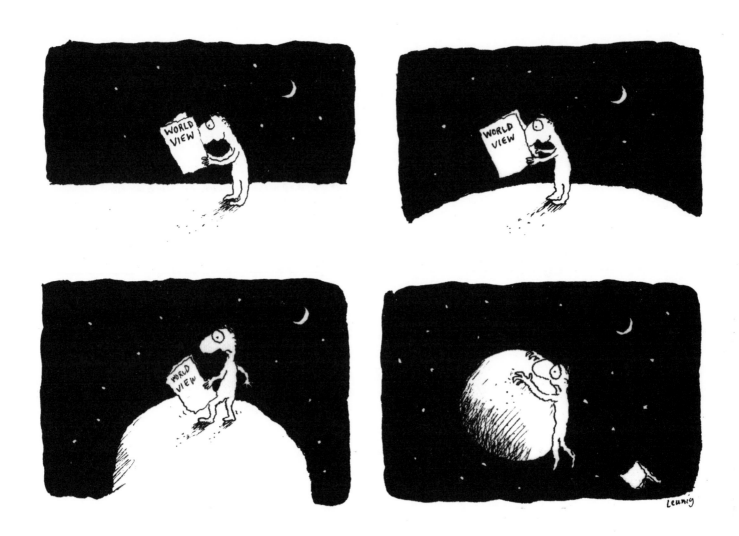

The aliens have already arrived on Earth. It happened many years ago.

Those in the second space ship joined the Labor party.

They came in two space ships.

Soon after a third space ship landed and those aboard joined the media.

Those in the first space ship joined the Liberal party.

These aliens now run the whole show ... and there's nothing you can do about it. There's nowhere to turn — except to the heavens and the stars.

Leunig

It is Spring
And man has ruined everything;
Every thing he touches,
Every thing that falls into his clutches,
Politicians clutch at lies and get elected.
I'm not represented or dejected.
What are leaders for?
They all believe in war;
The mess of lies. Power is a curse.
The lies they tell themselves are worse.
I am represented by a bird
That builds a nest and has not heard
The rotten lies.
It sings and represents me as it flies.

Leunig

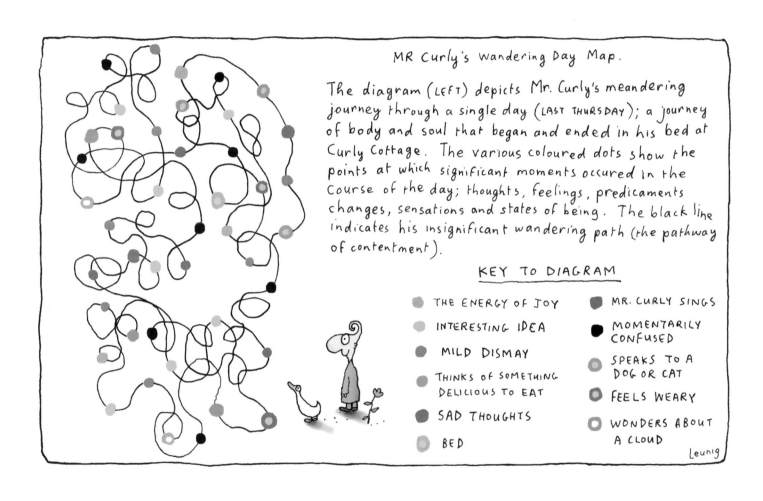

MR Curly's Wandering Day Map.

The diagram (LEFT) depicts Mr. Curly's meandering journey through a single day (LAST THURSDAY); a journey of body and soul that began and ended in his bed at Curly Cottage. The various coloured dots show the points at which significant moments occured in the course of the day; thoughts, feelings, predicaments changes, sensations and states of being. The black line indicates his insignificant wandering path (the pathway of contentment).

KEY TO DIAGRAM

THE ENERGY OF JOY

INTERESTING IDEA

MILD DISMAY

THINKS OF SOMETHING DELICIOUS TO EAT

SAD THOUGHTS

BED

MR. CURLY SINGS

MOMENTARILY CONFUSED

SPEAKS TO A DOG OR CAT

FEELS WEARY

WONDERS ABOUT A CLOUD

Leunig

# THE CORRUGATED IRON FLAG — POINTS FOR AND AGAINST.

THE SOUND OF IT FLAPPING
ABOVE US IS A FAMILIAR ONE

IT NEVER GOES LIMP
ON A WINDLESS DAY

AND VERY IMPORTANTLY:
MOST OF US HAVE ALREADY
FOUGHT UNDER IT.

Leunig

# NATIONAL INFRASTRUCTURE

**THE DULL CUBE PROJECT.**
A giant concrete cube for every town, city and suburb in the land.

**THE ARCH OF NOTHING.**
Gateway type arches on a grand scale to be constructed in civic spaces across the nation

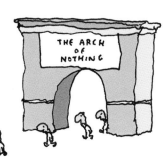

**THE NATIONAL TOOTHPASTE GRID.**
A pipeline looping around the continent to deliver toothpaste to every bathroom in Australia.

**THE SOLAR SAUSAGE SIZZLER PROJECT.**
Sausage sizzle panels to be installed on every rooftop in the land

Leunig

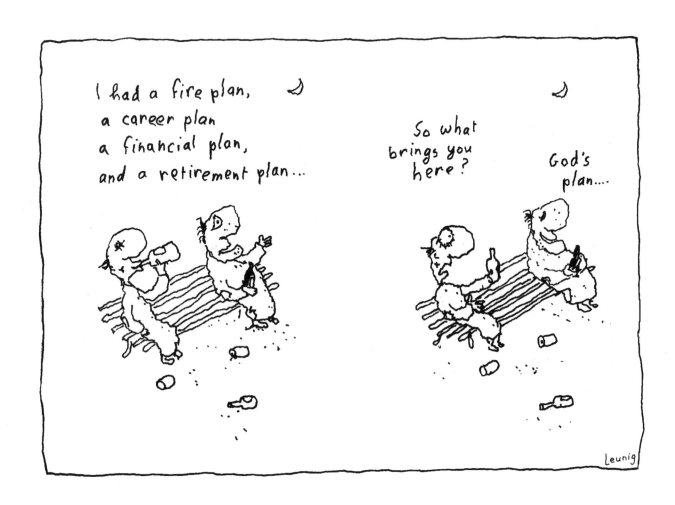

Mister Curly's bedside table
Has a leaning tower of Babel
With a duck to keep it stable
Sitting on the stack

Half-read books with dog-eared pages
Wisdom offered by the sages
Yet the work that most engages
Only gives a quack.

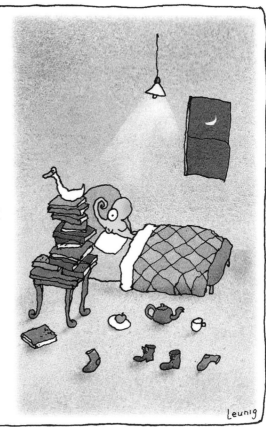

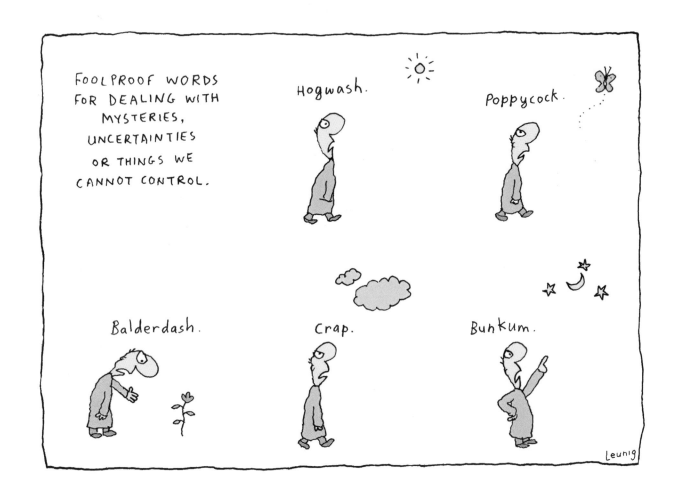

I miss those old Australian blokes
Who had a way of making jokes;
They spoke in fluent Curly;
A language I learned early.

In truth it was my native tongue;
Not spoken hard and fast, but sung
Or whistled, hummed and sighed
Or simply felt inside.

In these times of gaffes and slurs
And deep offence when someone errs
In all the hurley-burley;
Oh how I long for Curly.

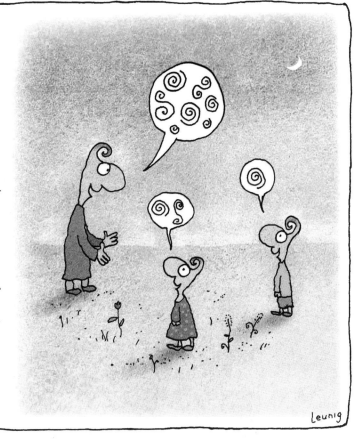

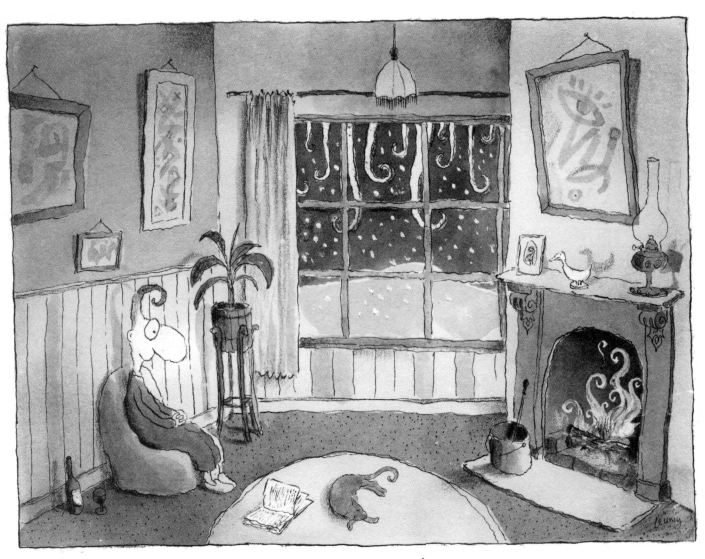

Mr. Curly imagines the approaching winter;
the icicles and the fire.

Inappropriate agrees with me
like sleeping with an angel in a tree.
Joining things that often don't belong
Is the way a pixie writes a song.

Political correctness is alright
So long as you don't have it in the night
While curled up in your bed like some dear child
With dreams so inappropriate and wild.

Leunig

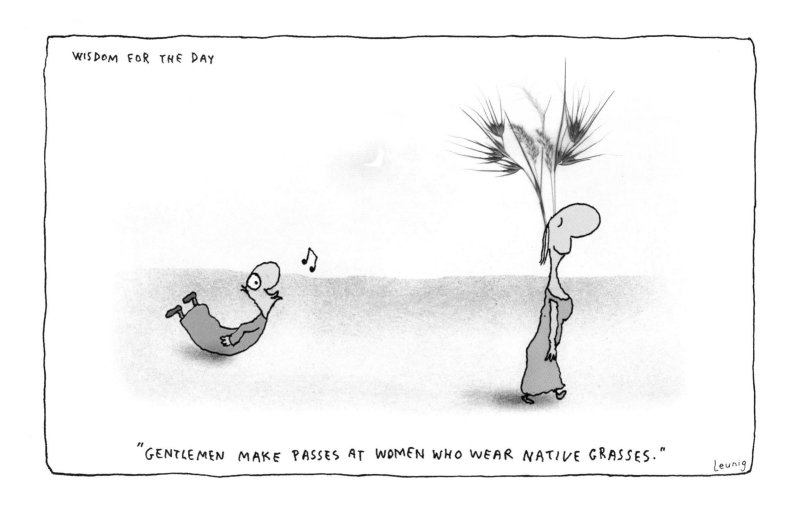

WISDOM FOR THE DAY

"GENTLEMEN MAKE PASSES AT WOMEN WHO WEAR NATIVE GRASSES."

Leunig

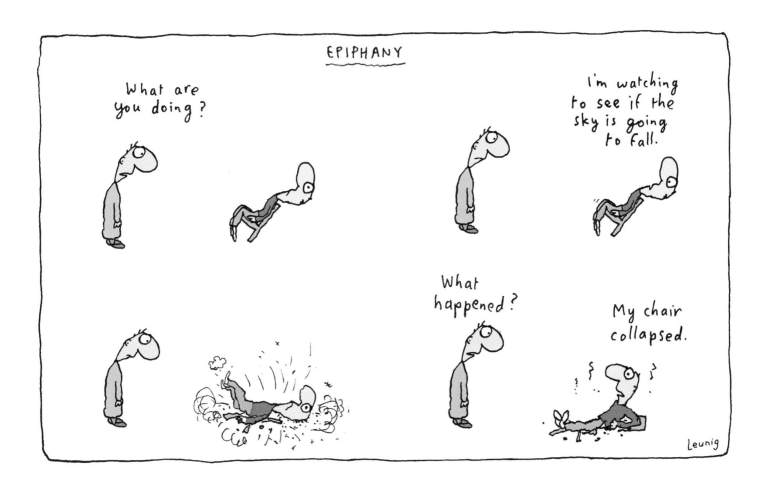

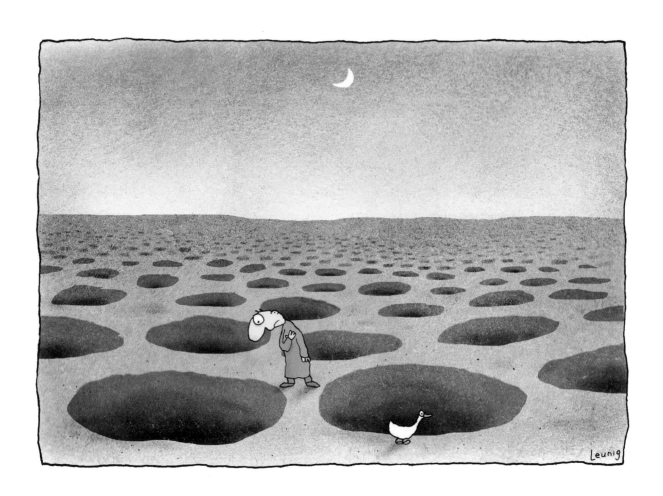

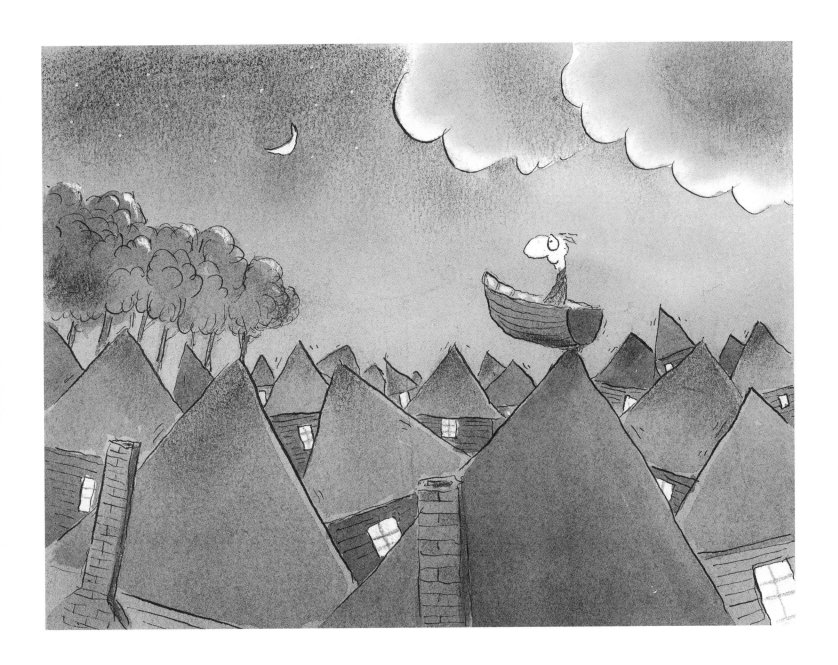

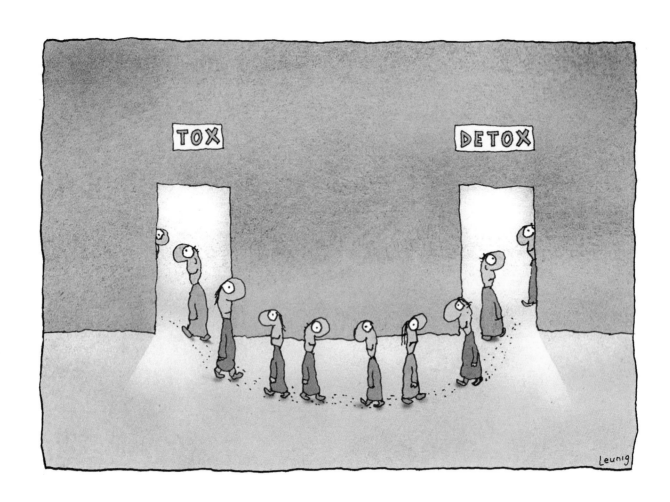

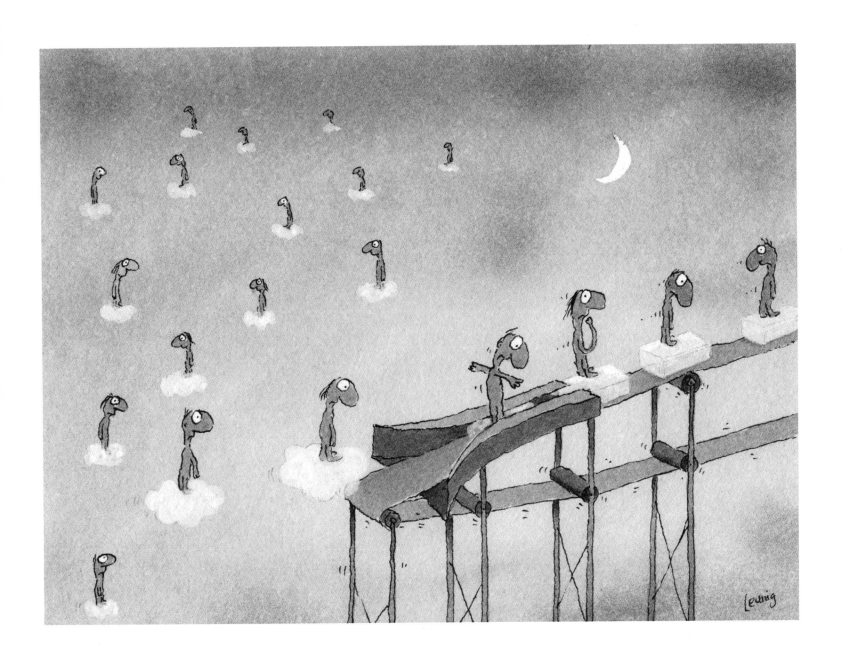

# MODERN MAN IN AN APARTMENT BLOCK

...I feel apart
... I feel blocked
... and I think I'm
coming apart.....

Leunig

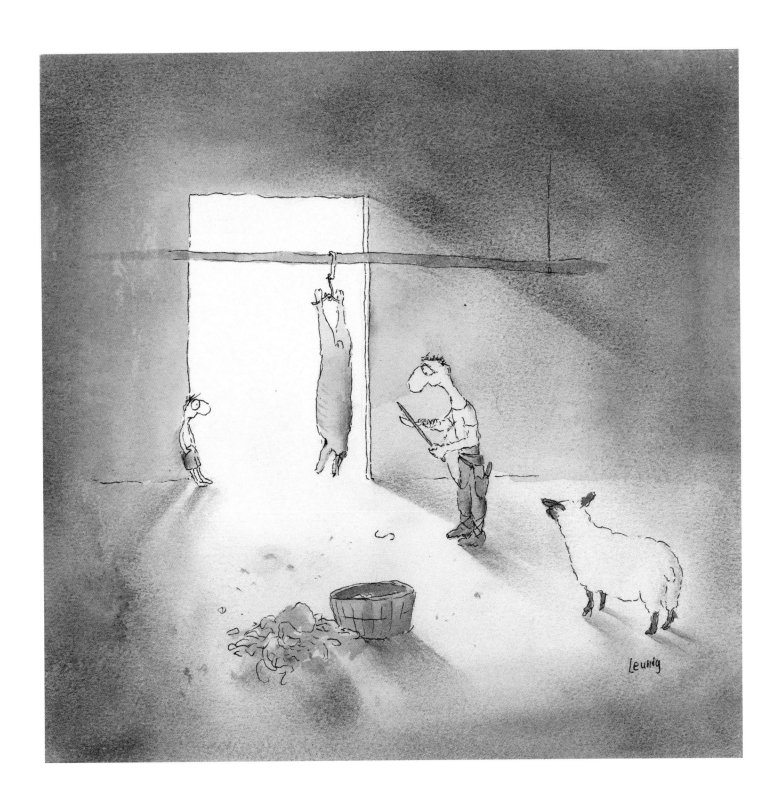

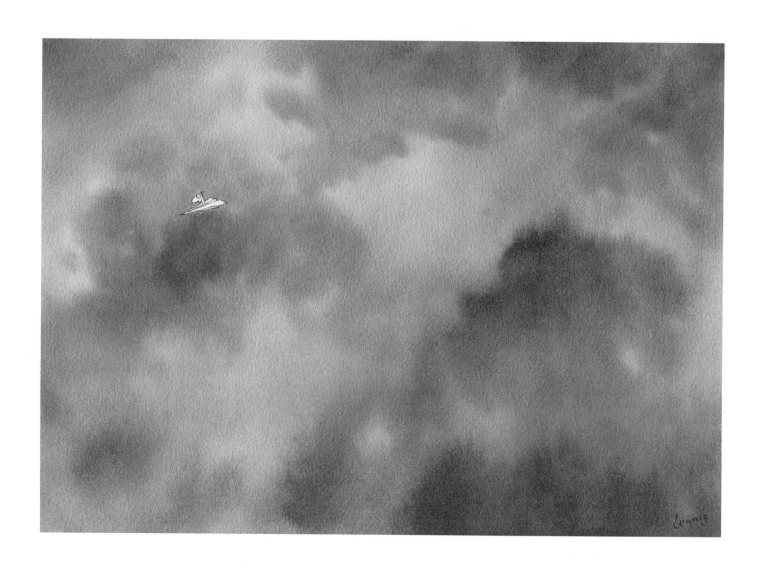

400